MW00795270

SALVADOR DALÍ AT HOME

SALVADOR dalí AT HOME

JACKIE DE BURCA

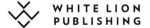

WHITE LION
PUBLISHING

CONTENTS

PREVIOUS Detail of the façade of the Dalí Theatre-Museum in Figueres.

OPPOSITE Salvador Dalí at home in Port Lligat, November 1957.

OVERLEAF Dalí's house in Cadaqués.

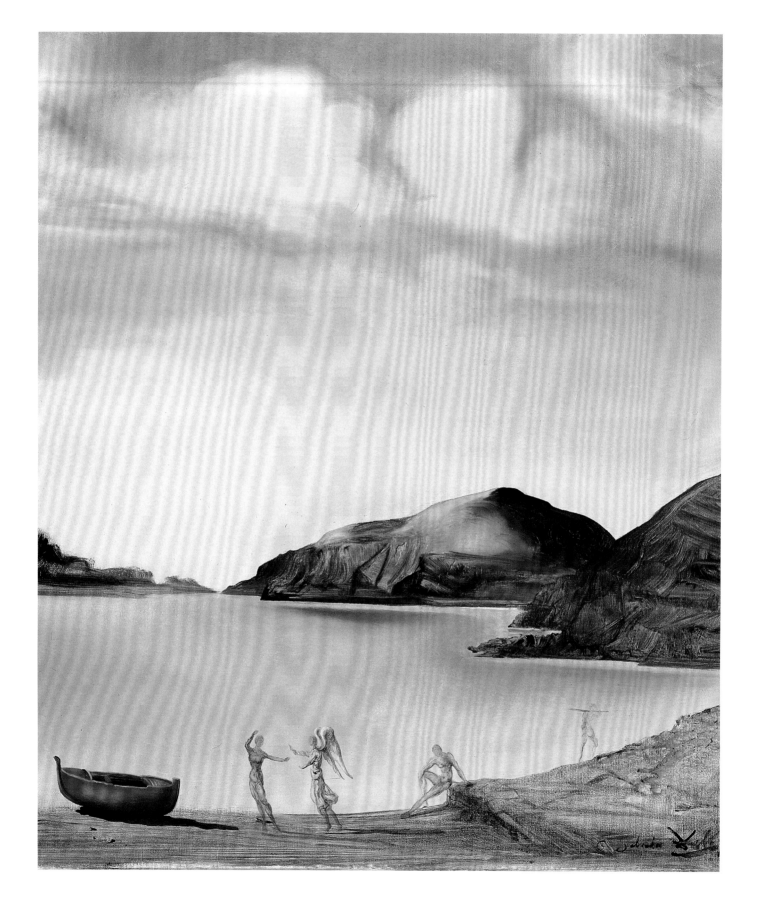

'But the best things about Dalí are his roots and his antennae.
Roots that reach down deep into the earth, where they search
for all those "succulent" things.' *Gilles Néret*[1]

ROOTS & ENVIRONMENT

Port Lligat at Sunset (detail),
1959, oil on canvas,
58.5 × 76.5 cm, private
collection.

The area where the second Salvador Dalí[2] was born on 11 May 1904, and in which he became entirely immersed, was the striking region of the Alt-Empordà, where his family could be traced back for several generations. This beautiful, dramatic part of the world has been sculpted by the Tramuntana wind, which regularly blows at eighty miles per hour. Pines perch precariously peering down over the sheer drops that dot the Mediterranean in this part of Catalonia. The strength and brutality of the Tramuntana have moulded both the land and those who live there. She has applied her artistic endeavours to the snow-capped peaks of the Pyrenees and affected the region's inhabitants for centuries, driving some even to suicide. It is said that because of her, the people of the Empordà region – the Empordanese – have a reputation for intransigence, having to push constantly against the wind. Salvador Dalí and his paternal ancestors did not escape this personality trait. She drove the artist's grandfather to flee to Barcelona, to avoid its potentially disastrous effects.[3] Yet paradoxically, few winds carry such romanticism as she does. Some of the shapes she has created are just as hallucinatory as aspects of Dalí's art.

In collaboration with the Tramuntana, erosion by the sea has created a spectacular coastline, which encompasses the rugged, natural wonder that is the Cap de Creus Natural Park. It was in this easternmost tip of Catalonia that Salvador Dalí spent countless hours wandering as a young boy, merging with this soulful landscape: a geologist's dream. The light has a special quality, adding to the drama, as it playfully adjusts the palette of colours in front of your eyes. Even an unimaginative person can be inspired by this natural paradise, and especially by the wonderful rock formations, which reveal animals, birds and surreal shapes. It is a place that undoubtedly encouraged Dalí's love of duplicity and illusion at a tender age. It is easy to appreciate how this setting would have influenced such a highly imaginative, suggestible person.

In July 2017, when the documentary film, *The Secret Life of Portlligat. Salvador Dalí's House*, was screened for the first time, Montse Aguer Teixidor, Director of the Gala-Salvador Dalí Foundation, said 'This house-cum-studio was the refuge of the artist and Gala, at the very heart of the only landscape in which it truly belonged: that of Port Lligat, Cadaqués and Cap de

Creus. A landscape that conditioned and stimulated the painter. I would even dare to say it gave him his identity. Dalí identified with it completely.'[4] However, had it not been for an interesting sequence of events, Dalí may not have ended up being born in Figueres, capital of the Alt-Empordà region, and would not have spent his dreamy summer holidays in Cadaqués, the breathtaking seaside town close to his future home-cum-studio at Port Lligat.

Generations of Dalí's paternal ancestors can be traced to the Empordà region. The parish records of Llers, a town renowned for its witches, show that there were Dalís living there in the late seventeenth century. Records before this time were destroyed in the Spanish Civil War, so it is impossible to know if his ancestors were based there even earlier.[5] What we do know is that, as the artist grew more defined in his own persona, he felt that he possessed a kind of magic. He would tell Carlos Lozano, whom he befriended and used as a model from 1969, that 'My magic will protect you always.'[6] Later in life, he created his own re-interpretation of the Tarot, in which he depicted himself as the Magician.[7]

The Dalí surname may be Arabic in origin, which the artist certainly felt was true. The Dalí male ancestors were mostly labourers, with the exception of a few blacksmiths, including the artist's great-great-grandfather, Pere Dalí Raguer. At the turn of the nineteenth century, Pere's elder brother, Silvestre Dalí Raguer, relocated from Llers to the remote fishing village of Cadaqués, forty miles away, and in 1817 Pere followed him there after the loss of his first wife, taking a local girl, Maria Cruanyes, as his second wife. The couple had three children: Pere, Cayetano and Salvador. Salvador was born in 1822, and in 1843 married Francisca Viñas, and although it was reportedly a turbulent marriage, she gave birth to Aniceto Ramund Salvador in 1846 and Gal Josep Salvador, Dalí's grandfather, on 1 July 1849.

By the time he had turned twenty, in 1869, Gal was living with Teresa Cusí Marcó, a married woman from Roses, who was five years older than him, along with her daughter Catalina Berta Cusí. His famous grandson would do something similar sixty years later in 1929, when he met the love of his life Gala, also a married woman, ten years his senior. In 1870, Gal inherited his mother's run-down house in Cadaqués, at 321 Carrer del Call, and started a transport business, driving between Cadaqués and Figueres, two of the most influential places in the future artist's life. Cadaqués' economy in the nineteenth century was predominantly based on salted fish and wine; its anchovies were in demand, especially in Rome. However, in 1873 when the phylloxera epidemic hit, the vines of the Empordà region were devastated. Even before this, Cadaqués' remote location, along with the Costa Brava's abundance of wonderful hiding places in the form of caves and inlets, had naturally lent itself to smuggling, but

BELOW Boats moored at Cadaqués, on the Mediterranean coast.

BOTTOM Surrealistic trees shaped by the Tramuntana wind.

OPPOSITE Salvador Dalí in Cap de Creus, 1958.

this increased notably after the epidemic. The nearby seaside town of Port de la Selva has a saying about its rival Cadaqués: 'In Cadaqués, tobacco hawkers, smugglers, good sailors and thieves.'[8] Much later in his life, the artist would himself be involved in a serious forgery scandal. He attributed his 'love of everything that is gilded and excessive, my passion for luxury and my love of oriental clothes',[9] to his Arabic lineage, believing that he was descended from the Moors.

In Cadaqués, on 25 July 1871, Gal and Teresa's first child was born, a girl they called Aniceta Francisca Ana, who sadly died in 1872. On 25 October 1872, Teresa produced a boy, Salvador Rafael Aniceto, the future artist's father. The couple's last child, Rafael Narciso Jacinto, was born on 23 January 1874. In 1881, Gal decided to relocate with his family to Barcelona. According to family tradition, the main reason for this move was to get away from the Tramuntana wind, which he felt was an extreme threat to his sanity. Additionally, for an ambitious man like Gal, Barcelona offered a more promising environment. The relocation also meant that in September 1882 his son, Salvador, could start his baccalaureate in Barcelona in one of the city's best schools. In 1883, his step-daughter, Catalina Berta, married into a very well connected legal family, the Serraclaras. Gal became involved in the Barcelona stock exchange, but in the mid-1880s, when things took a turn for the worse, he lost a fortune. The significant financial loss, along with the persecution complex he had developed, were too much for him and on 10 April 1886, he attempted to throw himself from his balcony, but was stopped by the police. Six days later, he successfully committed suicide, throwing himself, instead, into an internal patio, where he died

instantly. Sadly, he had not escaped the fate that he had hoped to leave behind in Cadaqués. The suicide became a family secret.[10]

The family were taken in by Teresa's daughter, Catalina, and her husband, where the boys remained until they had completed their education. Teresa remained until her death in 1912. Salvador completed his baccalaureate in 1888, and went on to study law at Barcelona University, graduating in 1893. Initially he worked part-time for the Serraclaras and also prepared deeds for a land registry office. However, like his brother, he sought security for life, which was most likely instilled by their father's legacy, as well as his Catalan roots, so he started studying to be a notary. In 1898, he applied unsuccessfully for a number of notary posts. However, a close friend from his school and university days, Josep 'Pepito' Pitxot, encouraged Salvador to focus his search for a notary post in Figueres, a thriving Catalan town and capital of the Alt-Empordà region. Pepito, who had married his own aunt, Angela, in 1900, and moved to Figueres, where she had inherited a house, would be the person who reconnected the Dalí family back to the Alt-Empordà. Over the years, various members of the Pitxot family would play important roles in Salvador Dalí's life: even after his death, his close friend the artist Antoni Pitxot (1934–2015) would become the first director of the Dalí Theatre-Museum, which he had helped the artist to design.

As the artist's father had fond memories of his birthplace in the white house near the church in Cadaqués, Figueres was a tempting choice for pursuing his chosen career, being the closest town to Cadaqués. After one unsuccessful attempt, he started his notary post in Figueres on 7 June 1900. It was this interesting sequence of events that brought Dalí's father back to his ancestral homeland. His new job also allowed him to marry his fiancée, Felipa Domènech i Ferrés. They were wed on 29 December 1900 in Barcelona.[11]

Felipa, who was two years younger than her husband, had plenty of creativity flowing through her veins and genes. The pretty Barcelona girl's maternal grandfather, Jaume Ferrés, was considered a great craftsman and was reputedly the first person in Catalonia to work with tortoiseshell, at his business creating *objets d'art*. Felipa's mother, Maria Anna Ferrés Sadurni, also had an artistic temperament, and her father ran a haberdashery business, but he died when Felipa was only thirteen. This meant that her mother, Maria Anna, inherited the business, so Felipa helped her, showing considerable talent and skill creating *objets d'art*. She especially loved making figurines from coloured candles, which would delight her artistic son in his early years. Her brother, Anselm, who was born in 1877, was also a creative soul and would be an important early influence on Salvador Dalí.

Felipa fell pregnant quickly, giving birth to the first Salvador, the artist's older brother, on 12 October 1901. Sadly, he died on 1 August 1903, aged less than twenty-two months, of an infectious gastroenteritis cold according to official records, although there are other theories that include a venereal disease deformity, passed on from his father, or meningitis, which could have resulted from his father hitting him. Neither of these theories has been proven, however.[12] Dalí senior, seeing how depressed his wife was, decided to take her away to a secluded spot. The bereaved couple went to a place near the lake at Requesens, in the foothills of the Pyrenees, overlooked by the Canigou mountain; an important sacred site for the Catalans, and considered by some to be a portal to other dimensions.[13] The place they visited is where Catalan pilgrims go every year to pray that the Tramuntana wind will continue to blow the Empordà plain free of disease. After such a terrible loss, the couple may have sought solace and peace in such a spot. However, considering that Señora Dalí gave birth to the 'real Salvador Dalí' nine months and ten days after her first son's death, it is also plausible that she was praying to become pregnant again and this time with a healthy, thriving baby.

In an elegant Modernist building in Figueres, where the couple lived on the first floor and the artist's father had his office on the ground floor, Salvador Felipe Jacinto Dalí y Domènech made his entrance into this world, at 8.45 p.m. on 11 May 1904.[14] Later he would be known as Salvador Dalí, a name which he felt perfectly explained the vital role he would play in the art world. Salvador translates as 'Saviour'. The artist felt that he was destined to be the saviour of Spanish art.

We can never know if Salvador Dalí's birth would have occurred if his brother hadn't been taken from his parents at such a tender age. It was under these circumstances that the great creative was born – a situation that the young Dalí perceived only too well and used to his benefit as much as possible. Yet paradoxically, he was also strongly affected by feeling that he was a replacement for the first Salvador. When he was five years old, his parents took him to his dead brother's grave, and informed him that he was his reincarnation; a declaration that obviously affected him in complex ways. This was possibly the first trigger of the duality that was so central to his artistic work, as well as to his public and private personae. Certainly, being told that he was a reincarnation of his late brother, at such a young age, could have helped to open up his imagination to endless possibilities. On the other hand, his sister Anna Maria describes an idyllic childhood in her memoirs, published in 1949.

Dalí's autobiography, *The Secret Life of Salvador Dalí*, is a wonderful web of unreliable memories, peppered with plenty of imagination, intricately woven together to keep the reader guessing what is true or false, and which parts are figments of his unbridled imagination. Ian Gibson, author of the ambitious Dalí biography, *The Shameful Life of Salvador Dalí*, does warn about trusting it as a source. It does, however, illustrate how Dalí sensed and imagined aspects of his life, including those people and places that played important roles in it. Meredith Etherington-Smith, author of the biography, *Dalí*, observed, 'So despite his obfuscations, in spite of himself, from time to time reality breaks through the clouds of invention . . . especially when he is describing his youth in Cadaqués. This was so central to his idea of his being, to the formation of his personality, that even he could not distort it enough to conceal it.'[15]

In *The Secret Life of Salvador Dalí* he claimed to have had intra-uterine memories; an environment he described as 'divine, it was paradise . . . Already at that time all pleasure, all enchantment for me was in my eyes, and the most splendid, the most striking vision was that of a pair of eggs fried in a pan, without the pan; to this is probably due that perturbation and that emotion which I have felt, the whole rest of my life, in the presence of this ever-hallucinatory image.'[16] Whether he truly believed he had this memory, or it was a colourful

ABOVE Felipa Domènech i Ferrés, Dalí's mother, in 1910.

OPPOSITE Salvador Dalí Cusí, the artist's father, in 1910 (left); the second Salvador Dalí in *c*.1911.

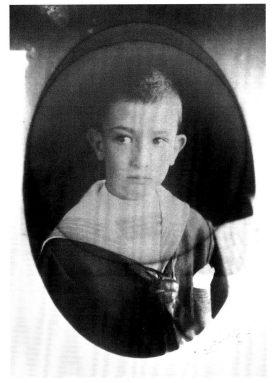

ROOTS & ENVIRONMENT 15

figment of his imagination, symbolically the egg became one of his favourite motifs in his work, as he developed as an artist. This Dalinian symbol combines the duality of the hard exterior and soft interior, with feelings of hope and love. He was so obsessed with the symbolic value of the intra-uterine that later on, as he conceived ongoing improvements to his house-cum-studio, one of these was to festoon the roof with huge, white eggs as an alternative balustrade.[17]

Outside the womb, his environment was privileged, nurturing and adoring. After the loss of the first Salvador, his mother was understandably overprotective of their second son. 'Aside from being forbidden from the kitchen I was allowed to do anything I pleased. I wet my bed till I was eight for the sheer fun of it. I was the absolute monarch of the house. Nothing was good enough for me. My father and mother worshipped me.'[18] His relationship with his dominant father became more complex and challenging as he grew older, although his father did encourage his artistic talent in many ways. His doting mother and the servants spoiled him, which may have encouraged him to use his temper to get what he wanted. 'But while I have always known exactly and with premeditation what I wished to obtain of my senses, the same is not true of my sentiments, which are light and fragile as soap-bubbles. For, generally speaking, I have never been able to foresee the hysterical and preposterous course of my conduct, and even less the final outcome of my acts, of which I am often the first astonished spectator.'[19] His mother Felipa played the role of adoring mother to perfection, commencing each new day of her son's life with the question, 'Sweetheart, what do you want? Sweetheart, what do you desire?' (*Cor qué vols? Cor qué desitges?*).

Another important presence in the household was Llúcia, his nurse. She was a kind, patient woman, who had Catalan folklore in her blood, so she sang Catalan lullabies to him and to his sister, Anna Maria, who was born on 6 January 1908. Although Dalí experimented immensely during his life, both artistically and in terms of the persona he adopted, his Catalan roots could never be denied. The Catalan temperament is naturally creative, energetic and inclined towards making money. Since the thirteenth century, the Catalans have been traders and merchants, as opposed to aristocratic empire builders, like the colonial Spanish. They are more similar to the natives of the Languedoc in France than they are to the Spanish.[20] Irony is often an integral characteristic of the Catalan people.

The town where Dalí was born was bustling. In 1878, the first trains had started arriving and departing from Figueres, which had a significant knock-on effect on the town's economy, leading to expansion and a growing population. By 1900, the town had a population of 10,714. Located at the edge of the beautiful Alt-Empordà plain, Figueres enjoys a privileged position at the junction of the route from Barcelona to Roussillon, France, and on the communication channel which runs from the Empordà coast into the Pre-Pyrenees. Its location meant that the town was influenced by wider European culture. As capital of the Alt-Empordà region, Figueres has historically been its main hub of economic and commercial activity. The Empordà plain was for Dalí 'the most concrete and objective piece of landscape that exists in the world'.[21] At the time of Dalí's birth, Modernist architecture had already made its mark in Figueres, as it had throughout Catalonia. The town had a number of fine Modernist buildings, one of which

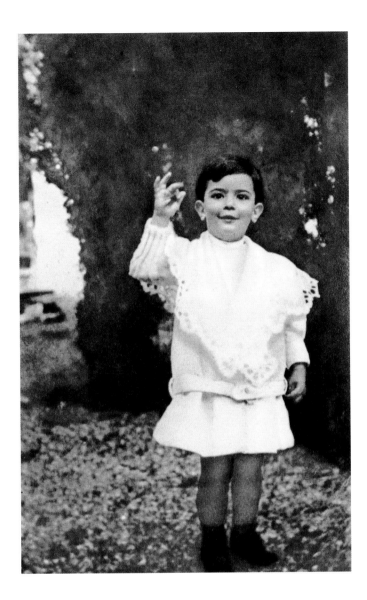

Salvador Dalí in *c*.1906.

was the rental building where the artist was born: Casa Puig, Carrer Monturiol 6 (now 20). It was built in 1898, by the prolific architect Josep Azemar i Pont.

The family's living quarters were situated on the first floor of Casa Puig, which was connected by an internal staircase to Señor Dalí's chambers on the ground floor, a mere 50 metres from the town's fashionable Rambla. The family apartment boasted a large terrace that ran the full length of the side, which overlooked a beautiful garden owned by the Marquesa de la Torre, a local aristocrat. On this terrace, Felipa bred canaries and doves, adorning the space with Dalí's then-favourite flowers – spikenards – and pots filled with lilies. His grandmother and maiden aunt moved in to the top floor in 1910, but spent plenty of time in the family apartment.

He had a good relationship with his sister, Anna Maria: 'My feeling for her was one of delirious tenderness, which had only grown since my kicking her.'[22] She would appear in many of his earlier paintings as his first model and muse. Their father had adapted wonderfully to his position and life in Figueres. In his university days back in Barcelona, both Señor Dalí and his brother had been vehement supporters of Catalan federalism, and he found a new home for this passionate expression in the club Sports Figuerense, moments away from his chambers and family home. It didn't take the corpulent, gregarious man long to become a prominent member of the liberal club, where each evening he enjoyed lively political debates.

The family became very friendly with the occupants of the mezzanine apartment below them who were a source of fascination for the young Dalí. The parents of the Matas family, who were originally from the province of Barcelona, had relocated from Buenos Aires with their three children. Dalí adored their elegant lifestyle, describing the family in his autobiography as 'an Argentine family named Matas, one of whose daughters, Ursulita, was a renowned beauty'.[23] In their apartment, 'I was worshipped as I was at home. There, every day at about six, around a monumental table in a drawing room with a stuffed stork, a group of fascinating creatures with the hair and the Argentine accent of angels would sit and take maté, served in a silver sipper which was passed from mouth

LEFT Casa Puig, Carrer Monturiol 6, Figueres, the birthplace of the artist.

OPPOSITE The Dalí family in Cadaqués: a maid, the artist's mother and father, Salvador, Caterina, Anna Maria and grandmother Anna.

OVERLEAF Cadaqués.

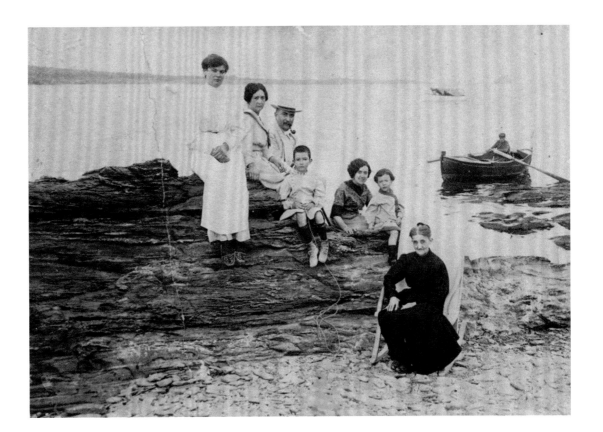

to mouth. This oral promiscuity troubled me peculiarly and engendered in me whirls of moral uneasiness in which the blue flashes of the diamonds of jealousy already shone.'[24]

Christmas time also stirred strong emotions during his earlier childhood years. As well as having family in Barcelona, the family had kept in contact with the Serraclaras there, so that up until 1912 they went there for Christmas. Young Salvador looked forward to it ferociously, knowing that he would receive a ridiculous number of presents, getting himself so worked up that he ended up having temper tantrums. In Spain, Christmas is celebrated on 24 December, but the most important date for children receiving gifts is on the eve of the Feast of Kings, 6 January. In his autobiography, Dalí recalled, 'On the day of the Feast of Kings I received among innumerable gifts a dazzling king's costume – a gold crown studded with great topazes and an ermine cape; from that time on I lived almost continually disguised in this costume.'[25] His love of dressing up would stay with him for life and his appearance, in his first school, would certainly garner a dramatic reaction from his less privileged classmates.

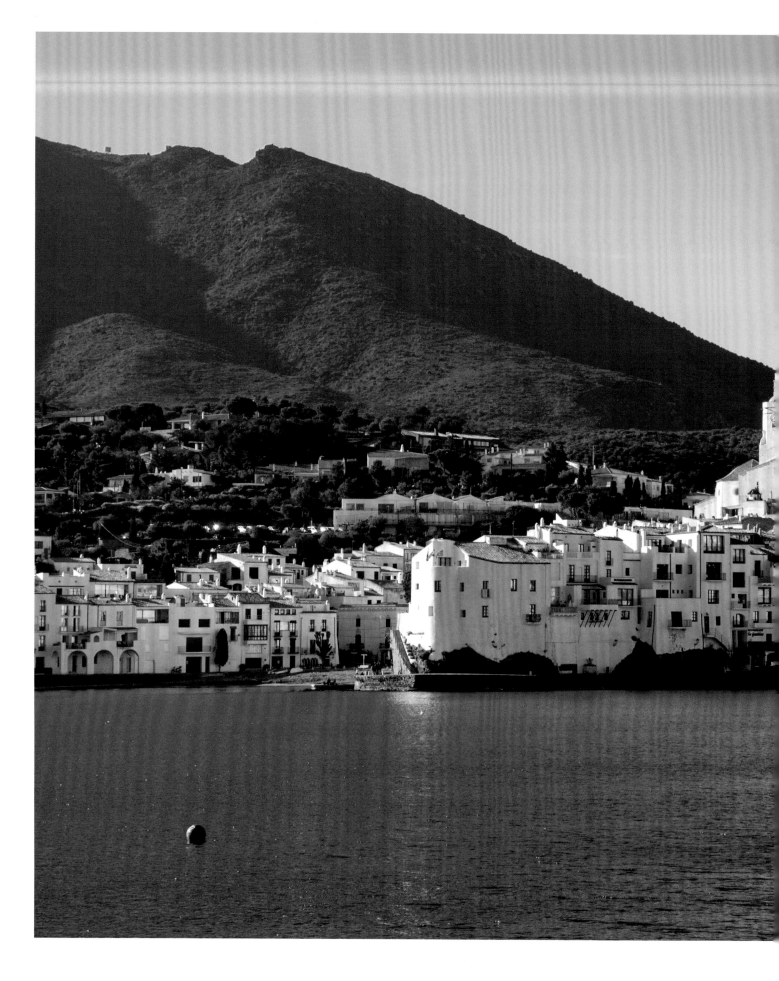

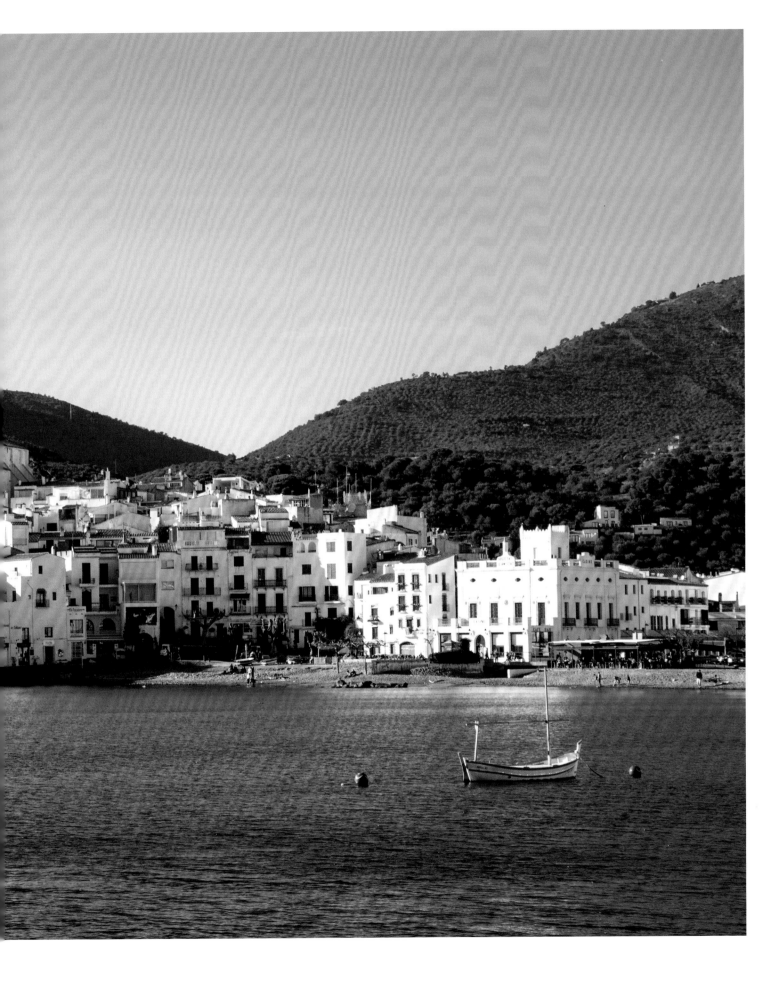

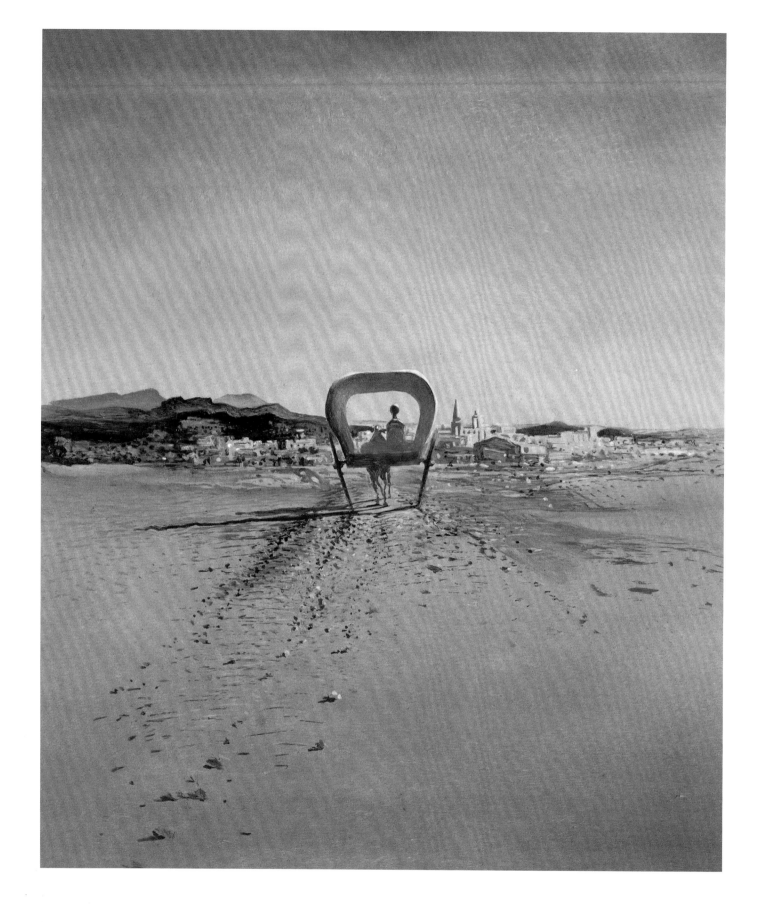

'I have quenched my desire for light and colour; I have spent the sultry summer days, painting like mad, trying to translate the incomparable beauty of the sea and sun-beaten shore.'
Salvador Dalí, aged thirteen[1]

INCOMPARABLE BEAUTY & OPTICAL ILLUSIONS

The Phantom Cart (detail), 1933, oil on panel, 19 × 24.1 cm, Dalí Theatre-Museum, Figueres.

At the Figueres Municipal Primary School, young Dalí's pristine appearance struck a stark comparison with that of his classmates. He painted an interesting picture of this in his autobiography: 'I alone wore a sailor suit with insignia embroidered in thick gold on the sleeves, and stars on my cap. I alone had hair that was combed a thousand times and that smelt good of a perfume that must have seemed so troubling to the other children who would take turns coming up to me to get a better sniff of my privileged head.'[2]

His teacher, Esteve Trayter, would sometimes take him to his private apartment after school; a place that had a great and lasting impact on him. 'This has remained for me the most mysterious of all the places that still crowd my memory.'[3] His teacher's apartment was a magical treasure trove of great dusty volumes on a monumental bookcase, interspersed with 'incongruous and heterogeneous objects'.[4] These included a 'gigantic rosary which he could barely carry . . . carved out of real wood from the Mount of Olives,'[5] a desiccated frog that Trayter called alternately 'my

pupil' (*le meva pubilla*) or 'my dancer', which was used to forecast the weather, images of Russia and 'a large square box which was the central object of all my ecstasies'. The box was 'a kind of optical theatre',[6] which transformed pictures, 'one into another in an incomprehensible way that could be compared only to the metamorphoses of the so-called "hypnagogic" images which appear to us in the state of "half-slumber". It was in this marvellous theatre of Señor Traite [Trayter] that I saw the images which were to stir me most deeply, for the rest of my life; the image of a little Russian girl especially.'[7] In *The Secret Life of Salvador Dalí* the artist maintained that the girl in the image was Gala, his future wife and muse. 'Was it Gala? I am certain it was.'[8] Of course, we need to bear in mind that his autobiography was crafted in 1941, at which point he had been with Gala for twelve years.

Optical illusions and symbols were found in many places by the young Dalí. When he was five, he saw an insect that had been eaten by ants, leaving only the shell of the insect behind. Ants

were to become one of his many prevailing motifs in his work, both in painting and film. They were symbolic of death, decay and impermanence, the putrefaction he grew to fear as well as representing his sexual desires. He also had an irrational fear of grasshoppers that arose around this time, as his classmates used to throw them at him. Grasshoppers became one of his most regularly used symbols, which he used to represent fear, waste and destruction.

The Dalí family friends, the Pitxots, were once again to be a central part of the plot that connected young Salvador to a place that would form the backdrop to much of his life: Cadaqués, the picturesque fishing village where his father had been born. The artist would later say about Cadaqués, 'I have had a wonderful time, as always, in this ideal and fantastic village of Cadaqués; there, at the side of the Latin sea, I have quenched my desire for light and colour; I have spent the sultry summer days, painting like mad, trying to translate the incomparable beauty of the sea and sun-beaten shore.'[9] The mother of Señor Dalí's great friend Pepito Pitxot, Antonia Gironés, had a strong entrepreneurial spirit. Having rented holiday accommodation in Cadaqués around the turn of the twentieth century, she decided that the family should own property there. She bought a promontory called Es Sortell, which was registered as wasteland, and built a modest L-shaped house based on designs by Miquel Utrillo, a painter friend of the family. Pepito, who had become passionate about horticulture, created a beautiful exotic garden on this unpromising plot. Gradually over the years the house was extended.

The Pitxot siblings were very creative, so it wasn't long before they started bringing lots of interesting, bohemian types to Cadaqués. Neither did it take much time for the Dalí family to become guests at Es Sortell, which gave Señor Dalí the chance to reconnect with his roots in the place where he had lived for the first nine years of his life. He soon felt the desire to rent or buy his own property there. Once again thanks to his great friend Pepito, he was able to fulfil this wish, and at the water's edge at Es Llané rented a converted stable owned by Pepito's sister, Maria. These days, Cadaqués is considered by many to be the most beautiful village of the Costa Brava. The young artist connected and identified with Cadaqués and its surrounds, perhaps experiencing a metamorphosis there. He digested the environment voraciously, just as a caterpillar digests itself. Then once he had stuffed himself enough, he metaphorically hung himself upside down from a twig, spun a silky cocoon, and eventually emerged as a butterfly. Here he had found all the artistic inspiration that he needed. Later he would say that

ABOVE Gala Éluard Dalí, born Elena Ivanovna Diakonova, in c.1910.

OPPOSITE Two views of the Dalís' home in Port Lligat.

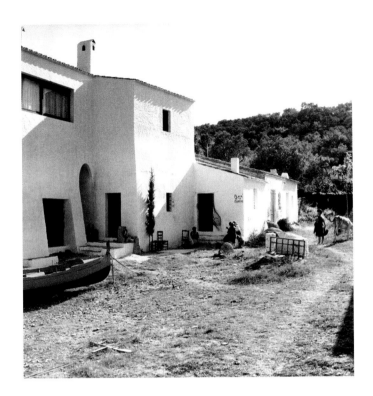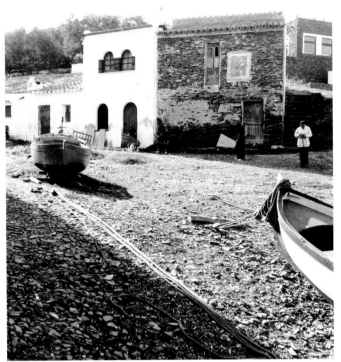

he was 'a human incarnation of this primitive landscape', that he embodied its 'living nucleus'. Once he had made this very special connection with Cadaqués and the Cap de Creus Natural Park, he felt impatient throughout the school year for summer to arrive, so he could return to his special, inspirational place – a setting that he perhaps felt was composed of spirituality itself. The gaze of Salvador Dalí found a fluid connection between his environment and his own essence; a bond so strong that it seemed as if sometimes he became

a part of it. It was this landscape and his Catalan roots which were key to a major aspect of his art.[10]

It's not difficult to understand why Dalí fell in love with Cadaqués and the surrounding Cap de Creus Natural Park. Once, Cadaqués was only accessible by sea, and even these days you need to navigate a challenging coastal road with spectacular views to reach this jewel on Catalonia's north-easterly corner.

The area has an incredible light that transforms the surrounding landscape. The rocky coastline

contrasts dramatically with the cobalt-blue waters, which seem perfectly chosen to highlight the gleaming, whitewashed village of Cadaqués, with its undulating, narrow streets, punctuated with slate. Piercing sunlight dances on the beautiful beaches and magical coves dotting this coast, where the Pyrenées meet the Mediterranean. During the summertime, the sun sparkles onto the shimmering azure blue sea, highlighting the sprawl of boats in the bay, and the whitewashed buildings which embrace it. Bougainvillea wraps itself around the houses, which seem to huddle around the village's small Baroque church, and its perfume wafts through the air. Meandering lanes take you through the former fishing village that Dalí explored and

investigated from his youth to much later in life, getting to know it in what would be recognised later as his incredible precision. What may appear to an untrained non-Dalinian eye to be an insignificant detail, was certainly not to him. Over the course of his career, he frequently transformed these local details into essential elements in his works. During the winter months, the azure-blue, serene landscape of the picture-perfect waterfront morphs into a different canvas. Lines of beech trees and walls act as wind breakers against the famous Tramuntana wind, which can blow ferociously for up to ten days at a time.

Later, as blossoms start to bloom, at the edge of the village, the vibrantly coloured flowers in

BELOW The rocky landscape of the Cap de Creus Natural Park.

OPPOSITE The bay of Cadaqués on a windy November day.

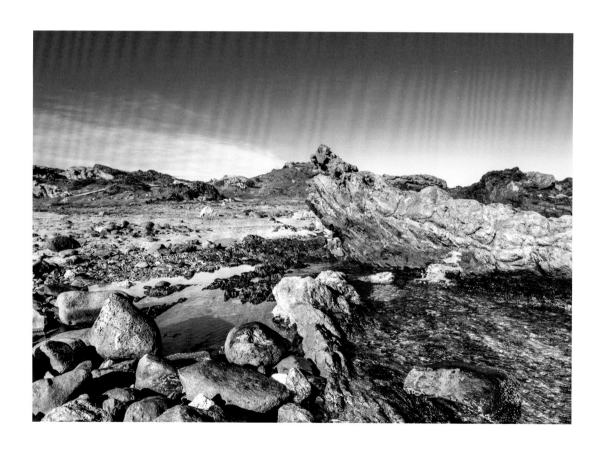

the gardens contrast beautifully with the silvery green mosaic of the olive trees. Dalí adored olive trees, recommending them in his seventh secret of *50 Secrets of Magic Craftsmanship*. 'You must therefore know, young painter, that the Seventh Secret of your art resides in the sympathies and antipathies of your retina, in the manner in which you daily nourish it. For this you must surround it, as habitually as possible, with a propitious environment, with a favourable retinal company . . . It is the olive tree, with the counterpoint of the myrtle, which by the constant, subdivided and tiny glittering and quivering of their leaves will surround your eye with that silvery mosaic so nourishing in trembling reminiscences for your retina that, whether your eyes are open or closed, all that you see will appear to you more silvered, minute, ample, gracious, smiling and euphoric.'[11] Cadaqués has had a deep, inspirational impact not only on Dalí, but also on Pablo Picasso, René Magritte, Henri Matisse, Albert Einstein, Federíco Garcia Lorca, Thomas Mann, Man Ray and countless others.

It wasn't only the magnificent landscape that affected the young artist in Cadaqués; the Pitxot family were also an important influence on him, opening up a world of creative arts and types to him. At their house in Es Sortell, the family had placed their piano outside on the rocks nearby the coast, and on some summer evenings they would

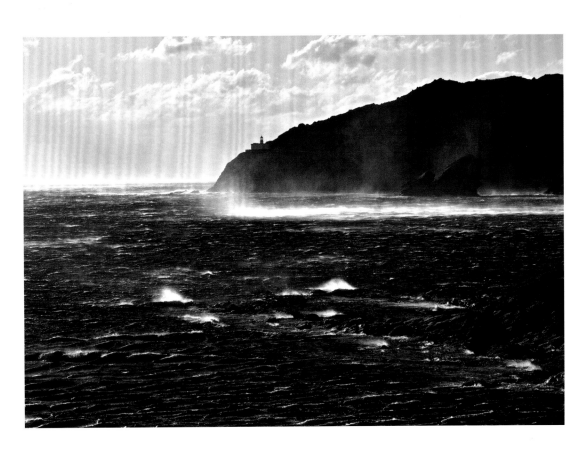

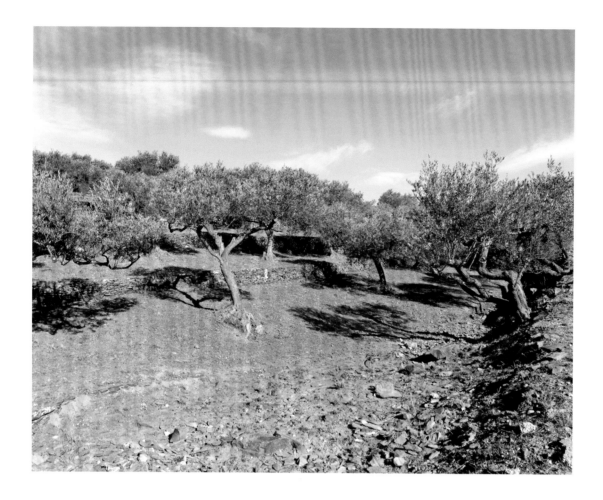

stage concerts there. This piano would later be a motif in some of Dalí's paintings. It was Ramón Pitxot who became his first mentor. The Catalan artist who painted in the Impressionist style met the young Dalí in Cadaqués in 1910. The six-year-old was inspired and impressed by Pitxot's paintings. Pitxot (1872–1925) was a good friend of Pablo Picasso, nine years his junior. He exhibited at Barcelona's famous Els Quatre Gats in 1899, immediately after Picasso's one-man show there, and also brought Picasso to Cadaqués in 1910.

The young Dalí produced his first known painting the same year, entitled *Landscape Near Figueras* (Figueras is the Catalan form of Figueres). *Landscape Near Figueras* was painted in oil over a 14 x 9 cm postcard. It clearly shows his innate talent, with a good sense of proportion and colour for his age, and the use of different brush strokes to create movement and depth. He painted the sky thinly, which allows some of the postcard to show through. Although it is predominantly in the Impressionist style, the work may have hinted at an early interest in, or perhaps an innate instinct for, Surrealism, which did not become a movement until around ten years later. This countryside was equally engrained into the cells and sensitivities of the artist, as he continually developed his talents.

In 1910, his father made a decision that was to have an important effect on his life. He enrolled his son in the new Christian Brothers college for the school year starting in autumn 1910. As a French order, the Christian Brothers taught the curriculum in French, which awakened Dalí's Francophilia. During the six years he spent there, he learned to

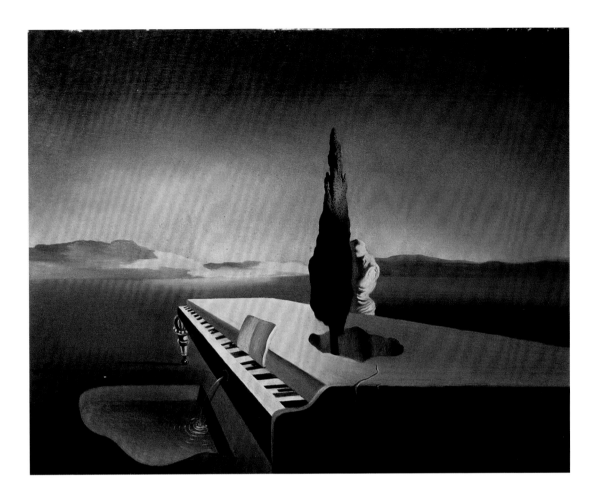

LEFT Landscape of olive trees in the Cap de Creus Natural Park.

ABOVE *Necrophiliac Fountain Flowing from a Grand Piano*, 1933, oil on canvas, 22 × 27 cm, private collection.

speak excellent French, albeit with a thick Catalan accent. Art was included in the curriculum and, although he doesn't mention his teacher by name, he wrote in an article in 1927 about his teacher's advice: 'To paint them well, to paint well in general, consists in not going over the line,' which he felt was good, logical counsel. In his autobiography, he recalls the views from the classroom. 'I see two cypresses through the window of classroom 1 of the Christian Brothers' School of Figueras, the school which immediately followed my supposedly harmful pedagogical experience at Señor Traite's. The window which served as a frame to my vision was opened only in the afternoon, but from then on I would absorb myself entirely in the contemplation of the changes of light on the two cypresses, along which the slightly sinuous shadow of the rectilinear architecture of our school would slowly rise; at a given moment, just before sunset, the pointed tip of the cypress on the right would appear strongly illuminated with a dark red, as though it had been dipped in wine, while the one on the left, already completely in the shadow, appeared to me to be a deep black.'[12] Outside the classroom, in the corridor, a wonderful collection of around sixty religious paintings, fossils and minerals,

LEFT *Landscape Near Figueras*,
1910, oil on postcard,
14 × 9 cm, Dalí Museum,
St Petersburg, Florida.

which had been brought from the original school in Beziers, France, stretched out in front of the young Dalí. The large brown moisture stains on the classroom's ceiling were also a constant inspiration to him for hallucinatory exercises, he claimed in his autobiography.

The efforts of the Christian Brothers to educate him were not well received, regardless of how hard they tried. In *The Secret Life of Salvador Dalí* he wrote: 'I did not want anyone to touch me, talk to me, to "disturb" what was going on within my head. I lived the reveries begun at Señor Traite's with heightened intensity, but feeling these now to be in peril I clutched at them even more dramatically, digging my nails into them as into a rescue plank.'[13] A school report caused uproar one dinner time in the family household. His father read it aloud, creating consternation, even though it alluded to his son's gentleness and discipline. However, it concluded that 'I was dominated by a kind of mental laziness so deeply rooted that it made it impossible for me to achieve any progress in my studies.'[14] The upset left his mother in floods of tears.

During his second year at the Christian Brothers' school, which was nicknamed *El Fossos* (The Holes), because of the surrounding wasteland with dips, the family moved to a more luxurious, spacious apartment, at Carrer Monturiol 24 (now 10) in July 1912.[15] Designed by the same architect as their first home, the new apartment unfortunately didn't offer the beautiful balcony of the first, but it did have a tiny space that the budding artist used as his first studio. On the

building's communal roof terrace, there were two abandoned laundry rooms and young Salvador installed himself in one of these. Although it only had enough space for a cement trough, Dalí, aged eight, set himself up with a chair in the trough and used a scrubbing board as his table. In his autobiography, he described how he inventively used his petite studio, in especially warm weather. '. . . on very hot days, I would take off my clothes. I then had only to open the faucet and the water filling the tray would rise along my body high up my waist.' When he wasn't immersed in creating art, he enjoyed prancing around the roof terrace, disguised in his king's costume, giving speeches to his imaginary subjects. Around this time, he also started going to the town's new cinema frequently – outings that triggered his lifelong love of film. While the cinema and his new tiny studio were exciting new phases for him, another fond chapter of his life was just about to come to an end.

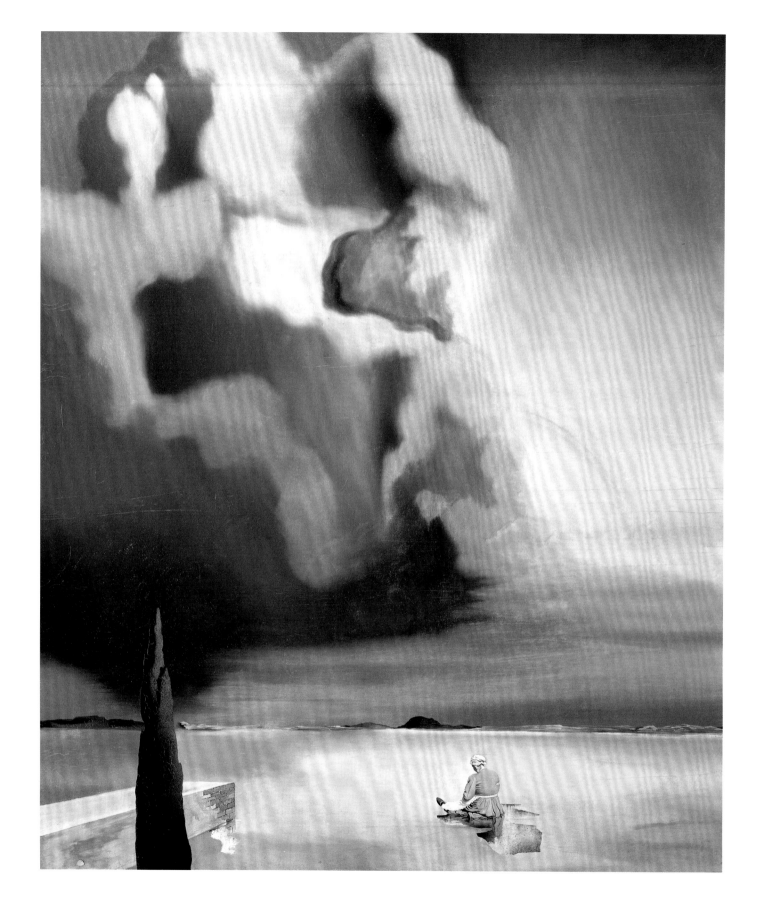

> 'When I paint, the sea roars. The others splash about in the bath.'
> *Salvador Dalí*

A WHOLE WORLD OF ASPIRATIONS

Just as Dalí's new studio environment was becoming an important space for him, another much-loved environment was soon to be temporarily removed from his life. His paternal grandmother, Teresa Cusí, passed away in Barcelona on 5 October 1912. Her death caused great sadness in the family, while also ushering in the end of the family's Christmas visits to Barcelona. However, his mother's brother, Anselm Domènech, was still living there, working in the city's most famous bookshop, Llíbrería Verdaguer, of which he later became a partner, in 1915. Anselm was an important influence on his nephew, as he helped encourage and develop his vocation by giving him art books and corresponding with him.[1]

During this period, the young artist's father was also collecting a series of books: Gowan's Art Books, which played a central role in his artistic development. First issued in 1905, this collection of highly visual volumes are still sought-after collectors' items today. His father gave him the series as a present. In *The Secret Life of Salvador Dalí*, he showed his deep gratitude, describing the collection as a present that 'produced an effect on me that was one of the most decisive in my life'.[2] Each volume of the collection featured a Great Master born before 1800, focusing on the artist's specific style and characteristics, illustrated with sixty black-and-white reproductions. The collection's final volume was issued in 1913, completing a set of fifty-two artists in total. Their impact on the young artist was immense, as he confirmed in his autobiography: 'I came to know by heart all those pictures of the history of art, which have been familiar to me since my earliest childhood, for I would spend entire days contemplating them.'[3]

In his miniature studio, he painted a series of tiny landscapes, with *Vilabertran* (1913) being the best known of this early collection. Vilabertran is a village located a few kilometres away from Figueres, and the walk there used to be one of the Dalí family's favourites. The Impressionist-influenced painting takes the viewer up a path towards a house, through a field of golden vegetation and poppies. There is an interesting interplay between the light colours of the house and vegetation, with the darker, shadowy representations of the trees. The setting is sundown, often favoured by the young artist.

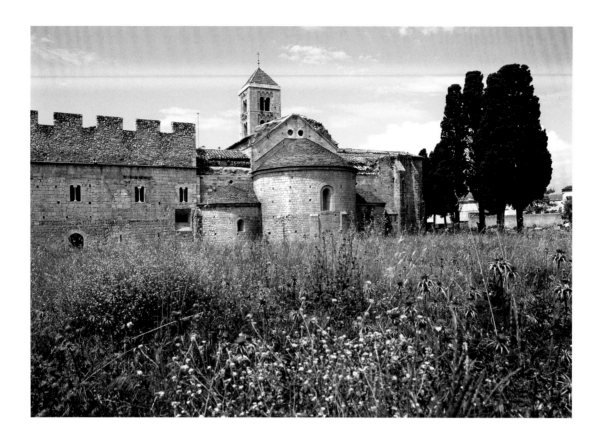

In May 1913, Ramon Pitxot, who continued to be a mentor to Dalí, exhibited around forty watercolours in the Ciné Edison in Figueres. Ramon was mainly based in Paris, but came to Cadaqués often in the summertime. The other Pitxot who showed a great interest in young Salvador was his father's friend, Ramon's brother, Pepito Pitxot. He became like a second father figure to him, frequently taking him on entertaining excursions. In his autobiography, Dalí compared Pepito to his six creative siblings, stating that 'Pepito was, perhaps, the most artistic of all without, however, having cultivated any of the fine arts in particular. But it was he who created the house in Cadaqués, and who had a unique sense of the garden and of life in general.'[6] The two became almost inseparable. Although this relationship grew to a certain extent because of both the close family connection and their creative common ground, it may have been spurred on by the young artist's growing dislike of some of his father's behaviour, which at the very least we could say lacked finesse. One example of this was when he witnessed his father fighting on the street, sporting only his pyjamas and underpants, outside their house. During the altercation, the two men fell to the ground, and young Salvador saw his father's penis pop out, 'like a sausage'.[7]

His school days at the Christian Brothers were soon to come to an end, as their curriculum didn't prepare students for the baccalaureate, which was required to obtain a place at university. This meant that young Salvador, who clearly had little interest in studying, had to prepare himself for the entrance exam to be accepted at the Figueres Institute.

Although the experience almost caused him to have a nervous breakdown, he did pass the exam in June 1916. The ordeal had left him very depleted, so his parents decided to send him off to the Pitxots at El Molí de la Torre (The Tower Mill), situated on the banks of the River Manol, located a little outside Figueres. In 1912, Pepito's wealthy sister María, an opera singer, had invested in this magnificent country house, on a large plot of land, as it was perfect to satisfy Pepito's horticultural interests. Constructed in the mid-nineteenth century, today it is included on the register of Architectural Heritage of Catalonia, as one of the Empordà region's most important homes and farms. Originally it served as a grist mill, making use of the irrigation of the Alguemà river. The property is all in brick, with a number of different bodies at varied heights, culminating in the roof where there is a terrace with a balustrade railing, and the polygonal tower, which was a source of fascination for young Salvador.

There are numerous pages in *The Secret Life of Salvador Dalí* dedicated to his exquisite experiences in El Molí de la Torre, which range from the erotic to the artistic. The impressionable twelve-year-old felt it was a magical place and decided very quickly that he needed to create a strict routine for his days and evenings, to make the most out of it. His early morning routine focused on the presence of Julia, the adopted daughter of Pepito and his wife, who was a blossoming sixteen-year-old. To maximise his erotic fantasies about her, he forced himself to wake up fifteen minutes before she came into the room to open the shutters and let the morning light pour in. He described this ritual in his autobiography, 'I succeeded nevertheless in waking up with great punctuality, that is to say fifteen minutes before Julia came in. I used this interval to savour the erotic emotion which I was going to derive from my act, and especially to invent the pose which varied daily, and which each morning had to correspond to the renewed desire of 'showing myself naked'. When she had opened the shutters, she would 'come over to my bed, and cover up my nakedness with the sheets . . . having done this she would kiss me on the brow to wake me up.'[8]

OPPOSITE The Monastery of Santa Maria de Vilabertran, near Figueres.

BELOW The Pitxot family at Cadaqués, c.1908.

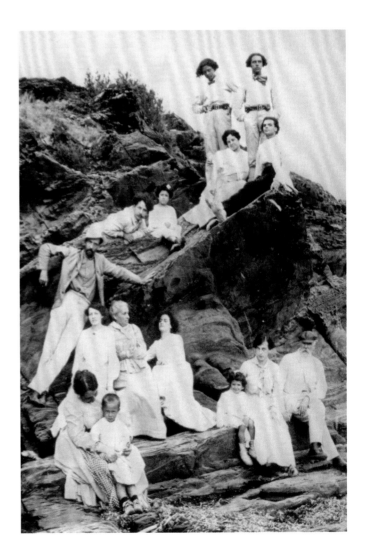

Later in the day he savoured another experience. 'My daily twilight visit to the terrace at the top of the Tower was by all means the most eagerly awaited and the most solemn moment of my days.'[9] His stay at El Molí de la Torre not only filled him with fresh energy and inspiration, but it could also be perceived as a small, yet important turning point. There he put into practice all aspects of himself that for a while he had been honing privately, with his family and in his schools. He had experienced extreme shyness, even shame, in front of some of his school colleagues, so he had been cultivating Dalinian ways of dealing with this, which were normally clever and dramatic. However, this time he had the opportunity to experiment with his behaviour in a more social setting, as a guest of the Pitxot family. He had also brought his box of oil paints and focused, with his unique passion and confidence, on becoming an Impressionist. In fact, the month's sojourn not only affected his painting, but it also inspired him to plan a novel, *Summer Afternoons*, whose central character was based on his young self.

At the end of the summer holidays, there was a pleasant surprise awaiting him in his new school: a talented drawing teacher who had a true vocation, Juan Nuñez Fernandez (1877–1963), who had been teaching at the Figueres Institute since 1906. This down-to-earth, charismatic man had graduated from the Academy of San Fernando in Madrid, and in 1915 won a medal for his wonderful engraving of Van Dyck's *The Kiss of Judas*. His favourite Old Masters were Rembrandt, Ribera and Velázquez, the latter for whom Dalí had a special, lifelong admiration. Nuñez was also the Director of the Municipal Drawing School, where the young artist's father had enrolled him for evening classes, along with extra tuition at the Marist Brothers' College, where Salvador's school lessons were revised. Nuñez, who had a penchant for precision, quickly saw that Dalí was an exceptionally talented student and started to invite him to his house for further explanations about art and its mysteries. These visits inspired Salvador so much that in his autobiography he wrote, 'I would always come away from Señor Nuñez' home stimulated to the highest degree, my cheeks flushed with the greatest

artistic ambitions. Imbued with a growing and almost religious respect for Art, I would come home with my head full of Rembrandt, go and shut myself up in the toilet and do "it".[10]

Both in the Municipal Drawing School and at the Institute, Salvador became good friends with Ramón Reig Corominas (1903–63), who would also rise to fame as one of Catalonia's most important watercolourists. The two friends enjoyed painting in nature together; they shared a strong attachment to the Empordà landscape and held each other in great esteem. Later, they would also have their work shown in some of the same collective exhibitions.[11]

Salvador's first year at the Figueres Institute ended on a high, as not only did he manage to pass all of his exams, but he was awarded a Special Merit certificate at the Municipal Drawing School. His father was so proud of this achievement that, according to his sister, he hosted an exhibition of his son's recent work in their apartment. Later in life, Dalí would go on to say that Nuñez was the teacher whom he most respected and the one from whom he learnt most.[12] As well as Dalí and his close friend, Ramón Reig Corominas, Nuñez inspired other students, to the extent that it could be argued that he created a school of painters in Figueres.

On 11 May 1917, Dalí became a teenager, with a glorious summer ahead of him and, according to what he later wrote, entering a phase of his life which was marked with the urge to become even more himself than before. 'My adolescence was marked by a conscious reinforcement of all myths, of all manias, of all my deficiencies, of all the gifts, the traits of genius and character adumbrated in my early childhood. I did not want to correct myself

in any way.'[13] He had let his hair grow long and he was also 'waiting impatiently for the down on my face to grow, so that I could shave and have long side whiskers . . . I wanted to make myself "look unusual".'[14] Summer, of course, meant spending time in his beloved Cadaqués. 'My summers were wholly taken up with my body, myself and the landscape, and it was the landscape that I liked best. I, who know you so well, Salvador, know that you could not love that landscape of Cadaqués so much if in reality it was not the most beautiful landscape in the world – for it is the most beautiful landscape in the world, isn't it?'[15]

The end of the First World War in autumn 1918 brought fresh optimism, which inspired Salvador and some of his fellow students to start a school magazine, *Studium*. During its publication, he wrote a combination of prose, poems and essays about great Spanish artists, which included El Greco, Goya and, of course, Velázquez.[16] The following year he had his first ever public exhibition; a group show at the Societat de Concerts at the Teatre Principal, where he exhibited alongside two other artists from Figueres, and sold two paintings. This is the same theatre that today is the Dalí Theatre-Museum. The local newspaper, the *Empordà Federal*, wrote that Dalí was 'already one of those great artists who will cause a great sensation'. He was aged fifteen.[17]

During this period of his life he was also reading voraciously, immersing himself in art and philosophy. He particularly liked reading Immanuel Kant. From a political perspective, he loathed capitalism and longed for a revolution. Along with a few of his friends, he produced three sporadic issues of a satirical magazine, *El Sanyó Pancraci* (named after a local eccentric, Mr Pancraci), which had been inspired by their numerous discussions about politics and art.[18]

In Figueres, he rented a studio at 4 Carrer Muralla, where the intellectual art and political discussions had taken place, after 15 February 1920, when the last of the three editions of the magazine had appeared. He decorated this studio with murals. In Cadaqués, he had inherited a studio from Ramon Pitxot. Beginning his work there he experienced ecstasy as he took out his tubes of oil paints: 'Those

clean and shiny tubes represented a whole world of aspirations . . . My ecstasy as I lost myself in the mystery of light, of colour, of life. My soul merging with that of Nature.'[19]

Between 1919 and 1921, he produced over eighty works of art, which have been catalogued. These are predominantly local landscapes, but also include domestic scenes, portraits and self-portraits. The self-portraits from 1919–21 are especially interesting because of the intention they reveal: the desire to project a certain image of himself, both in terms of artistic and personal self-affirmation.[20] In his self-portrait of *c*.1920, we see the young artist in the right foreground of his favourite landscape of Cadaqués, with his striking sideburns. He has painted himself against his beloved landscape, yet has chosen hues for himself and his attire that reflect the setting, blending his image into the environment. In his *Portrait of My Father* (1920), he depicted his adored landscape, but portrayed his father in sharp contrast to it, wearing a dark suit. However, in *Portrait of My Father and the House at Es Llaner* (*c*.1920), his father is illustrated in tones that merge him more fluidly with the setting, but not to the same degree as his son. Throughout his life, Dalí was on a quest to experiment, learn and create – a process that one can witness from his early works onwards. He once said about himself, that 'The mills of his mind grind continuously, and he possesses the universal curiosity of Renaissance man.'

Tragically, his mother died in February 1921, from cancer. Her death absolutely devastated him. However, it also imbued him with an intense burning ambition, even deeper than before. His father married his mother's sister the following year, most likely a marriage of convenience. To add to his intense grief, his second father figure, Pepito Pitxot, also passed away not long before he was due to leave for Madrid to sit the entrance examination to attend the San Fernando Royal Academy of Fine Arts (Real Academia de Bellas Artes de San Fernando). However, his next environment, Madrid, along with his new experiences, lifestyle, art and comrades, were soon to go some way to distract him from his grief.

ABOVE *Portrait of My Father*, 1920, oil on canvas, 91 × 66.5 cm, Gala-Salvador Dalí Foundation, Figueres.

RIGHT The rocky landscape of the Costa Brava.

BELOW RIGHT *Self-Portrait with the Neck of Raphael*, 1920–21, oil on canvas, 41 × 53 cm, Gala-Salvador Dalí Foundation, Figueres.

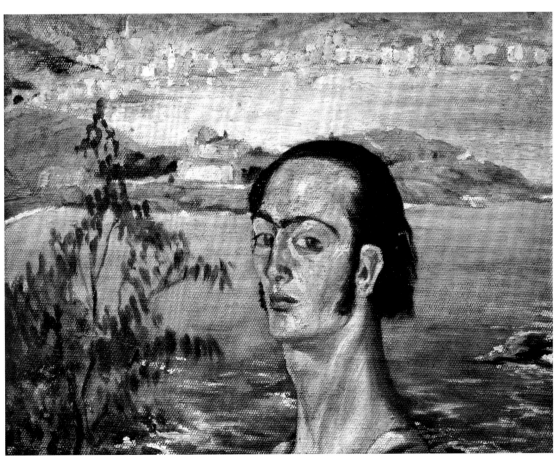

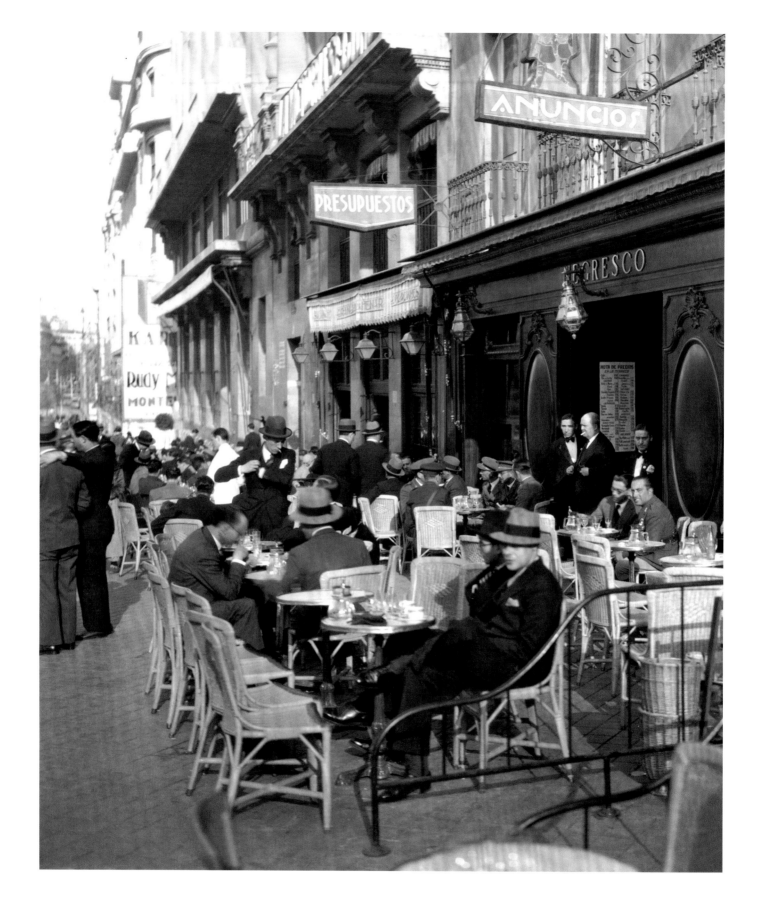

> 'We began . . . to haunt the cafés of Madrid in which the whole artistic, literary and political future of Spain was beginning to cook with a strong odour of burning oil.' *Salvador Dalí*[1]

FROM HERMIT TO DANDY IN MADRID

Before taking the entrance examination for the San Fernando Royal Academy of Fine Arts in Madrid, the young artist had to agree to take a selection of courses, which would eventually qualify him as a Professor of Art, to give his father the peace of mind that one way or the other, he would be able to support himself upon graduating from the Academy. Although he had produced the work required for the entrance exam in smaller dimensions than instructed, he was successful. The Academy was a former noble mansion, built originally in 1720, which had been known as Mesón de la Miel.[2] At that time it was a large building in the Baroque style, but the Academy administration felt that its Baroque façade was not in keeping with an Academy of the Fine Arts, so instead it was renovated in the Neoclassical style. 'The temple of the Academy of Fine Arts of Madrid already loomed before me, with all its stairways, all its columns and all its pediments of glory,' said Dalí.[3]

The contrast between the magical city of Madrid in the Roaring Twenties and his home town of Figueres, combined with the friends that

he would make, was the perfect recipe to shift Salvador deeper into his defining identity and encourage his immense, innate talent to blossom even further. His lodgings were in the Students' Residence (Residencia de Estudiantes), which could house up to 150 students, who came from well-off families. However, for his first few months, Dalí lived somewhat like a hermit, avoiding the groups who gathered there, and his life was mainly divided between the Academy and the Residence. According to his autobiography, curious groups would form as he made a striking appearance either leaving or returning to his lodgings. Sporting long hair and sideburns, he 'bought a large black felt hat, and a pipe which I did not smoke and never lighted, but which I kept constantly hanging from the corner of my mouth. I loathed long trousers, and decided to wear short pants with stockings, and sometimes puttees.'[4]

During this phase, he never exceeded a budget of more than one peseta per day, and on Sunday mornings he went to the Prado Museum, where he 'made Cubist sketch plans of the composition

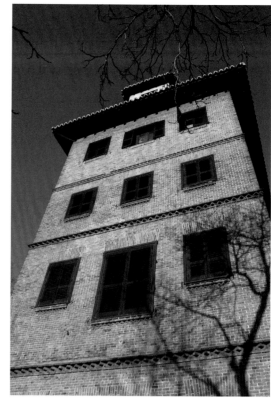

of various paintings'.[5] Even before his arrival in Madrid, his shift away from Impressionism had already begun and he continually experimented with different styles. He had started to get to know the work of the French Surrealists, such as André Breton, Paul Éluard, Louis Aragon and Jacques Baron. Additionally, he delved into Pointillism, Divisionism and Cubism, studying leaders of the movement: Pablo Picasso, Juan Gris and Georges Braque. In his room he was starting to paint his first Cubist works, which were influenced especially by Gris.[6] Although he was experimenting with different genres and his work was prolific, he found the tuition at the Academy to be disappointing. The tutors were unprepared for such an avant-garde student, and Impressionism, which he had already moved away from, was the prevailing style there.[7]

After four months of his monastic lifestyle, he was discovered by one of the many groups at the Residence, who greatly admired his Cubist paintings. The group included Luis Buñuel, Pepín Bello, Eugenio Montes, Pedro Garfias, Rafael Barrades and Federico García Lorca. By early 1923, he was firm friends with this group, especially with Lorca and Buñuel; the latter took great pleasure in defending his new friend's appearance, if need be physically, when on nights out in the city. Dalí himself, who tired of these incidents, decided it was time to change his look. He managed to carry out this feat in a day, which '. . . created a sensation among all students of the School of Fine Arts, and I immediately realised that, far from getting to look like everyone else as I tried to, and in spite of having bought everything in the most exclusive fashion

ABOVE LEFT Façade of the San Fernando Royal Academy of Fine Arts, Calle de Alcalá.

ABOVE RIGHT The Residencia de Estudiantes in Madrid, now a European Heritage site.

A room in the Residencia de Estudiantes, as it may have looked in the 1920s, when Lorca, Dalí and Buñuel lived here.

shops, I had succeeded in bringing these things together in such an unusual way that people still turned round to me as I went by exactly as they had before.'[8]

His merging with this group was immensely stimulating for him. It not only triggered a change in his appearance, but also in his lifestyle, and augmented his artistic and intellectual experiences. Many notable speakers came to the Academy, including Albert Einstein, H.G. Wells and Madame Curie, to further enrich the students' education. The Residence was brimming with artistic, intellectual and scientific stimulation, and he became a frequent visitor of the city's buzzing nightlife with his group of friends, who managed to build a reputation for wildness. Dalí continued to work on his own eccentric, erratic behaviour. His special party trick was placing a banknote in his whisky and, after waiting for it to disintegrate, drinking both the liquid and the money. The list of their haunts is too long to mention, but their sessions took them to many of Madrid's fashionable bars and restaurants of the day.

Although Dalí obviously enjoyed the company of his friends in Madrid during the 1920s, he still required solitude and time to create, so he struck a balance between his social life and painting for hours on end in his room. In

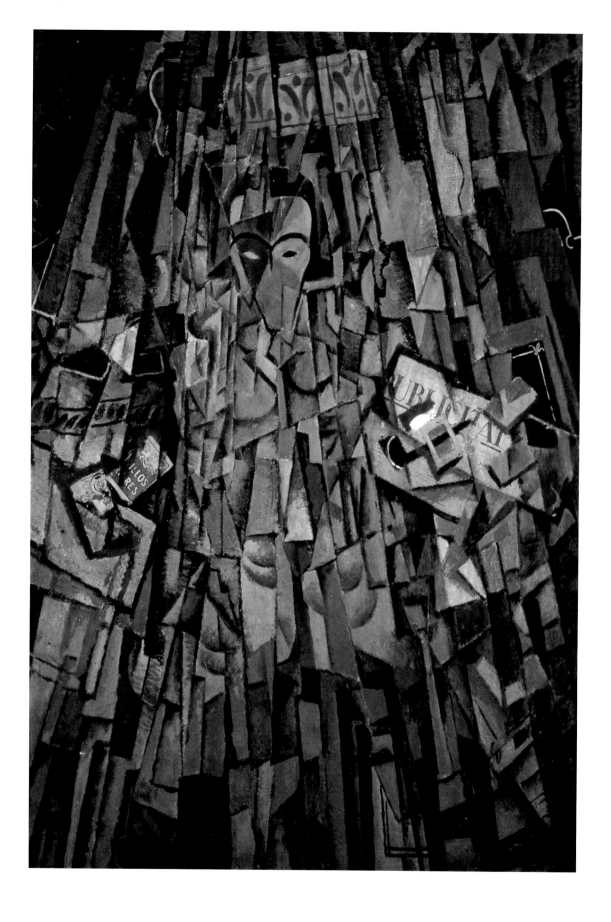

fact, he created so many paintings during his early student days, from September 1922 onwards, that it was a challenge for visitors to manoeuvre around his works. In 1923, he produced his first work that put a Dalinian stamp on Cubism: *Cubist Self-Portrait*. Normally a Cubist painting consists of all of its forms in entire fragmentation; however, in this work, Dalí left his own face unfragmented. Some of his artistic influences at this stage included, among others, Derain and Matisse. During 1923, he painted groups of nudes that were obviously indebted to the style of Matisse.

Another core influence in 1923 came when he was introduced to Sigmund Freud's writing. *The Interpretation of Dreams* had been re-issued in a Spanish edition, and Dalí found it to be life-changing. His own personal copy, held in a private collection, has handwritten notes in the margins. He would later write about its impact on him in his autobiography. 'The book struck me as one of the capital discoveries in my life, and I was overtaken by a real vice for self-interpretation, not only of dreams, but of all that happened to me, however casual it might have appeared at first sight.'[9]

Dalí's dissatisfaction with the Academy increased in the autumn of 1923, when he walked out of a meeting. The appointment of a Professor whom he had supported had been turned down, which led to a big student protest, believed by the Academy's authorities to have been initiated by Dalí's walkout. He was suspended for a year, but he attended classes at Madrid's Free Academy and continued to paint. However, he later moved back to his home town, where he studied once again under Juan Nuñez, at which stage he produced his first artistic prints and etchings.

Back in Figueres, it didn't take long before he was in trouble again. General Miguel Primo de Rivera had taken power in September 1923, which led to a seven-year period of a moderate military dictatorship in the Spanish government. Señor Dalí was an outspoken critic of this government, and in May 1924 his son, along with some of his friends, was arrested, most likely to take the troublemakers off the streets before the visit of King Alfonso XIII to Catalonia. His month or so in jail didn't appear to bother him too much and he was released on 11 June 1924. 'This period of imprisonment pleased me immeasurably. I was naturally among the political prisoners, all of whose friends, co-religionists and relatives showered us with gifts. Every evening we drank very bad native champagne.'[10]

Another native influence came to light that year, in the form of illustrations that Dalí produced for a poem, which contributed to the literary mythification of the Empordà region. The poem was *The Witches of Llers*, written by a close friend. Carles Fages de Climent had grown up on the same street as Dalí and the two became lifelong friends and artistic collaborators.[11] Quite possibly he drew on his ancestral roots when he created the illustrations for *The Witches of Llers*.

In autumn 1924, he returned to the Academy in Madrid, 'where I was awaited with delirious impatience by my group'.[12] At this stage he was simultaneously assimilating the most recent developments in Purism, Cubism and highly detailed Representationalism. During this period he was also influenced by the nineteenth-century German Romantic painter Caspar David Friedrich, as well as Italian artist Giorgio de Chirico, who was painting in the new form of Realism, which would later

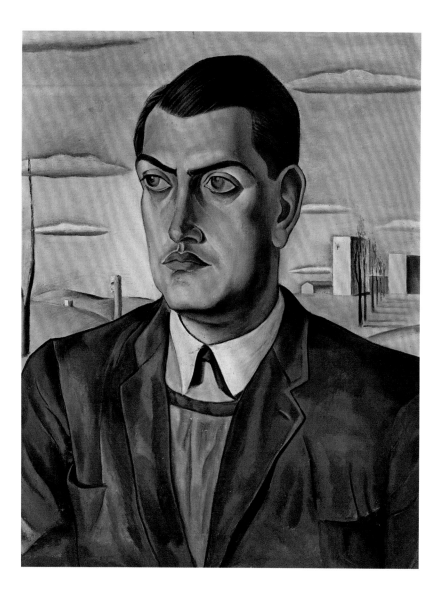

LEFT *Portrait of Luis Buñuel*, 1924, oil on canvas, 70 × 60 cm, Museo Nacional Centro de Arte Reina Sofia, Madrid.

OPPOSITE *Pierrot Playing the Guitar*, 1925, oil on canvas, 198 × 149 cm, Museo Nacional Centro de Arte Reina Sofia, Madrid.

be known as Surrealism. De Chirico's works were characterised by their eerie images, with humans placed onto dark, impersonal, haunting landscapes. Dalí's portrait of his friend, Luis Buñuel, shows his excitement with this period of De Chirico's art. Buñuel's forceful personality is highlighted as he sits black suited in the foreground, which is set against a backdrop of an abandoned landscape, with tiny buildings. The twenty-year-old Dalí continued to find the Academy's tuition beneath him, so he continued his weekly visits to the Prado, which

was for him a great repository of learning. He was clearly delving into many different styles in order to find his own Dalinian point of perfection, which would enable him to express his innermost self.

During his time in Madrid, his friendship with Lorca grew deep, and they shared intellectual interests. Dalí found the dark, handsome man, who was six years older than him, both charming and intellectually stimulating. Lorca was openly homosexual, and although Dalí didn't respond to his advances, he did become rather obsessive about

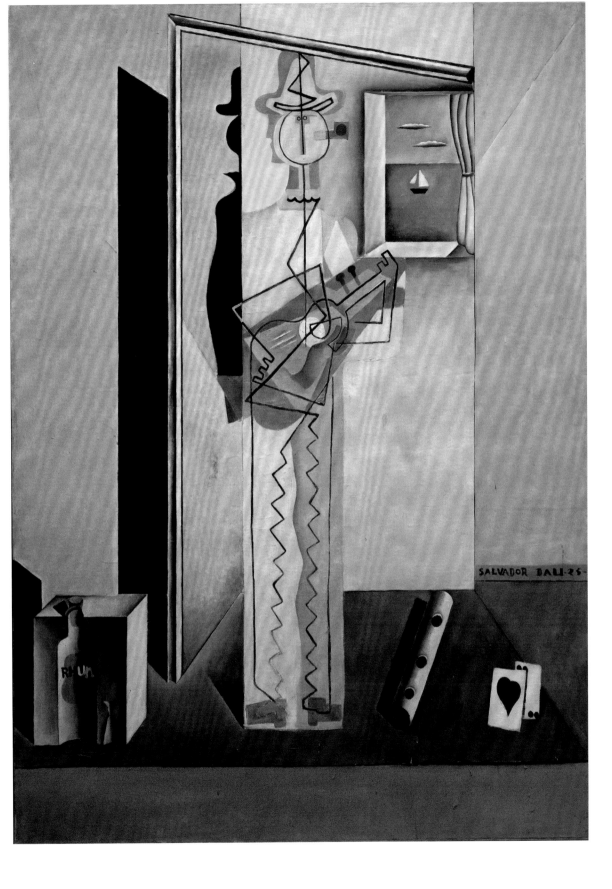

him. In 1925, during Holy Week, he invited Lorca to his family's summer house in Cadaqués, where it seems the poet fell in love with him. According to the Spanish art critic and poet Rafael Santos Torroella, 1925 marked the beginning of Dalí's Lorca Period and certainly there are some works from this time which support this theory.[13] One example is *Pierrot Playing the Guitar*, with its range of influences, which clearly include both Lorca and Picasso. However, the artist takes Cubism down a different route by reworking the style to include fantasy and the metaphysical. A psychological aspect is also evident: a dark, shrouded figure stands behind the Pierrot, as if a shadow. It is likely that Dalí intended the shadow to represent himself, and the Pierrot, Lorca, perhaps showing how he felt they had grown so close that they were one person. It could be considered that they were on corresponding quests.[14]

In November 1925, Dalí held his first ever solo exhibition in the Dalmau Gallery in Barcelona. Although the critics were puzzled by the range of styles across the seventeen paintings that he showed, they did review the exhibition positively. His father was delighted with this success, and funded a trip to Paris and Brussels for Dalí, his sister and stepmother. They travelled to Paris in late April 1926, a month that had already begun with a significant highlight for Dalí, as Lorca had published his *Ode to Salvador Dalí*, which was an important testimonial to his talents. Although the family travelled also to Versailles and later to Brussels, the undisputed highlight of the trip was Dalí's meeting with Picasso in Paris. He brought a painting to show to him, *Girl from Figueres,* which Picasso spent fifteen minutes studying, but said nothing. Afterwards Picasso passed two hours showing the young artist his own canvases. 'At each new canvas he cast me a glance filled with vivacity and an intelligence so violent it made me tremble. I left without in turn having made the slightest comment. At the end, on the landing on the stairs, just as I was about to leave, we exchanged a glance which meant exactly, "You get the idea? I get it!"'[15] He also met with Buñuel in Paris, and on his return to Catalonia, his experiences and the welcome he had received in the French capital already had him considering relocating there.

In mid-June 1926, he executed a cunning, flagrant plan he had devised in order to be expelled from the Academy. At his History of Art oral exam, he refused to be examined, stating, 'None of the professors of the school of San Fernando being competent to judge me, I retire.'[16] Unsurprisingly, this had the desired effect, as the professors were suitably insulted just as he had intended, and eight days later he was expelled from the Academy. 'I wanted to have done with the School of Fine Arts and the orgiastic life of Madrid once and for all; I wanted to be forced to escape all that and come back to Figueras to work for a year, after which I would try to convince my father that my studies should be continued in Paris.'[17] This part of his plan had gone smoothly, but how would the rest of it pan out?

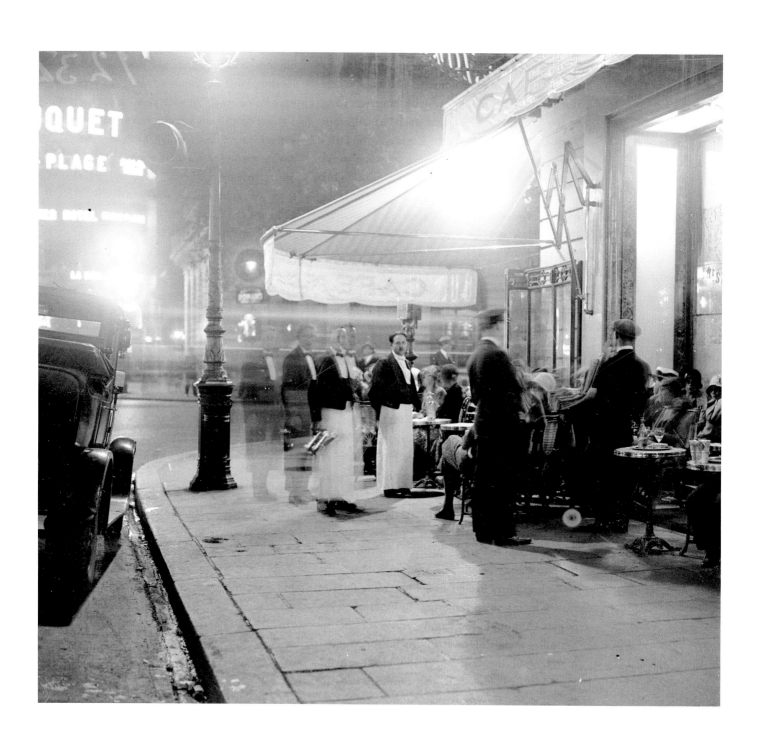

> 'For the rest of my life I was always to make use of the occult and esoteric subways of the spirit.' *Salvador Dalí*[1]

POUNCING ON PARIS

Back in his home town of Figueres, Dalí concentrated on his plan to work for a year, before hopefully relocating to Paris. One of his most successful pencil drawings of this period was a portrait of his sister and father, about which he observed that 'in the expression of my father's face can be seen the mark of the pathetic bitterness which my expulsion from the Academy had produced on him.'[2] He also created a series of mythological paintings, in which he attempted to 'draw positive conclusions from my Cubist experience by linking its lesson of geometric order to the eternal principles of tradition.'[3]

During 1926, his work was shown in a number of group exhibitions in Barcelona and Madrid. In 1927, he took part in the Autumn Salon at the Sala Parés, Barcelona, for the second time, and he had another one-man show at the Dalmau. Twenty paintings were included, which were even more stylistically varied than his debut solo exhibition at the same gallery. Even so, it was largely a huge hit with the press and talk of his work was filtering through to Paris. *Girl with Curls*, from 1926, includes elements of the Surrealist style that he would come to embrace.

One of his influences, his fellow Catalan artist Joan Miró, was already enjoying notable success in Paris. Other creative influences at this time were Surrealists Max Ernst, Jean Arp, André Masson and Yves Tanguy, and Proto-Surrealists Carlo Carra and Giorgio de Chirico. Tanguy's *The Ring of Invisibility* (1926), which Dalí saw in a 1926 reproduction in *La Révolution Surréaliste*,[4] had a particular impact on him. We can see a shift in how he incorporated his native landscapes of the Empordan plain, close to Figueres, just as Tanguy featured desert-like landscapes and De Chirico eerie cityscapes. Connecting with these local landscapes in this way possibly triggered a change in him. These were the places that he had connected with from his earliest years. He had learned from them, during his most formative periods, embracing them as his teacher, naturally merging with them and channelling them into his creations. Soon after, he also started to feature the polymorphic forms of Tanguy's influence. He did flirt briefly with automatic drawing, but dismissed it rather quickly.

However, a spanner was thrown in the works, which would delay his grand Parisian plan; this was

the fact that he couldn't avoid doing his military service. He started his nine months of compulsory service in February 1927, at the Castell de Sant Ferran in Figueres.[5] During this time, it was impossible for him to maintain his normal prolific creative output, but he did produce some pictures and literature nonetheless. He designed the costumes and sets for his dear friend, Lorca, for the premiere of *Mariana Pineda*. He spent time with Lorca in Barcelona, Sitges, and Cadaqués during his three-month summer leave in 1927, and Lorca continued

to be an important influence both personally and artistically on Dalí.

He also managed to contribute some poems, drawings and prose to Catalonia's most renowned avant-garde publication of the day, *L'Amic de les Arts* (The Friend of the Arts), produced in Sitges. One piece of prose was 'San Sebastián'; the saint was a theme of some paintings of his Lorca Period, and the prose alluded regularly to Federico Lorca, while also inspiring Lorca to write his own set of prose poems.[6] It also demonstrated his early interest in

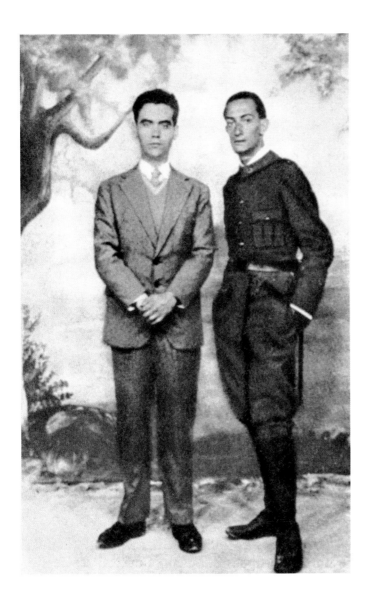

science, referring to a range of apparatus types to
measure the agony of the martyred saint, for example
a 'heliometer for calculating the apparent distances
between aesthetic values' and another for 'distilling
[his] coagulate'.[7] A photograph taken that year shows
Dalí holding a copy of *Science and Invention*, an
English-language journal from New York, reporting
on the latest scientific advances of the day.

It seems from a letter that Dalí wrote to Lorca in
autumn of the same year, that he had made an artistic
breakthrough. 'Federico, I am painting pictures
which make me die for joy, I am creating with an
absolute naturalness, without the slightest aesthetic
concern, I am making things that inspire me with
a very profound emotion and I am trying to paint
them honestly.'[8] One of the most arresting works
from this time is *Little Ashes*, with its strange and
dreamlike collection of objects. Around this period,
he also mentioned in *The Secret Life of Salvador Dalí*
that 'I am in Figueras and am preparing, as I have
already said, to pounce on Paris.'[9]

His close friend Luis Buñuel had been in
touch with him about a possible collaboration on
a film that would be produced with the help of a
loan from his mother. However, Dalí felt that his
concept was extremely mediocre. Coincidentally,
around the same time, he had written a scenario
himself, which he felt 'had the touch of genius'.[10]
When he told Buñuel about the scenario, it excited
him so much that he announced that he was going
to come to Figueres in early 1929. Together they
developed what would eventually turn out to be *Un
Chien Andalou*. Buñuel later returned to Paris, but
they continued collaborating at a distance, working
efficiently enough that filming was scheduled for
2 April 1929.[11] When Dalí arrived at long last, ready to
pounce on Paris, he stayed at a very uninspiring hotel,
located on Rue Vivienne,[12] the street that connects
the National Library to the Boulevard Montmartre.
On this trip, he spent two months in Paris, visiting Le
Havre briefly to film the beach sequence.

In Paris, Joan Miró took him under his wing.
The hard-working, reliable artist, as Dalí discovered,
was given to long bouts of silence, but on one of
their evenings out, Miró advised his fellow Catalan

LEFT *Girl with Curls*, 1926, oil on panel, 51 × 40 cm, Dalí Museum, St Petersburg, Florida.

OPPOSITE *Little Ashes*, 1927–8, oil on panel, 64 × 48 cm, Museo Nacional Centro de Arte Reina Sofía, Madrid.

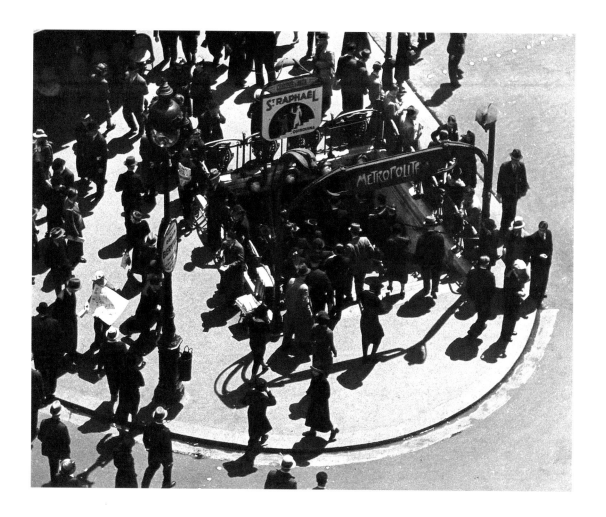

ABOVE A crowded street corner and Métro station entrance, Paris, 1936.

that 'The important thing in life is to be stubborn. When what I'm looking for doesn't come out in my paintings I knock my head furiously against the wall till it's bloody.' Miró took him to meet a number of important society people, but Dalí at that stage was still struggling with his shyness. He exhibited the same timidity when he was introduced to Breton and other Surrealists, which resulted in Maxime Alexander describing him as 'a timid little young man, very self-effacing, wearing a suit and a hard-collar like a shop assistant and the only one of us

with a moustache'.[13] The outings with Miró also included a dinner at Pierre Loeb's, where they were joined by six other artists who had signed with the dealer, but whom Dalí felt exuded an air of limited success. Out of this group, the only one who stood out to him was Pavel Tchelitchew, the Russian-born Surrealist. Tchelitchew witnessed Dalí's terror at having to enter the Métro for the very first time, an ordeal that was made worse by the fact that his fellow artist left one stop before him. Yet the experience triggered an important realisation, which

ABOVE A crowded street corner and Métro station entrance, Paris, 1936.

56 SALVADOR DALÍ AT HOME

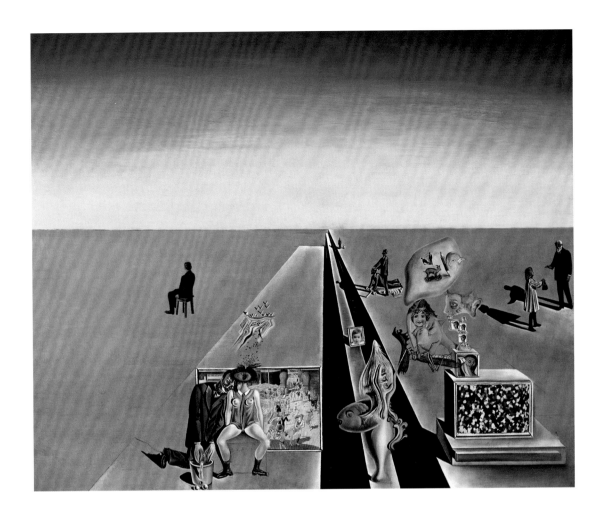

ABOVE *The First Days of
Spring*, 1929, oil and collage
on panel, 49.5 × 64 cm, Dalí
Museum, St Petersburg,
Florida.

he perceived to be the exact formula for his success.
The oppression of the Paris underground system,
which offered a stark contrast to other aspects of his
life, made him decide that 'For the rest of my life I
was always to make use of the occult and esoteric
subways of the spirit.'[14]

Beside his initial fear of the Métro, it is evident
through a series of six literary documentary articles
he wrote for *L'Amic de les Arts* during his stay that
the magnificent Paris of the late-1920s had lived up
to his expectations engrained from his 1926 visit, and

left him filled with enthusiasm.[15] It was a Paris that
was determined to seek joy and beauty after the end
of the First World War, with a thriving café culture,
art and literary scene. The capital city in the world
for Surrealism and the avant-garde was packed with
beautiful architecture, including plenty of striking
Art Deco buildings and theatres. Its left bank was
buzzing with artists and writers, who had gravitated
to the world's most exciting, glamorous, cultural city
of the day. One could easily have run into F. Scott
Fitzgerald or Ernest Hemingway in a Parisian café.

The city's right bank, Montmartre, had been famous for its dance halls and cafés since the 1890s. The 1920s saw it welcome ragtime, jazz and black music. Dalí started to love jazz at this time.

He had taken his recently finished painting, *The First Days of Spring*, with him to Paris. According to the artist's autobiography, it had been created using his own personal process, of the time, to generate irrational images. 'I spent the whole day seated before my easel, my eyes staring fixedly, trying to "see", like a medium . . . the images that would spring up in my imagination.'[16] From this painting onwards, Dalí felt that he had discovered his own original Dalinian method, which was at once both objective and subjective. He made this breakthrough by combining his own personal symbolism with that of Freud.

In May 1929, Miró's unwavering support of Dalí paid off, after he introduced him to Camille Goemans, who had recently opened his own gallery in Rue de Seine. Goemans, a close friend of René Magritte, signed a contract with Dalí on 14 May, three days after his twenty-fifth birthday. The contract paid him 1,000 francs per month and stated that all of his work between 15 May and 15 November 1929 was to go to the gallery. Goemans would then organise an exhibition for the 1929–30 season. Goemans also introduced Dalí to the poet Paul Éluard, telling him of his importance, but also mentioning that he bought paintings. A mutual admiration grew, and the poet promised to visit Dalí in Cadaqués.

On 6 June 1929, *Un Chien Andalou* premiered in Paris, getting a reaction of combined shock and intrigue,[17] but it was generally positively received as something new and bizarre. This wasn't the reaction the collaborators had hoped for; in fact, Dalí was disappointed not only with this but also with the finished product, which he felt wasn't disgusting enough. The film opens with a girl having her eye sliced open,[18] which gives the viewer a hint of what else is to come. It did, however, cause enough of a sensation in the world's artistic capital to ensure that Dalí was regarded as an *enfant terrible*. Working in a different medium had helped him explore and sharpen his visual imagery. He also made his first

sculptural works, including ceramic pieces and objects, towards the end of the 1920s.

However, Dalí had to leave Paris earlier than expected as he was unwell. After his train journey back to Catalonia he awoke the following morning 'to the sun-swept landscape of the Ampurdan plain'.[19] He was experiencing 'a kind of transparency, as though I could see and hear all the delightful little viscous mechanisms of my reflowering physiology'.[20] But that was not all he was feeling, if you can believe the account in his autobiography. 'I had a vague presentiment, which grew and became increasingly precise, that all these signs were the visceral portents of love – I was going to know love this summer . . . This could be none other than Galuchka, resuscitated by growth, and with a new woman's body.'[21] That summer his sexual and emotional energy was extremely highly strung, which resulted in amazing laughing fits, where he sometimes ended up writhing around on his bed. He began to fear impending madness. Whether the presentiment he wrote about occurred in reality or was part of his elaborate fantasies, we won't ever know, but what we can certainly be sure of is that in the summer of 1929, one of history's most talked about love affairs began.

While he may have been deeply disappointed about the reaction to *Un Chien Andalou*, he certainly wasn't when, in the summertime of 1929, Éluard kept his promise to visit Cadaqués. A group from Paris, which included Éluard and his wife, Gala, and the couple's daughter Cécile, Luis Buñuel, Goemans and a friend of his, and René Magritte and his wife, arrived in his favourite place – the spot where he felt like a human incarnation of the primitive

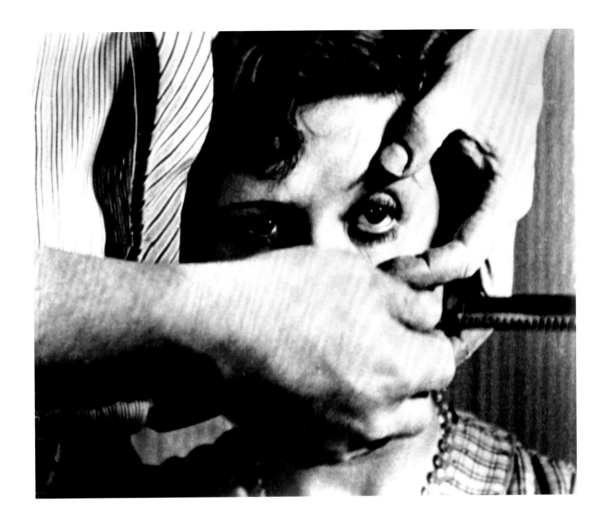

landscape. It was love at first sight for Dalí when he met Gala, but of course, he had to hide this in front of her then husband, Paul Éluard. She was equally attracted to him, but not from first sight. Born in Russia, Gala, whose real name was Elena Ivanovna Diakonova, had been in a *marriage à trois*, with her husband and the strikingly handsome German Dada artist, Max Ernst, in the early 1920s. By 1929, her marriage to Éluard was failing.[22] 'She was destined to be my Gradiva, the one who moves forward, my victory, my wife.'[23] (The name Gradiva comes from the title of a novel by W. Jensen, the main character of which was Sigmund Freud.) Her presence pushed the abundance of emotional and sexual frustration in Dalí higher, possibly exaggerated even more, as she connected with him on his bizarre psychological wavelength. His behaviour was becoming even more eccentric. When Éluard departed for Paris in September, Gala stayed on to initiate the love affair that would be the artist's most important lifelong relationship; although not a connection that would please everyone around them.

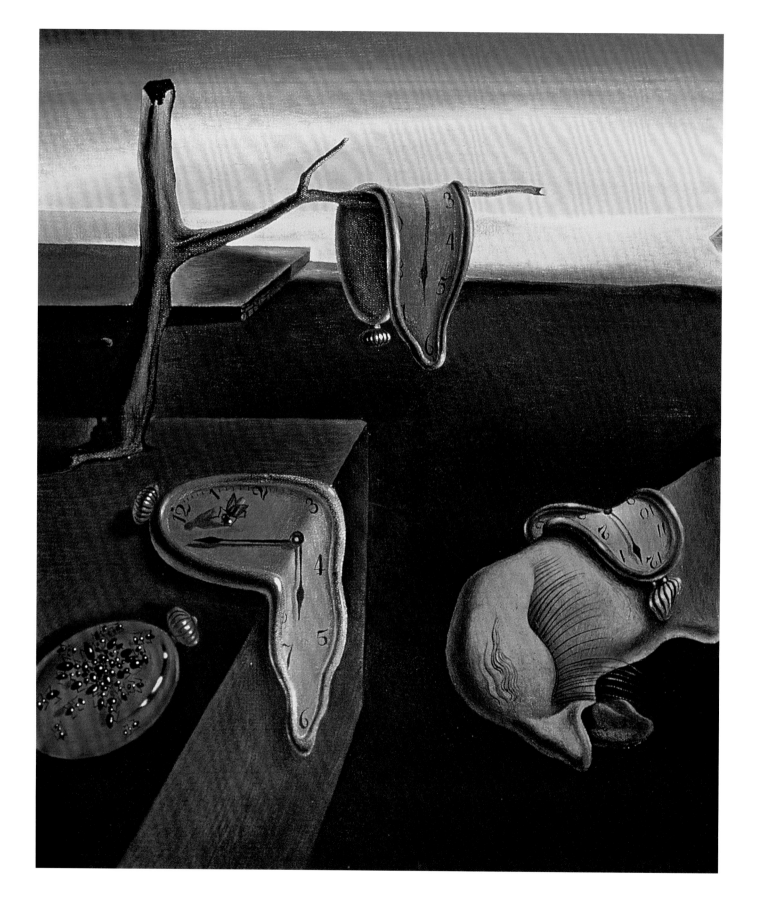

> 'In that privileged place, reality and the sublime dimension almost come together. My mystical paradise begins in the plains of the Empordà, is surrounded by the Alberes hills, and reaches plenitude in the bay of Cadaqués.' *Salvador Dalí*[1]

STEPPING INTO SURREALISM

The Persistence of Memory (detail), 1931, oil on canvas, 24 × 33 cm, Museum of Modern Art, New York.

It wasn't love at first sight for Gala, as 'she had thought me an unbearably obnoxious creature because of my pomaded hair and my elegance . . . My Madrid period had in truth left its imprint on me in love of adornment.'[2] However, after a couple of days in Cadaqués, Gala asked to go for a walk with Salvador. Perhaps she had recognised that he was the man who would help her fulfil her own myth. Between two fits of laughter, Dalí told her that he loved her.[3] From that point on, their relationship began to blossom, but this also awakened a deep fear in Dalí, who frequently said to Gala, '"Above all don't, please don't hurt me. And I mustn't hurt you either. We must never hurt each other." And then I would suggest to her a walk at sunset to some geological height from which we would get a fine view.'[4] Despite his fears, Dalí regarded Gala as his lover, muse and saviour. A later, important muse and friend, Amanda Lear, who clearly couldn't bear Gala and described her as always complaining, wrote in her book *My Life with Dalí*, 'Dalí had the patience of an angel and clearly adored her. When he was with her, he behaved like a child in front of his mother;

and when his conversation strayed to more erotic topics, she pretended not to hear.'[5]

Gala left Cadaqués in late September, at which stage he threw himself back into his work passionately, preparing for his Paris exhibition. It had been *Un Chien Andalou* that had marked his official entrance into the Surrealist group, but the paintings that he produced that autumn were a superb selection of works, with his own Dalinian take on the genre. His relationship with Gala appeared to have cured the impending madness that had been of great concern to him that summer, leaving him free to create some of his most loved masterpieces and collaborate on another film with Buñuel.

By the end of the 1920s, he had also read Richard Krafft-Ebing's *Psychopathia Sexualis*, which had originally been published in German in 1886, when the 'acceptable' sexual norms were rather different than those of the current day. The book features over 200 case studies of sexual deviancies, which are communicated in the words of each patient featured. Ranging from the mundane to the bizarre and horrific, these case studies most likely

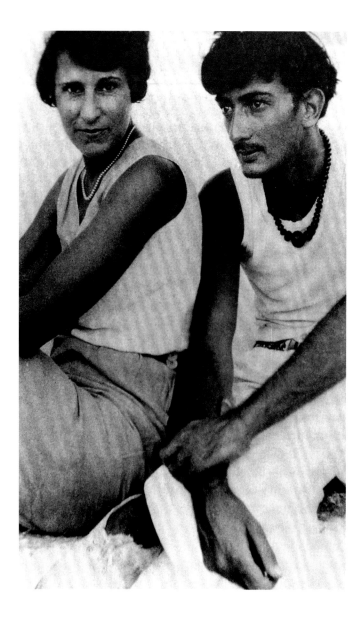

helped Dalí to explore his own fantasies more freely,
and drawing upon them gave his works even more
imaginative potency.[6]

Of the numerous creations that he produced that
year, the painting commonly known as *The Great
Masturbator* is one of Dalí's most famous works.
The artist himself labelled it as an 'expression of
my heterosexual anxiety'.[7] It is a superb coming
together of the landscape he felt so much a part
of, with his almost lifelong sexual confusion and
recent experiences with Gala. He depicts himself as
exhausted, with a grasshopper and ants on his face.[8]
In *The Unspeakable Confessions of Salvador Dalí*, the
artist described beautifully this connection with his
environment: 'In that privileged place, reality and
the sublime dimension almost come together. My
mystical paradise begins in the plains of the Empordà,
is surrounded by the Alberes hills, and reaches
plenitude in the bay of Cadaqués. This land is my
permanent inspiration. The only place in the world,
too, where I feel loved. When I painted that rock that
I entitled *The Great Masturbator*, I did nothing more
than render homage to one of the promontories of
my kingdom, and my painting was a hymn to one
of the jewels of my crown.' This was 'the only place
in the world, too, where I feel loved',[9] both integral
aspects which explain his remarkable connection to
this wonderful place.

He painted *The Great Masturbator* at the same
time as another one of his most important works,
The Enigma of Desire, just as he was completing *The
Lugubrious Game*. *The Enigma of Desire* was the first
work to sell at the Goemans Gallery, in late 1929. This
work features his beloved landscape of Cap de Creus
combined with Gaudí's architecture and a Baroque-
style appendage, which elongates the face. He also
produced *Sometimes I Spit with Pleasure on the Portrait
of My Mother (The Sacred Heart)* the same year; an
ink on canvas, with the words of the work's title in
French; this would soon cause a severe family rift.

His planned exhibition was to be held in the
Goemans Gallery from 20 November to 5 December
1929, and while he was in Paris preparing for it, he
discovered that Gala had devoted some of her time
to organising some of his scribblings, which 'formed

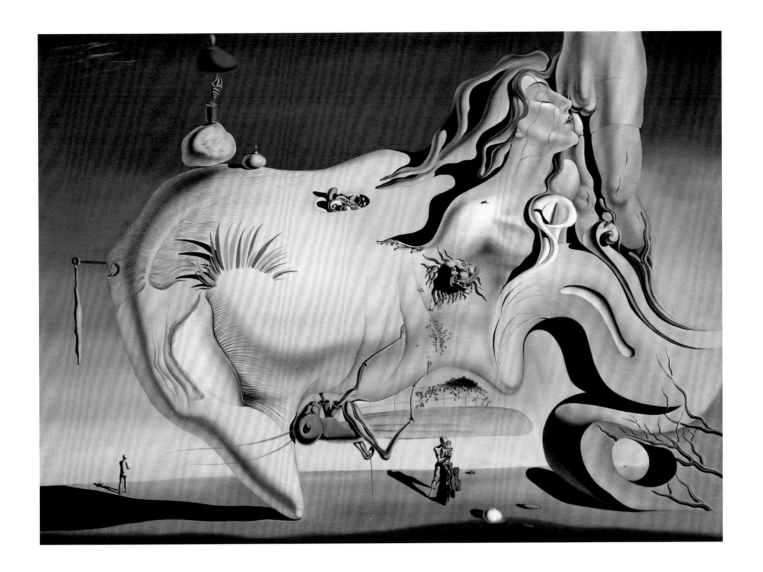

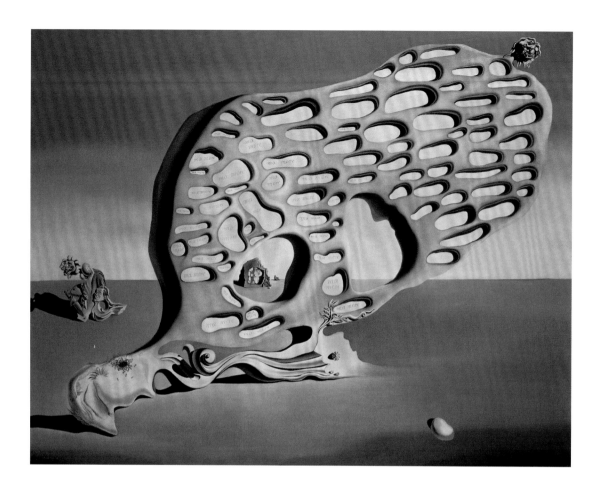

fairly well-developed notes which on Gala's advice I took up again and recast into a theoretical and poetic work.'[10] The result was the book *La Femme Visible* (The Visible Woman), which was published by the Éditions Surréalistes in 1930. Essays such as 'The Putrified Donkey', along with the paintings and other art he was producing during this period, reveal that he was laying the foundations for his paranoiac-critical method, which enables artists to use a self-induced paranoid state and systematic irrational thought to tap into the subconscious mind. The artist can then let go of pre-conceived notions about the world, and view it in new and unique ways.[11]

Having spent so much of his life furiously studying and experimenting with a range of artistic styles, he had now invented his own method, which enabled him to push his boundaries, creating works that clearly showed he had found his own form of expression. At the same time, he had stepped fully into Surrealism. 'The subconscious has a symbolic language that is truly a universal language, for it speaks with the vocabulary of the great vital

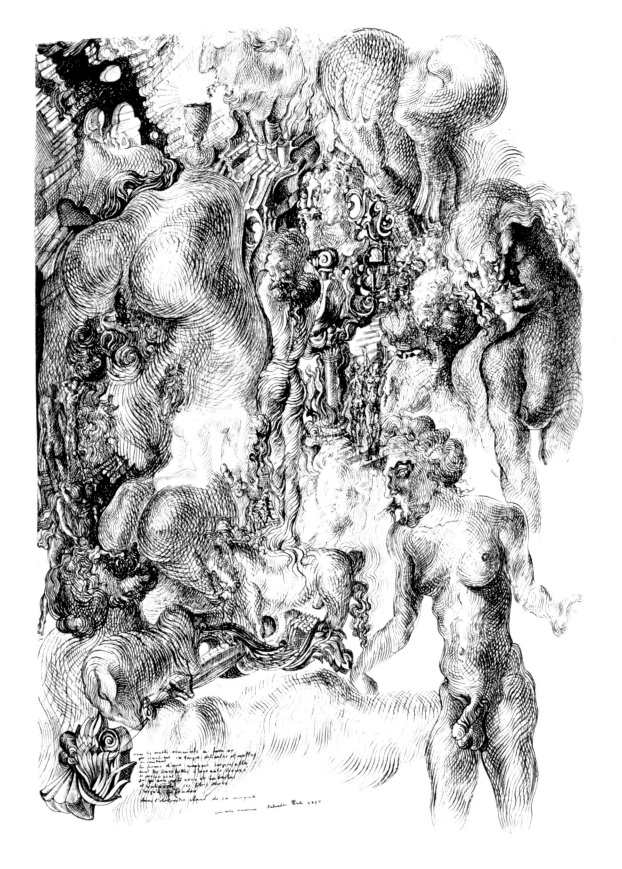

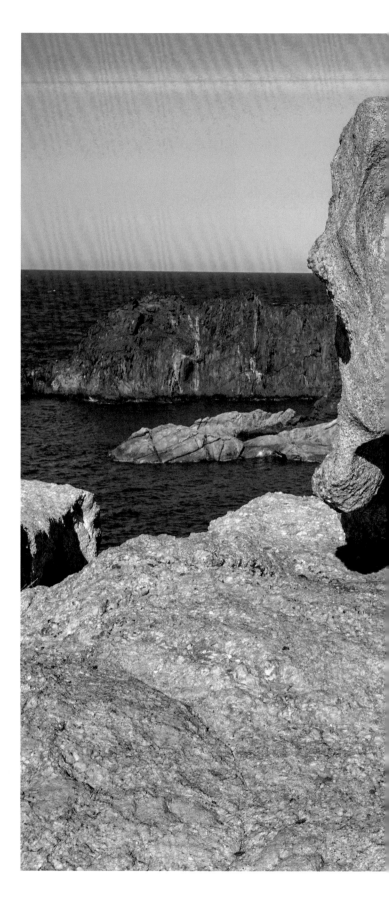

Strange rock formations on
the seashore, Cap de Creus
Natural Park.

constants, sexual instinct, feeling of death, physical notion of the enigma of space – these vital constants are universally echoed in every human. To understand an aesthetic picture, training in the appreciation is necessary, cultural and intellectual preparation. For Surrealism the only pre-requisite is a receptive and intuitive human being.'[12]

However, only two days before the opening of the exhibition, he surprised himself by deciding to leave with Gala 'on a voyage of love . . . Thus I did not even see how the paintings in this first exhibit of my work were hung, and I confess that during our voyage Gala and I were so much occupied by our two bodies that we hardly for a single moment thought about my exhibit, which I already looked upon as "ours".'[13] They went to Barcelona and then on to Sitges.

The exhibition was a huge success, and all eleven paintings were sold. Breton himself bought one, *Accommodations of Desire,* as well as penning an introductory essay for Dalí's exhibition catalogue. Very importantly for the artist, there was also a prestigious collector present, the Vicomte de Noailles, who bought *The Lugubrious Game.* Unfortunately, however, Goemans was in a lot of debt and couldn't afford to pay the artist what he was due. De Noailles came to his rescue, by paying him an advance of 29,000 francs for another painting, which was soon to come in very handy. In addition, he gave Dalí and Buñuel the money for their next film, *L'Age d'Or,* and introduced the artist to his next dealer, Pierre Colle.

Buñuel came to Catalonia to collaborate with Dalí on the next film. 'For this film,' said Dalí, 'I want a lot of archbishops, bones and monstrances. I want especially archbishops with their embroidered tiaras bathing amid the rocky cataclysms of Cap Creus.'[14]

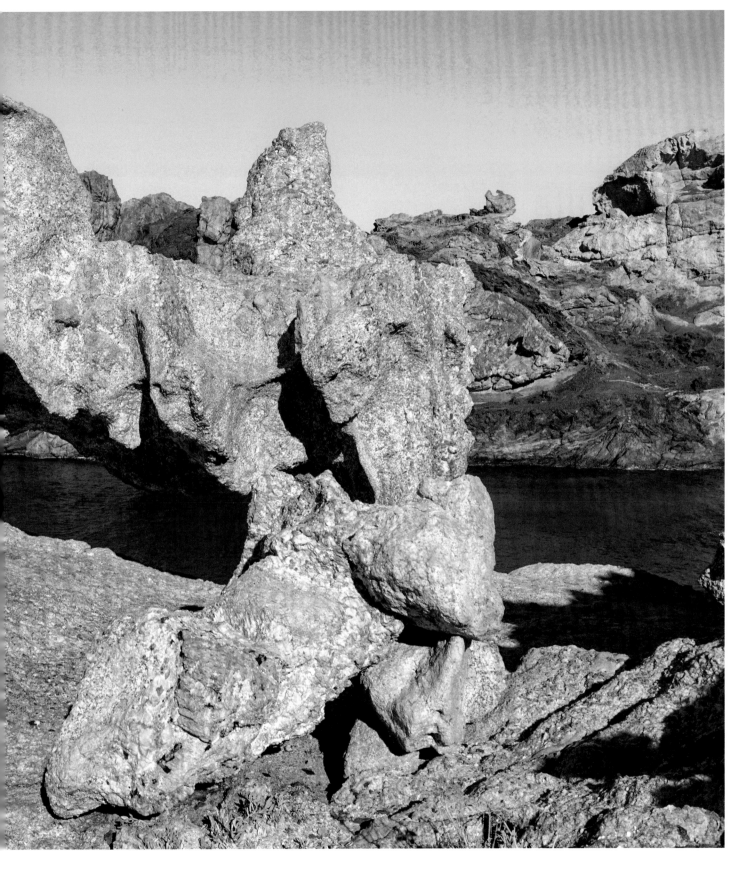

Buñuel wanted to push the film further down the anti-clerical route, but Dalí stood his ground. Soon his collaborator returned to Paris to begin getting the film into production, so Dalí was left by himself in Cadaqués. One day at noon, while enjoying his favourite sea urchins, a white cat appeared before him with something gleaming in its eye. The object turned out to be a fish hook, which Dalí soon began to feel was a bad omen. A few days later he received 'a letter from my father notifying me of my irrevocable banishment from the bosom of my family'.[15] Undoubtedly, this family rift was caused by the combination of his strong disapproval of his son's relationship with Gala, and how deeply offended he had been by *Sometimes I Spit with Pleasure on the Portrait of My Mother*. After cutting off all of his hair and burying it in a hole in the sand in Cadaqués,

Dalí contemplated for a couple of hours on 'a small hill from which one overlooks the whole village of Cadaqués',[16] and decided to go back to Paris on a train the next day, leaving behind the panorama that had always been a much-loved refuge and vital inspiration for him.[17]

Back in Paris, he was invited to dinner at the Vicomte's house one evening. 'Their house intimidated me, and I was extremely flattered to see my painting, *The Lugubrious Game*, hung between a Cranach and a Watteau.'[18] During this period, it is evident that he was still struggling to overcome his shyness. 'The remnants of my pathological timidity edged my character with extremely uncommunicative features, features so abrupt that I was in effect conscious that people would look forward nervously to the infrequent occasions when I would open my mouth. Then, with

OPPOSITE The library
(above) and dining room
(below) in the Dalís' house at
Port Lligat.

ABOVE Salvador Dalí
posing with his stuffed bear
at Port Lligat in November
1957.

a remark that was terribly crude and charged with
Spanish fanaticism, I would express all that my pent-up
eloquence had accumulated . . .'[19] On one occasion, he
had been listening to an art critic discuss the 'matter'
of Courbet, touching on how he spread it out and was
comfortable in handling it, he quipped, "'Have you
ever tried to eat it?" Becoming wittily French, I added,
"When it comes to s—t, I still prefer Chardin's".'[20]

Apart from meeting society people through De
Noailles, the advance that he had been given put him
in a position to buy the little fisherman's cottage at
Port Lligat in March 1930. Gala had spent a short
period of time back with her husband, but later that
year she moved in with Dalí. Located in the area that
he most loved, this place would become his home-
cum-studio for much of his life, which the couple
gradually extended by buying more cottages over a
period of forty-two years, creating their own perfect
little kingdom. Ultra Violet, who was one of Dalí's
important muses in the early 1960s, recounted her
first visit to Port Lligat in her 1988 book *Famous for
15 Minutes: My Years with Andy Warhol*:

> I am amazed by his house. A multilevel
> agglomeration of purest white-chalk
> fishermen's cottages, it looks like a
> miniature Moorish fortress. I call it the
> White Labyrinth. As I approach the narrow
> entrance door, it opens. Inside, I fall back at
> the sight of a gigantic, ten-foot-high white
> bear glaring down at me. His eyes glitter and
> his fangs gleam . . . The dining room is a tiny
> six feet by four feet, no bigger than a scatter
> rug. Against one white wall there is a built-in
> cement bench, in front of it a table a foot and
> a half wide. Dalí slides into a tiny chair that
> fits into an excavated niche in the opposite
> wall. We are lunching in a doll house that is
> as unreal as if we were inside our heads.[21]

In a place where a Surreal stuffed bear greets
you, and the watchful eyes of an owl gaze out over its
head, into the quirky, bijoux space, which is home to
a Mae West Lips Sofa, you can only start to imagine
what lies ahead. Outside, the fishermen have been

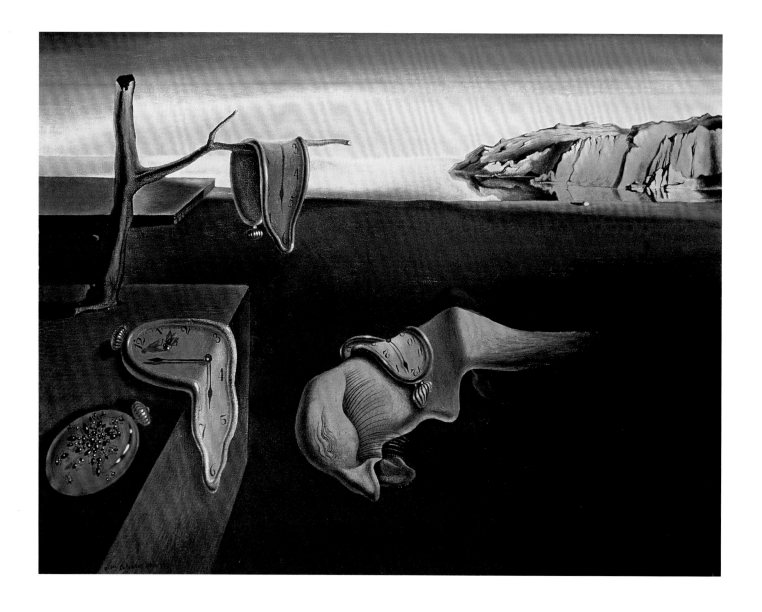

preparing their boat, apparently oblivious to the curious groups of visitors who come to bear witness to Salvador Dalí's very personal and extremely unique space. Each room has its own story on show to visitors, but at the same time there is the feeling of a life filled with duality, held in those bright-white Mediterranean walls; the routine day-to-day life of the artist and his wife and the social gatherings, for which the couple were renowned. The somewhat normal and the definitely Surreal, overlapping in all aspects of their lives. One can imagine the quiet times that they spent there together as a couple, when Salvador woke up early, painting in his idyllic studio for hours on end, with its perfect blend of enchanting views and incredible light. In the couples' bedroom, there is a mirror positioned to capture the first light of dawn as it breaks through, another piece in the puzzle of how Salvador Dalí truly lived his art. The artist once said about Port Lligat, 'It was where I learnt to become poor, to limit and file down my thoughts, so that they would acquire the sharpness of an axe, where blood tasted of blood, and honey of honey. A life that was hard without metaphor or wine, a life with the light of eternity.'[22]

Professionally, his collaboration with Buñuel on *L'Age d'Or* had left him feeling deeply disappointed and betrayed. Essentially the film is a Surrealist tale about a woman and a man who are passionately in love, and their attempts to consummate their passion are thwarted by the Church, their families and bourgeois society. Dalí felt that his collaborator had entirely narrowed its focus by making it an attack against clericalism. He felt that the film, which was even more violent than its predecessor, had lost much of its originally planned meaning. On top of this, one

of his own paintings was destroyed when a right-wing crowd smashed up the cinema, damaging a number of works of arts, soon after the premiere.

In Spain, the political atmosphere was becoming heated. General Primo de Riviera had gone into exile in Paris in 1930, leaving behind him a trail of caretaker governments who had promised to hold general elections, but didn't manage to do so until 2 April 1931. The election results showed that the majority of the public were in favour of a Republic, so King Alfonso XIII, who had supported the dictatorship, followed in Primo de Riviera's footsteps, seeking exile in Paris, but without abdicating.[23] When Spain's Second Republic was proclaimed on 14 April 1931, and reforms were announced, there was a huge conflict between the Church and the Republic. This culminated in an irate pastoral letter from the Primate of All Spain, Cardinal Segura, which was followed by a number of convents being set on fire in Madrid on 11 May 1931. The Surrealists, who had been observing the events, issued a very extreme tract, wherein they condoned the incendiaries and looked for a Marxist-style revolution for Spain. The tract was signed by a number of the movement's important members, including ten foreign comrades, of which two may have been Dalí and Buñuel.[24]

This political unrest formed part of the backdrop to Dalí's first exhibition at the Pierre Colle Gallery, which ran from 3 to 15 June 1931. Sixteen paintings were exhibited along with *Gradiva*, a sculpture created in copper, and seven pastels. This show marked the beginning of his 'soft watches' phase, which we can first see in his most famous and much-anticipated work of the exhibition, *The Persistence of Memory*. Time and eternity are the themes of this wonderful painting, which are evident by both the decay of life, implied by the swarming ants and, of course, from the famous melting watches; both of which are recognisable images that the artist portrayed in either unfamiliar ways or contexts. The painting was created with Dalí's incredible precision, yet also with determination 'to systematise confusion and thus to help discredit completely the world of reality'.[25] The reality of the scene is those distant golden cliffs, which are a seascape based on his adored surroundings in

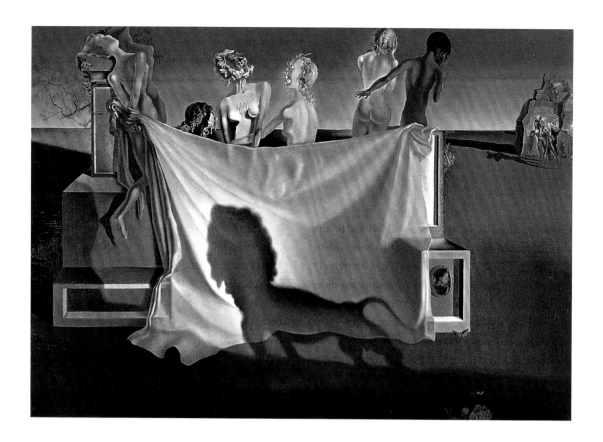

Catalonia. *The Persistence of Memory* has often been interpreted as a self-portrait, yet the large central creature was undoubtedly created in Dalí's incredible imagination, although it could certainly represent the artist. The creature, who is partially covered by one of the melting clocks, has long insect-like lashes, a deformed nose and eye, and what could be a fat snail or tongue, which oozes out from the nose. As in a number of his Dalinian Surrealist works, it is as if the local landscape is his stabilising reality, while his imagination runs riot to succeed in achieving systemised confusion and spilling out elements of his psyche. *The Persistence of Memory* was purchased by an American dealer, Julien Levy.

Another important theme of this exhibition was his then-broken, yet always complex relationship with his father. A number of paintings reveal references about this difficult relationship, but it is definitely *The Old Age of William Tell*[26] which is the strongest statement of the feelings he had about his father, and certainly the most sexually crude. His father is depicted banishing his son and his lover, like Adam and Eve, from his sight.[27] The old man stays on in Paradise, being tended to by two women.[28]

Meanwhile, Gala had been diagnosed with a cyst. She had an operation, which may have been a hysterectomy. By 21 July 1931, she had arrived, with their friend, the writer and poet René Crevel, to Vernet-les-Bains, overlooked by the sacred Catalan mountain, the Canigou, to convalesce. Dalí, who had been delayed in Paris, arrived two days later at the charming spa. Éluard also came to visit them briefly, and on 30 July, Dalí, Gala and Crevel made their way to the couple's home in Port Lligat.[29]

ABOVE *The Old Age of William Tell*, 1931, oil on canvas, 98 × 140 cm, private collection.

OPPOSITE Dalí posing with a sea urchin in the role of William Tell's son. Photograph by Luis Buñuel, December 1929.

OVERLEAF The Dalis' house at Port Lligat, 1960.

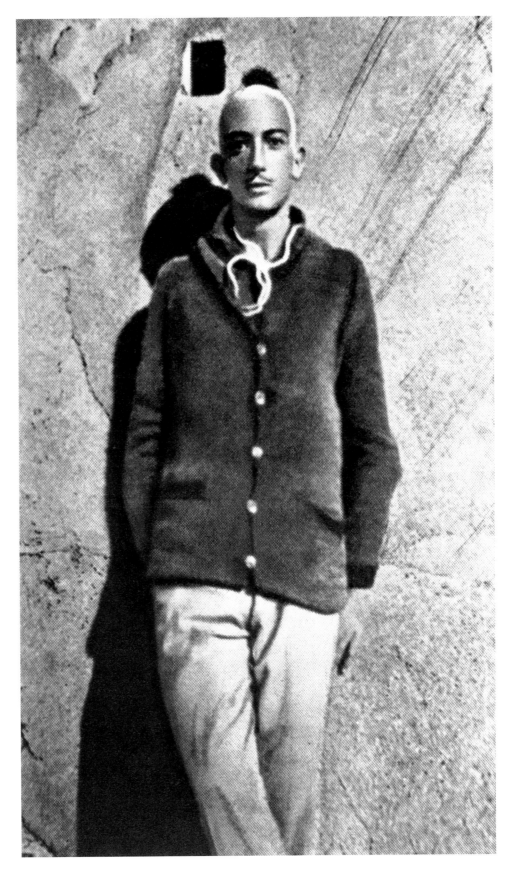

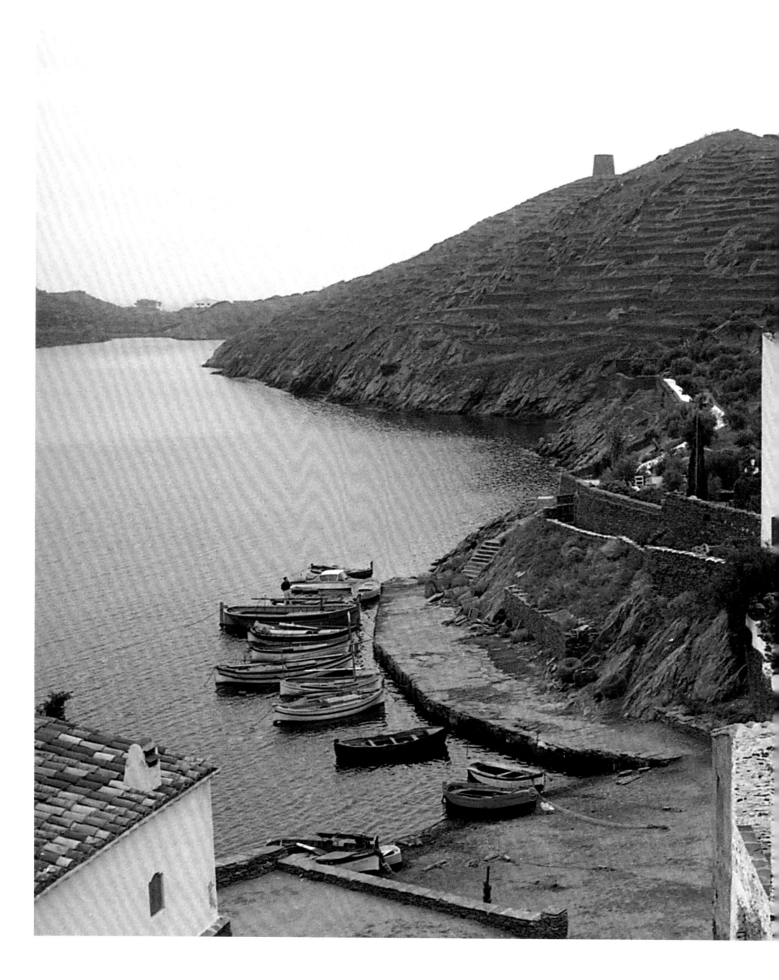

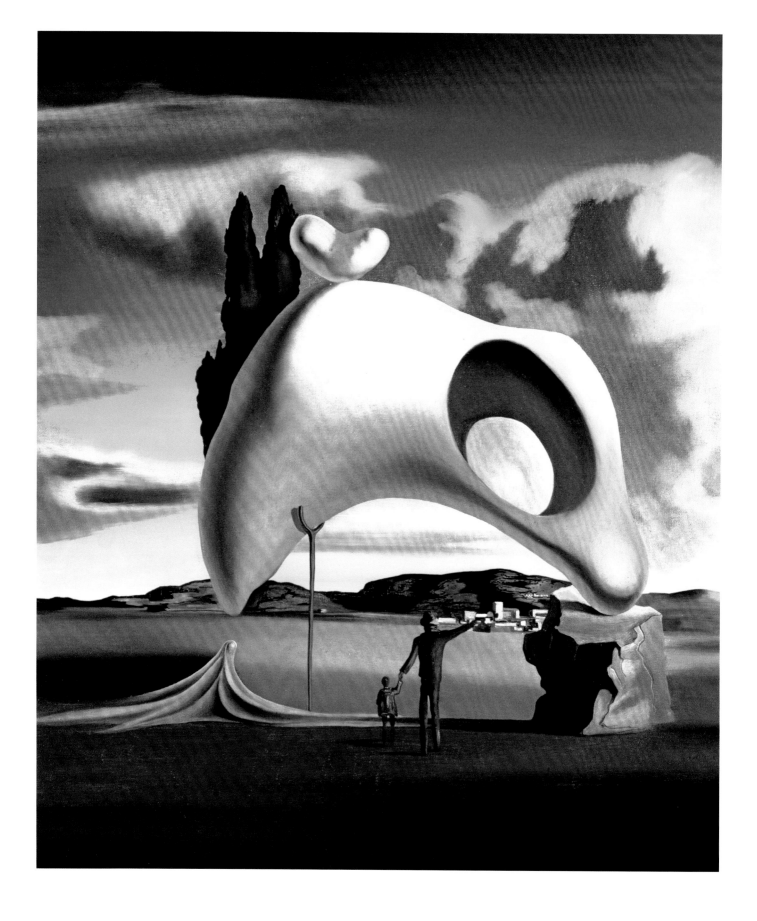

'Dalí was fascinated by the theory of relativity because it offered the idea that reality could not be reduced to a single flow.'
Gavin Parkinson[1]

FASCINATIONS, FANTASIES & FINANCES

Back in the womb of Port Lligat, Gala could continue to recover and Dalí was in the perfect environment to create. Their friend René Crevel was impressed with the beautiful surroundings, although not by the local inhabitants, whom he perceived to be poverty-stricken, backward and illiterate.[2] The French writer, who struggled with his bisexuality, may have found the striking place to be in sharp contrast with its native people, who not only had to survive the Tramuntana wind, but also a challenging economy, up until the days that tourism took over. Crevel would sadly commit suicide in 1935.

In December 1931, Dalí published a book, which he considered a poem: *L'Amour et la Mémoire* (Love and Memory), which was essentially an ode to Gala. However, in order to emphasise how much her entrance into his life had affected him, he contrasted her with his sister, Anna Maria, who had been his muse before Gala's arrival.[3] Also in December, *Rêverie* (Daydream), a provocative piece about a shocking, masturbatory fantasy which goes on for days, was published. Two important places from his childhood are featured: El Molí de la Torre, the mill owned by

the Pitxot family, and the site of family walks, La Font del Soc.

Meanwhile, Julien Levy, who had been living in Paris since 1927, returned to his native New York ready to introduce Surrealism to America. Financed by an inheritance from his mother, he opened his gallery on 602 Madison Avenue in 1931. The gallery was specially designed with curved walls so visitors could view one work at a time. Before the launch of his first Surrealist exhibition, he generously lent the collection to the Wadsworth Atheneum in Hartford, Connecticut, at the end of 1931. Then in January 1932, 'Surrealism: Paintings, Drawings and Photographs' opened at his new gallery. It included landmark multi-media works from a number of artists, including Pablo Picasso, Max Ernst, Joseph Cornell and Marcel Duchamp, while also introducing Salvador Dalí's *The Persistence of Memory* to New York, which he had purchased in Paris at the trade price of $250.[4] A review in *Art News* said, 'A pleasant madness prevails at Julien Levy's new and interesting gallery, with its miscellany of surrealistic paintings, drawings, prints, and what-not. Mr Levy has been

GALA

Gala Dalí in 1930.

at considerable pains to inform us what these ultra-modern men are up to, and he is to be congratulated on the well-rounded line-up of the surrealistic camp.'[5] Levy later wrote in his autobiography about his first meeting with Dalí: 'He was disquieting to me. He has never ceased to be so, not because of his ambiguity but rather by his single-minded intensity and frankness.'[6]

By 1932, Dalí was even busier than before, but burdened by the personal upset of the rift with his father, the unwavering presence of Gala was a vital anchor for him. She divorced Paul Éluard the same year. The renowned Dalí scholar Dawn Ades said that, regardless of their unusual relationship, including the fact that she took young lovers into her eighties, Gala 'put him in order. She was his muse, she was his mistress, she was his amanuensis.'[7]

While working, Dalí was using a brilliant artificial light, with a jeweller's magnifying glass in one of his eyes. Employing only the very finest sable brushes for the majority of each canvas, he was able to achieve a superb level of detail without breaking up the brush marks. During this period, the majority of the paintings he produced were very small. The broken relationship with his father, tangled with his fantasies, continued to be a recurring theme in some of his works at this time. *The Birth of Liquid Desires*, which he had started to paint in 1931, is also related to his writings about fantasy and masturbation in *Rêverie*. The work features William Tell, who for the artist represented the archetypal theme of paternal assault. In the centre is the grotesque dream-image of a hermaphroditic creature, which is a fusion of father, son and possibly mother. The infinite expanse of landscape is reminiscent of Tanguy's 1920s work, and it includes the same rock formation featured in *The Great Masturbator*, drawing on his favourite landscape. William Tell's apple has been replaced by a loaf of bread, one of his cherished symbolic images.[8]

He returned to Paris for his second exhibition at the Pierre Colle Gallery, which took place from 11 May to 17 June 1932, showcasing a total of twenty-seven works, a couple of which were Surrealist objects.[9] Dalí moved easily from the two-dimensional

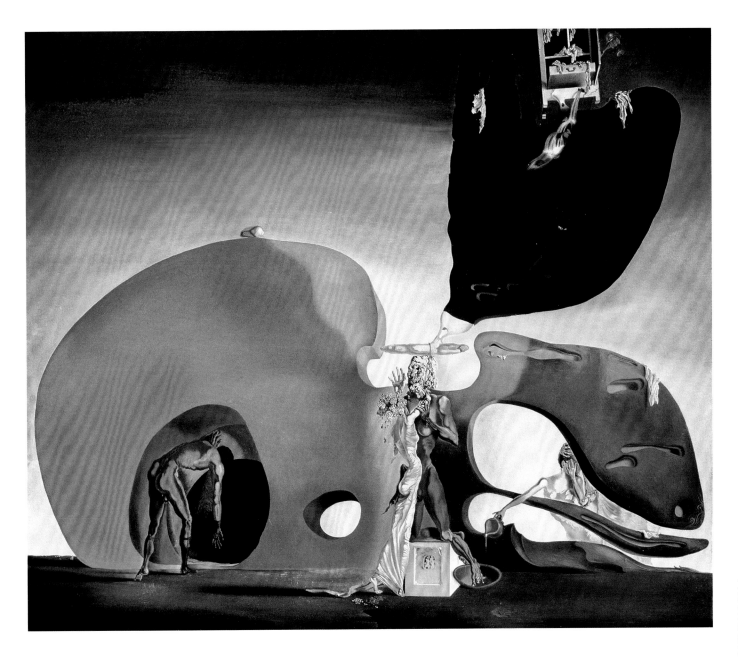

The Birth of Liquid Desires,
1932, oil on canvas,
95 × 112 cm, Peggy
Guggenheim Foundation,
Venice.

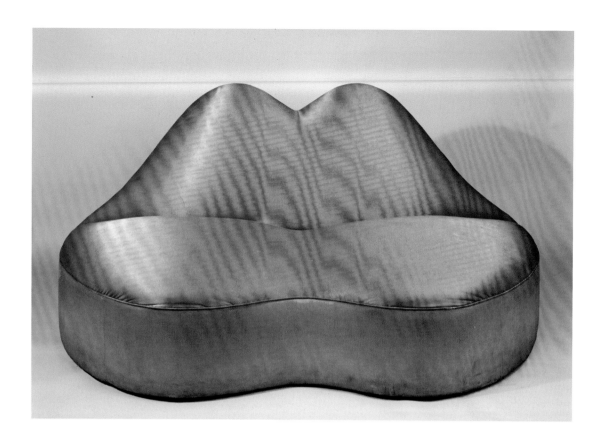

representations in his paintings, into three dimensions. One of the earliest examples of this, commonly known as *Fireworks,* but originally titled *Board of Demented Associations,* was created between 1930 and 1931. The Surrealists considered Marcel Duchamp to be their direct predecessor in this genre. Dalí would meet him during the 1930s, and this odd couple would continue a friendship that spanned over thirty years. In fact from the mid-1950s, Duchamp would rent a house near Port Lligat every summer until his death in 1968.[10] Duchamp, the father of Conceptual Art, had invented his first *objet tout fait* in 1913: a bicycle wheel mounted on a stool.

During the 1930s, Dalí made numerous Surrealist objects, of which the most famous are the *Lobster Telephone* and *Mae West Lips Sofa;* both are classical examples of this genre. Underlying his creation of these objects was the belief that they had the potential to unlock secret desires of the unconscious. This he achieved by juxtaposing objects that are not normally associated with each other in a way that may seem very playful, yet can trigger deep psychological conflicts and reactions from the viewer. Being a Surrealist also led him into the world of modern physics – an influence that we can see in his paintings from the 1930s onwards. 'Dalí was fascinated by the theory of relativity because it offered the idea that reality could not be reduced to a single flow.'[11] Einstein's theory, followed by quantum physics theories, were very stimulating for Dalí and the other Surrealists.

Some time during the summer of 1932, Gala and Salvador were introduced by René Crevel to the rich, creative socialite Caresse Crosby. A publisher and patron of the arts, Caresse was preposterously

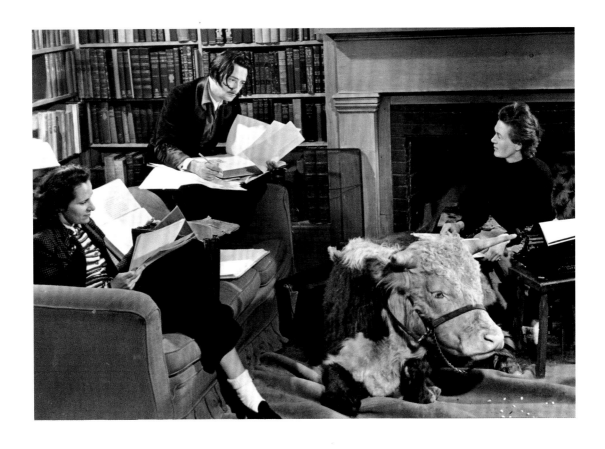

The Dalís with Caresse Crosby and a bull, at Hampton Manor, Virginia, in 1940.

well-connected. She and her second husband, Harry Crosby, had lived a crazy Bohemian existence in Paris, which included an open marriage, until he had an affair that ended in December 1929 with a double suicide with his lover. It wasn't long after meeting Caresse that Dalí and Gala became part of the fascinating collection of socialites, writers, artists and Surrealists who enjoyed wild times at her mill, 35 miles north of Paris. Located in the grounds of the Château d'Ermenonville, in the heart of a stunning forest surrounded by a moat, the reflection of the magnificent Château twinkles in the river Launette's running water. The mill, Le Moulin du Soleil (The Mill of Sun), where the Crosbys had gathered a menagerie of animals, included a ten-bedroom hayloft, a dining room in the stable and a famous stairwell, which did double duty as a guestbook. Watercolour

paints were left for visitors to leave their mark on the curved walls; Dalí intertwined his name with that of a Pulitzer Prize-winning American writer, and D.H. Lawrence drew a phoenix.[12] 'Every weekend we went to the Moulin du Soleil. We ate in the horse stable, filled with tiger skins and stuffed parrots.'[13] Other regulars to Le Moulin du Soleil included Max Ernst, André Breton and Julien Levy, along with many Irish, English and American writers.[14] Caresse became a close friend of the Dalís and a patron of his work, a relationship that continued across the Atlantic, where in 1940 they would stay at her property, Hampton Manor in Virginia.

Even though he was extremely busy and his reputation was growing, money was a serious problem, particularly as his dealer, Colle, was not in a position to renew his contract. Dalí and Gala had

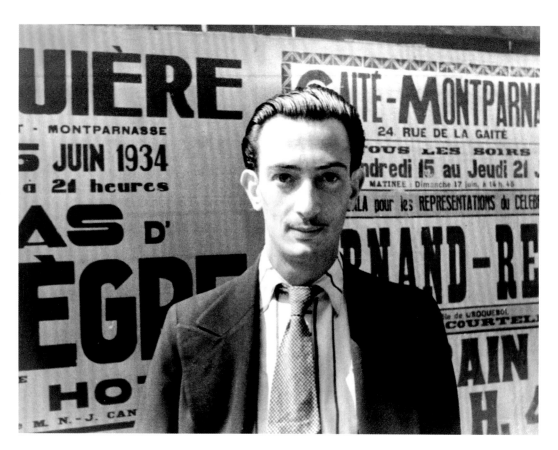

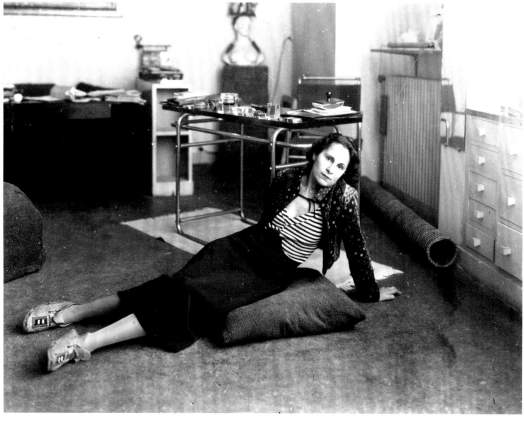

spent a great deal of their savings on the house in Port Lligat. In early July 1932, they had to move from 7 rue Becquerel, where they had been living, into a more modest studio, located in an area which was a colony for writers and painters, called Villa Seurat. The rue Becquerel property had originally been rented by Éluard for Gala. Dalí was clearly not delighted with the new place. 'As soon as we returned from Spain to Paris, we moved from 7 rue Becquerel to 7 rue Gauguet. It was a modern building. I consider that this kind of architecture is auto-punitive architecture, architecture of poor people – and we were poor.'[15] The couple would travel back to Port Lligat when their finances were particularly low, leaving Paris, which he described as 'bubbling like a witch's cauldron'.[16] 'This was the discouraging period of my inventions. More and more the sale of my paintings was coming up against the freemasonry of modern art. I received a letter from the Vicomte de Noailles which made me foresee the worst difficulties. I therefore had to make up my mind to earn money in another way.'[17] Towards the end of 1932, Dalí spoke to De Noailles about the creation of the Zodiac Group. The aim of the group was to patronise his work to enable him to have a regular income, with each member of the syndicate being allowed to choose a certain number of works per year. Later in January 1933, Gala persuaded Prince Jean-Louis de Faucigny-Lucinge, another wealthy patron of the arts, to join, which brought the group to a total of eleven collectors, including the Vicomte de Noailles and Caresse Crosby.

In 1932, Dalí published his book *Babaouo*, in which he outlined his concept of cinema. He also wrote a screenplay with the same name that year, which incorporated both a film script and a ballet.

The film was eventually produced in 1997, while the unproduced ballet featured both characters and scenery from Cap de Creus. The word 'Babaouo' means something along the lines of a simpleton. Unlike other Surrealist films, *Babaouo* has a storyline, with a beginning and an end, but is packed full of irrational, strange events, which sidetrack the plot's linear progression. Dalí indicated in his script that the action 'takes place in 1934 in any country of Europe, during the civil war'.[18] The Spanish Civil War would start in 1936.

In 1933 he produced designs to illustrate a new edition of Isidore Ducasse's *Les Chants de Maldoror*; these etchings are commonly considered to be his best. From 7 to 18 June 1933, a collective Surrealist exhibition took place at the Pierre Colle Gallery, which featured twenty-two artists, including Dalí, Giacometti and Picasso, who was then briefly flirting with the movement. The comprehensive show also focused on the new importance of Surrealist objects, and additionally included poets. Directly following that exhibition, Dalí's solo show ran at the gallery from 19 to 29 June. Later that year he was thrilled to discover that one of the people he most admired, Antoni Gaudí, had visited Cap de Creus as a young boy. This made him feel that Gaudí's architecture had, just like his own art, been inspired by the cape's geological wonders. He planned to write an article around this topic, and on 13 September his friend J.V. Foix announced in *La Publicat* that Man Ray, whom Dalí knew from Paris, was coming to photograph both the Art Nouveau architecture of Barcelona and Cap de Creus for his article.

In the city of New York, which would later become his second home, Dalí's first American solo exhibition was held, at Julien Levy's gallery, from 21 November until 8 December 1933. The reviews and public reaction were positive, and Levy claimed the show was a sell-out.[19] One of the critics, Lewis Mumford, who wrote about the exhibition in his book *Mumford on Modern Art in the 1930s*, observed the influence of Flemish masters, such as Bosch. Mumford noted that 'his pictures have the accurate nastiness of the sort of dream one can neither describe at the breakfast table, nor recall . . . Dalí does not

permit the dream to dissolve; his pictures are, as it were, frozen nightmares. It would be intolerable to look at them if one could not also smile, and if one did not suspect that the madman who painted them is grinning at us, too – a little impudently, like a precocious boy who has mastered a new obscenity.'[20] Dalí was excited about the reaction to the exhibition, and began to think that a visit to America would translate into even more success.

While he had been extremely busy in 1933, the following year was going to be even more hectic. The events of 1934 included his civil marriage to Gala in January and six one-man shows, one of which in New York was dedicated solely to the *Chants de Maldoror* etchings. There was a second exhibition in New York, two in Paris, one in London and another back in Barcelona in October. He sent a letter to his uncle Rafael, who was based there, to help him work towards a reconciliation with his father. Rafael wrote to Dalí's father enclosing the letter Dalí had sent, telling him that he was sure his son was repentant.[21] However, not long after, a political uprising in the Catalan capital forced Dalí and Gala to flee back to France. After they arrived in Paris safely, their driver was tragically killed by a stray bullet en route back to Barcelona. The experience and situation profoundly shook the artist.

The Dalís' overall financial situation and the need for money in order to make the journey to America for the late-1934 exhibition meant that Dalí found himself 'at a moment when I was simultaneously at the height of my reputation and influence and at the low point of my financial resources.'[22] Feeling frustrated from a fruitless day of searching for ways to make money, he came across a legless, blind man on the boulevard Edgar-Quinet. Seated in a cart, this blind man had a perky air about him and when he required help from a passer-by, he took out a small cane and tapped the pavement impertinently. Dalí claimed that he kicked the man's cart, sending him scooting across the boulevard. However, the blind man 'remained stiff

with outraged dignity'.[23] The experience made the artist realise 'how I was going to go about crossing the Atlantic. For three days I ran all over Paris, armed with the symbolic cane of the blind man, which in my hands had become the magic wand of my anger.'[24] He managed to raise the required funds, and a cane became an integral part of his image.

In November 1934, the Dalís boarded the SS *Champlain* at Le Havre to sail to the United States, but even after his triumph of raising the money for the voyage, Dalí was faced with a huge challenge to overcome his travel fears. On board, he wore his lifejacket all the time. 'I went out on the deck of the *Champlain*, and suddenly I beheld New York. It arose before me, verdigris, pink and creamy white. It looked like an immense Gothic Roquefort cheese. I love Roquefort, and I exclaimed, "New York salutes me!"'[25] Before disembarking, on 14 November, Caresse Crosby had asked the steamship's baker to make a loaf of bread for Dalí, two metres long, for dramatic effect, as he walked down the gangplank.[26] He had also prepared a broadsheet, entitled *New York Salutes Me!*, which was distributed both on board and to the press who awaited him in New York.

America was the perfect place for Dalí's exhibitionism, especially during the time of the Great Depression, when those who had money were focused on finding novel ways to spend it to keep their spirits up. During this first stay in New York, he delivered an extremely successful talk at the Museum of Modern Art, and just as he had hoped, it wasn't long before he was being photographed everywhere he went. Before the Dalís left in mid-January 1935 to go back to Europe, Caresse Crosby threw an elaborate costume ball in his honour. It was outrageous enough, and with the right guest list, to attract plenty of press coverage. This resulted in photographs of Dalí with his head bandaged in hospital gauze, wearing a pair of spotlit breasts supported by a brassiere, dancing below a giant cow's carcass. They were able to make a suitably dramatic departure from America.

Gala and Salvador Dalí aboard the SS *Champlain* on their arrival in New York on 14 November 1934.

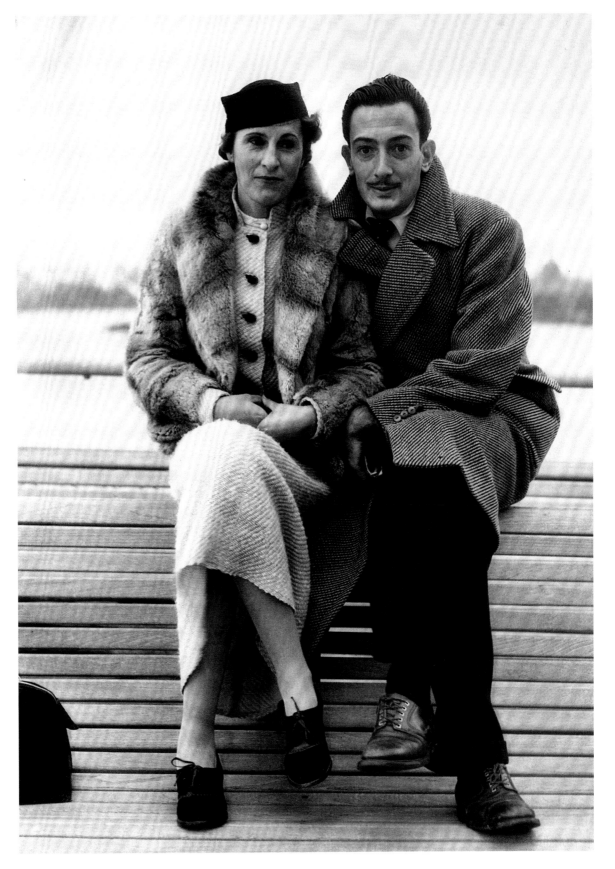

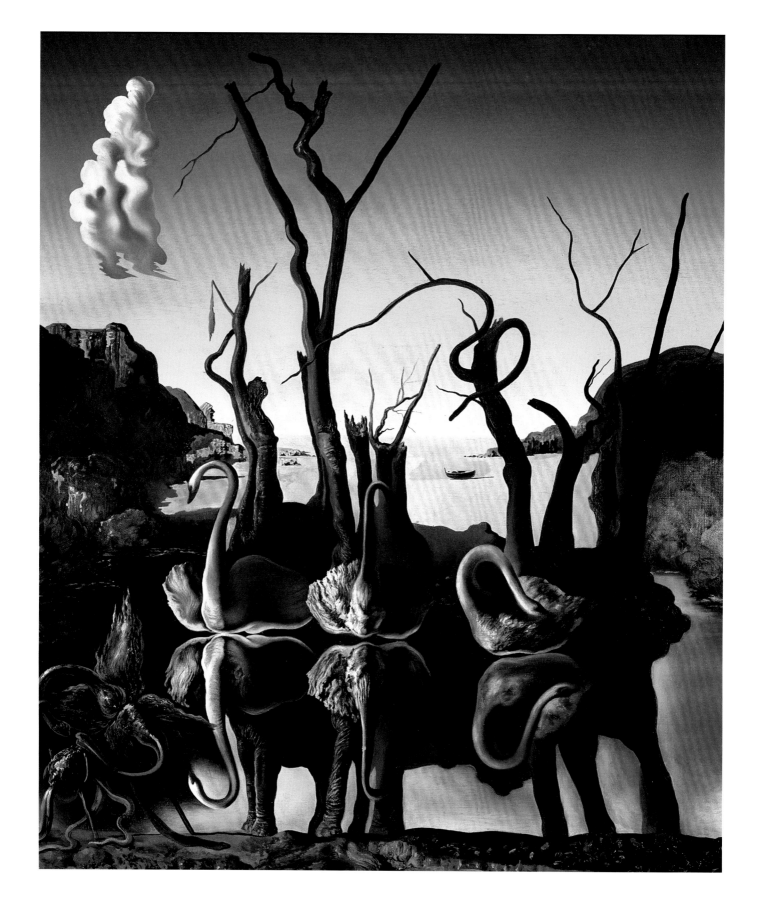

'I am not a Surrealist; I am Surrealism. Surrealism is not a party or a label; it is a state of mind, unique, to each his own, that can be affected by no party line, taboo, or morality. It is the total freedom to be and the right to absolute dreaming.' *Salvador Dalí*[1]

I AM SURREALISM

In March 1935, Dalí finally visited his father to try to reach a reconciliation with him. After a tempestuous meeting, during which the artist was in tears, an agreement of sorts was reached.[2]

In July, Dalí published a nineteen-page essay, *The Conquest of the Irrational*, in which he explained his paranoiac-critical method. 'The important thing is what one wishes to communicate: the concrete irrational subject,' which he does using a 'spontaneous method of irrational knowledge based on the interpretative-critical association of delirious phenomena'. Essential to his paranoiac-critical method is the brain's ability to fabricate links between things that are in reality not connected.[3] The Gestalt Principle of Closure demonstrates that our brains will group individual elements as a whole. Additionally, facial pareidolia is the visual predisposition to find faces in inanimate objects, vague or accidental information. In fact, the human aptitude to discover meaning, allied with this face-detection skill, can result in spectacular cases of pareidolia, when the mind responds to stimuli and searches for familiar patterns. It is actually a sign of a well-wired brain.

Of course, this was something that Dalí had practised from childhood.

The same year he painted *Suburbs of a Paranoiac-Critical Town: Afternoon on the Outskirts of European History*,[4] which he started painting in Palamós. The work features some architectural elements from Palamós, but Carrer del Call, in Cadaqués, is also evoked on the right. Ian Gibson, in *The Shameful Life of Salvador Dalí*, points out that although Dalí's grandfather's suicide had been kept as a family secret, Dalí would have known about it. Gal, his grandfather, had lived at 321 Carrer del Call, before fleeing to Barcelona in his attempt to avoid taking his own life. The painting not only makes it evident that the village of Cadaqués is inherently linked to his paranoiac-critical method, but additionally may hint at the relevance of his grandfather's paranoia, which coupled with serious money issues and a persecution complex, had led to his suicide, even out of Cadaqués. The painting also features a safe and a golden key, in the foreground, about which Gibson hypothesises: 'Might the suggestion not be that Gal is the key, or one of the keys, to the understanding of Dalí's personality?'[5]

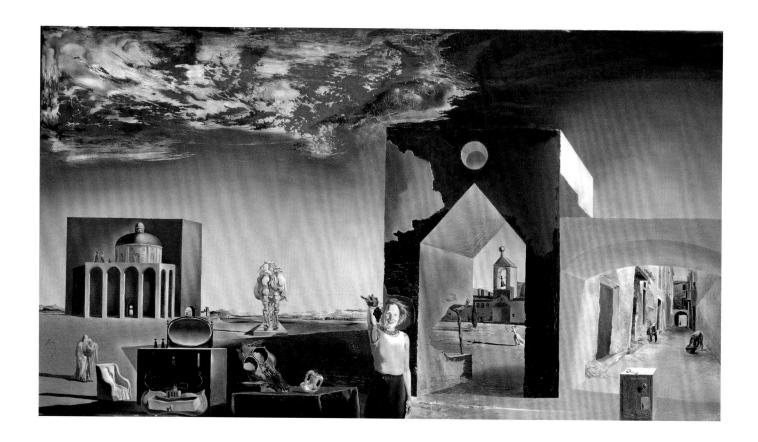

Certainly, some of Dalí's own writings suggest a possible tendency towards paranoia and depression. In *The Secret Life of Salvador Dalí*, he expressed how the six years that he and Gala had spent working furiously creating art and publicity had taken their toll on him. Chronologically this appears to be late 1936, however his autobiography is frequently unreliable in these cases. 'I suddenly felt myself in the grip of a depression which I was unable to define. I wanted to return to Spain as soon as possible!'[6] Alone with Gala: 'At last, I said to Gala, I would

be able to do "important" things.' They arrived in Port Lligat late on a bright December afternoon. 'Never had I understood so well how beautiful the landscape of Port Lligat was! ...The memories of the extravagant and brilliant life I had been leading these last years, in Paris, London and New York, struck me now as remote and without reality.'[7] Port Lligat is undoubtedly a blissful, little piece of heaven on earth.

Yet Dalí felt gripped by a paralysing fear. Success was already his and there was plenty more for the taking, but perhaps the road to arrive there and so

Suburbs of a Paranoiac-Critical Town, Afternoon on the Outskirts of European History, 1935, oil on panel, 46 × 66 cm, Museum Boymans van Beuningen, Rotterdam.

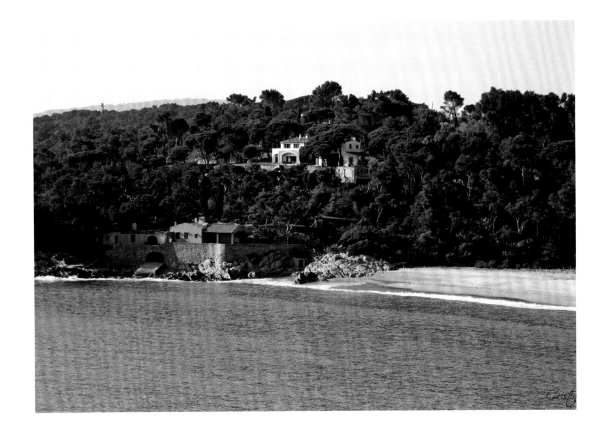

much time spent away from the womb of Port Lligat
may have contributed to this debilitating feeling.
'In the daytime I would run out abjectly and sit
with the fishermen who came to chat in a spot
sheltered by the wind and warmed by the sun, out
of the Tramuntana which did not relax its unleashed
violence. The talk about the troubles and hardships
that were the daily lot of the fishermen succeeded
in distracting me a little from my obsessions.'⁸ One
day, when he woke up from a much-needed siesta,
he felt: 'Like a chrysalis, I had wrapped myself in the

silk shroud of my imagination, and this had to be
pierced and torn to enable the paranoiac butterfly of
my spirit to emerge.'⁹ His deep anxiety had grown
into a morbid fear of death; could this be a similar
sense of panic that had driven his grandfather to
move to Barcelona? However, Gala helped trigger his
metamorphosis. '"You have accomplished nothing
yet! It is not time for you to die!" My Surrealist
glory was worthless. I must incorporate Surrealism in
tradition. My imagination must become classic again
. . . Instead of stagnating in the anecdotic mirage of

my success, I had now to begin to fight for a thing that was "important".[10]

In July 1935, the Dalís met the extremely wealthy poet and British patron of Surrealism, Edward James, at Mas Juny, in Palamós, a little over fifty miles south of Cadaqués, on the Catalan coast.[11] James, who have may have been the son of King Edward VII, according to his own memoirs,[12] would become a close friend, as well as a patron. In fact, the three struck such a special bond that they promised to correspond and meet again soon. It wasn't long

before James, who was always on the move, was back in Catalonia, where he also saw Lorca, at what would be the final meeting between Lorca and Dalí.[13] James invited Lorca, along with the Dalís, to come to Italy that autumn, but Lorca's schedule and father's health made that impossible, although he did struggle with his decision.

The Dalís did travel to Italy with Edward James, who had rented Villa Cimbrone in Ravello, the place which had inspired Wagner's opera *Parsifal*. In the early days of October, the three left Barcelona by

train, travelling to Turin, where they then continued the route by car, passing through Modena and Rome, and onwards to Villa Cimbrone. In his autobiography, Dalí wrote: 'My voyage to Italy was generally interpreted as the symbol of my reputed lightness and frivolity of spirit. Only the few friends who closely followed my work could observe that it was precisely in the course of this voyage to Italy that the hardest and most decisive combats of my soul took place.'[14] This statement is supported by what Edward James told Edith Sitwell after this trip to Italy, whose observation was that Dalí had rid himself of those tiresome and unfortunate obsessions, which had been damaging to his work. James now regarded him as 'the most normal and happy man imaginable, no longer overwrought with nerves.'[15] This change that Edward James felt he had observed in his friend undoubtedly enabled him to fully embrace Dalí as a genius, stepping into the role of patron as well as close friend in 1936. In fact, in March 1936, when Dalí wished to purchase another cottage to extend Port Lligat, James advanced 5,000 francs and encouraged Lord Berners to put up the other 5,000 francs required.

Situated on a rocky outcrop on the Amalfi Coast, embraced by lush nature, Villa Cimbrone is quite possibly the Amalfi Coast's most spectacular sight. The impressive property, which can be traced back to at least the eleventh century, affords the most wonderful views over the Mediterranean. In the early twentieth century, Lord Grimthorpe, a British nobleman, had extensive work carried out on both the villa itself and its gardens. The view from the belvedere of Villa Cimbrone, known as the Terrazza dell'Infinito (Terrace of Infinity) lined with marble busts, was considered by Gore Vidal to be the finest in the world. The beautiful, painstakingly cared for gardens complete the picture of a strikingly elegant, romantic Italian scene. Some postcards from Dalí to his friend, Foix, show his enthusiasm for Italy clearly. 'Italy's turning out to be more Surrealist than even the Pope.'[16] This journey would be the beginning of a long relationship with Italy, although in reality this had started during his youth, when his lifelong study of the Old Masters commenced.

From 22 to 29 May 1936, Dalí participated in the Exposition Surréaliste d'Objets at Galerie Charles Ratton, in Paris. In the summer he had an exhibition at the International Surrealist Exhibition at the New Burlington Galleries, in London, where he also gave a lecture and in typical Dalinian publicity mode, he decided to organise one of his most remarkable, risky stunts. He attempted to deliver the lecture wearing a deep-sea diving outfit, which was hired for him by his equally eccentric friend and patron, Lord Berners. Reportedly when asked how deep he would like to descend by the supplier of the diving gear, Lord Berners reply was, 'His dive was to be into the

depths of the human subconscious – and he hoped to encourage the British public to make the journey with him.'[17] This time his exhibitionism nearly killed him, as he almost suffocated. The audience greatly enjoyed his stunt, believing that it was all part of the performance. The exhibition opened on 11 June 1936, and not only stopped the traffic in Piccadilly because of the crowds, but it also 'stopped the British arts establishment in its tracks, forcing it to reappraise what art actually was as well as what an exhibition could be.'[18] During his time in London, Dalí visited the National Gallery, where he was captivated with Andrea Mantegna's *Agony in the Garden*. We can see this in a later work, *Swans Reflecting Elephants*, in which he depicted the conjunction of unusual rock formations and cityscape.

Among his works for his patron and friend Edward James, undoubtedly one of the most famous pieces is *Lobster Telephone*, which he created in 1936. In this work he brings together two symbolic objects – telephone and lobster – each of which, for him, had underlying sexual connotations. He

The International Surrealist Exhibition in London, in summer 1936. Back row: Diana Brinton-Lee, Salvador Dalí (in diving suit), Rupert Lee; front row: Paul Éluard, Musch Éluard, E.L.T. Mesens.

Lobster Telephone, 1936, steel, plaster, rubber, resin and paper, 17.8 × 33 × 17.8 cm, Tate Modern, London.

used a lobster to cover his female models' sexual organs, yet he had also chosen lobsters as the perfect symbol for danger and castration, linked to Freud's castration theory. The anatomical difference of lobsters to humans, of wearing their skeleton outside, also made him feel that they were excellent Surrealistic symbols. Throughout his career, he frequently drew close analogies between sex and food. Of course, his home-cum-studio is situated in Port Lligat, a short walk from the fishing village of Cadaqués, of which the famous Catalan writer and journalist, Josep Pla, said, 'In Cadaqués there are four delightful dishes: sea urchins in winter, rock mussels in spring; lobster or European lobster in summer.' The lobster's tail is strategically placed directly over the phone's mouthpiece. In his autobiography, he stated, 'I do not understand why, when I ask for a grilled lobster in a restaurant, I am never served a cooked telephone; I do not understand why champagne is always chilled and why on the other hand telephones, which are habitually so frightfully warm and disagreeably

Soft Construction with
Boiled Beans (Premonition
of Civil War), 1936, oil on
canvas, 99.9 × 100 cm,
Philadelphia Museum of Art,
Pennsylvania.

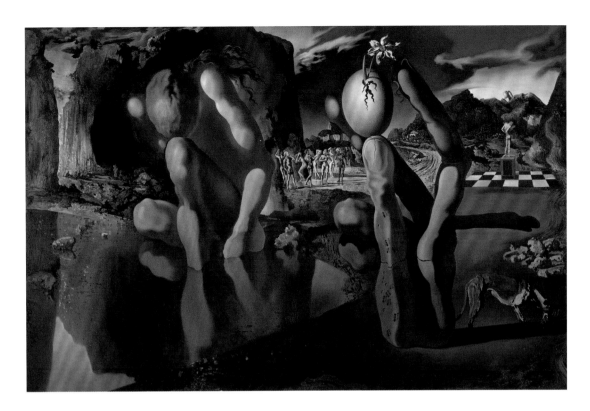

sticky to the touch, are not also put in silver buckets with crushed ice around them.'[19]

In the not-so-Surreal world, on 17 July 1936, just a few days after Dalí had delivered his famous diving-suit lecture in London, the Spanish Civil War broke out. His anticipation of this conflict can be observed in his painting, *Soft Construction with Boiled Beans (Premonition of Civil War)* completed a few months before its outbreak. A little over a month later on 19 August, his very close friend and collaborator, Federico Lorca, was murdered in Granada by a Fascist firing squad. The Dalís had already fled to Paris.

During this same period, he was clearly digesting the Big Apple and America on his trips there. He knew what he wanted and how to get it;

few people have understood as well as Dalí how, when and what to feed the media. The environment, although full of potential commercially, posed such a stark contrast to his beloved Catalonia. 'New York, your cathedrals sit knitting stockings in the shadow of gigantic banks, stockings and mittens for the Negro quintuplets who will be born in Virginia, stockings and mittens for the swallows, drunken and drenched with Coca-Cola . . .'[20] Those were the early days of his relationship with the American media, which would develop into a fruitful collaboration for both parties. As his work became more diverse and prolific, the press began to regard him as the leader of Surrealism, the prophet of the subconscious, the world of dreams and imagination, the creator of the paranoiac-critical method, the man capable of thinking the unthinkable.

In December Dalí made his winter trip to New York, where he took part in a group exhibition at the Museum of Modern Art; 'Fantastic Art, Dada Surrealism', as well as his individual exhibition at Levy's gallery. 'I believe the Dalinian mythology which was already so crystallised upon my return to New York owed a great deal to the violent eccentricity of this lecture in a diving suit, as well as to the distinction of the exhibit of my paintings.'[21] On 14 December, he appeared on the cover of *Time* magazine, which featured Man Ray's photographic portrait of him. 'I was soon to learn the breadth of that publication's influence: I could not cross a street without being recognised and my arm was soon sore from autographing every weird bit of paper shoved under my nose.'[22]

That Christmas he sent the American comedian Harpo Marx a harp with barbed wire strings. The comedian, who obviously enjoyed the gift, sent Dalí a photograph of himself where he appears with bandaged fingers. In early 1937, he visited Hollywood to work on a scenario with the comedian, but it wasn't ever produced. He sent a postcard to André Breton, writing, 'I'm in Hollywood, where I've made contact with the three American surrealists, Harpo Marx, Disney and Cecil B. DeMille.'[23]

He also started collaborating with the renowned couturier Elsa Schiaparelli, designing hats, handbags and dresses, into which he injected his typical creativity, producing handbags shaped as telephones and even a lobster dress.

Later in 1937, when he returned to Paris, he completed the painting *Metamorphosis of Narcissus*, which his close friend, secretary and biographer, Robert Descharnes, noted was a work that meant a great deal to its creator. He felt that it marked the first Surrealist work to offer a consistent interpretation of an irrational subject.[24] His poem of the same name was published by the Éditions Surréalistes, while Julien Levy published it in English. This was the same painting that Dalí brought along to his 1938

meeting in London with Sigmund Freud, who told him, 'It is not the unconscious I see in your pictures, but the conscious.'[25]

In early 1938, he took part in the Exposition Internationale du Surréalisme, which was organised by André Breton and Paul Éluard at the Galerie Beaux-Arts in Paris. His elaborate Surrealist object, the *Rainy Taxi*, was shown in the gallery's entrance. Its roof had been pierced to let rain enter, and inside the car was a mannequin in a dress with a print which portrayed Millet's *The Angelus*, over which around 200 live snails crawled. At this time Dalí's relationship with the Surrealists and the movement's leader, André Breton, was on shaky ground, because of a whole range of his views, one of which was his fascination with Hitler. In 1934, he had almost been expelled from the movement. Many of the Surrealists had serious doubts about his 1938 painting, *The Enigma of Hitler,* though he later stated in *Diary of a Genius* (1964): 'I could not be a Nazi, because if Hitler conquered Europe he would seize the opportunity to do away with all hysterical characters like myself.' The Surrealists asked him to sign a document to prove that he wasn't an enemy of the proletariat, which he did without any qualms. Dalí, who loved the bustle of Paris, a city where fashion and art were inextricably linked, could be found more frequently at glittering parties, rather than spending every evening with the Surrealists at their preferred cafés in Montmartre.[26]

The rocky relations between Dalí and the Surrealists escalated further after the end of the Spanish Civil War on 1 April 1939. In a letter to Buñuel, who had asked him for a loan, he not only refused him but also made clear his admiration for the Spanish Falangist Party. Falangism was Spain's version of Italian Fascism, but at this stage Dalí was looking forward to returning to his homeland, now under Franco's Fascist rule. Both Breton and Buñuel were utterly disgusted with him, which Breton made evident in his June article, *The Latest Tendencies in*

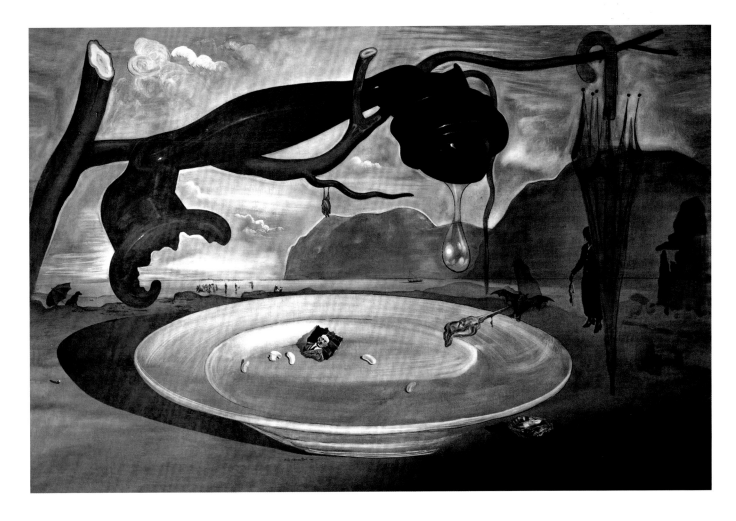

Dalí with Coco Chanel in 1938.

Surrealist Painting, which marked Dalí's expulsion from the Surrealist movement.[27] Soon after this, we see a shift in his work towards Classicism.

Late September 1938 brought a time to pause and paint in a beautiful property, La Pausa, so named because of the legend that Mary Magdalene rested under the olives trees there, after she had fled from Jerusalem after Christ's Crucifixion. La Pausa, perched on the cliffs of the exclusive French Riviera La Toracca neighbourhood, was owned and co-designed by Coco Chanel, who definitely put her own incredibly elegant stamp on the property. This stunning, secluded haven was undoubtedly perfect to inspire creativity, with its panoramic views of Monaco Bay, Saint-Jean-Cap-Ferra and Cap d'Ail. La Pausa's architecture draws its inspiration from Coco's childhood years in a French twelfth-century convent-orphanage, with its austere stone staircase curving up from the main entrance, the arches framing the windows and doors, and the courtyard enclosed with pillared cloisters. The bathrooms have separate servants' entrances, so that guests can have a bath drawn for them and their clothes removed for cleaning, without being disturbed. The garden is beautifully simple, with 350 olive trees, some of them centuries old, interspersed with lavender and rosemary. Dalí produced a number of paintings at La Pausa, in Roquebrune on the Cote d'Azur, one of which was *Endless Enigma*. In this work, Dalí presents the viewer with six strata of perception, where new scenarios appear depending on your own angle and frame of mind, yet each seems to suggest imminent metamorphosis. Apart from the environment where *Endless Enigma* was created, the Second World War was soon to break out and once again Dalí would go through his own metamorphosis.[28]

Another journey he made that year, was to Italy, where he spent time in Lord Berners' beautiful house in Rome, located close to the Forum. There he painted *Impressions of Africa*, which was the consequence of a brief excursion to Sicily, 'where I found mingled reminiscences of Catalonia and of Africa'.[29] Dalí had never actually been to Africa, but he felt he knew it.

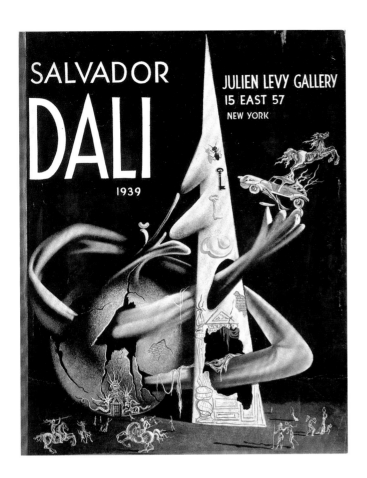

The catalogue for Dalí's solo
exhibition at the Julien Levy
Gallery, New York, 1939.

In 1939, Dalí was back in New York, where he decorated the Bonwit-Teller department store windows, but management rearranged his design before its unveiling. An enraged Dalí threw a bathtub through one of the windows, which resulted in his arrest, but he was released soon after. He had a successful solo exhibition at the Julien Levy Gallery and was commissioned to design the *Dream of Venus Pavilion* for the New York World Fair in June. This pavilion featured a remarkable façade, elaborated with numerous protuberances, which was a little reminiscent of Antoni Gaudí's Pedrera building. Hedgehogs, cacti and crutches embellished the outer part of the building. Visitors entered through a spread-leg archway, which contained features such as a new version of his famous *Rainy Taxi* and a ceiling of inverted umbrellas.

Inside, visitors could enjoy aquatic dance shows in two large swimming pools, with sirens designed by Dalí. Reproductions of *The Birth of Venus* by Sandro Botticelli and *Saint John the Baptist* by Leonardo da Vinci could be seen through the façades' openings. However, yet again there were conflicts between Dalí's initial ideas and the end result, and again he was furious. In retaliation, he published his 'Declaration of the Independence of the Imagination and the Rights of Man to His Own Madness'.

A more satisfactory creative output that year was his set and costume designs for the ballet *Bacchanale*. In the programme he wrote, 'The setting represents Mount Venus (the Venusberg near Eisenach), the background showing Salvador Dalí's birthplace, the Ampurdan plain, in the centre of which rises the temple as seen in *The Marriage of the Virgin* by Raphael.'[30] The dance critic Jack Anderson, who considered the ballet to be that season's scandal, wrote, 'Dalí's decor was dominated by a huge swan with a hole in its breast through which dancers emerge, some in remarkable costumes.'[31] The landscape that he had once again used in his art, and that he so deeply desired to return to, would yet again be taken out of his reach the following year.

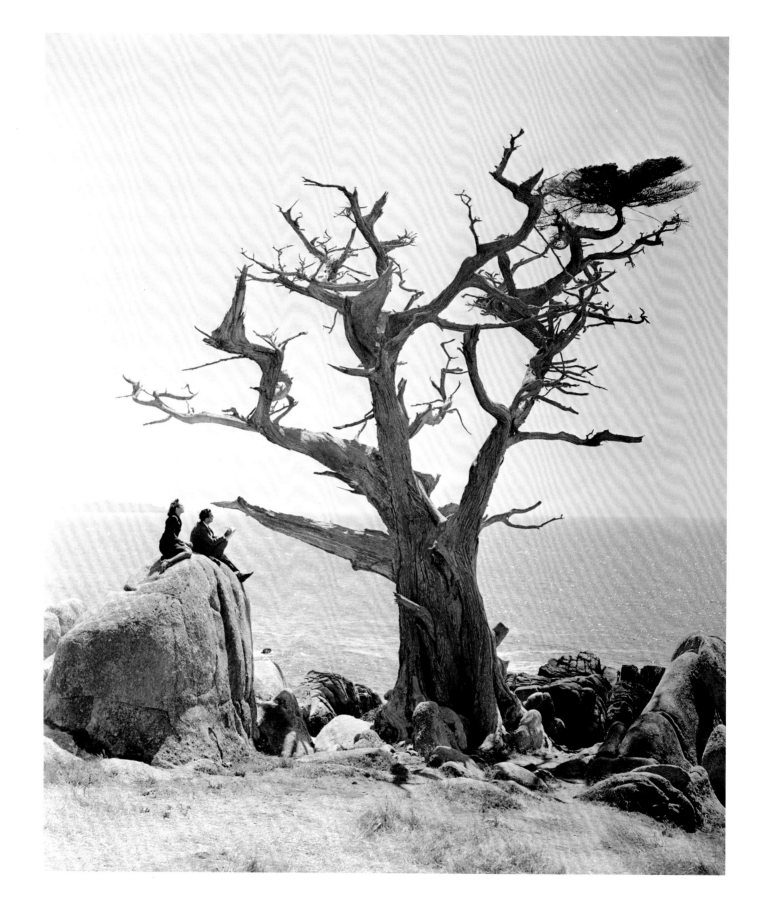

> 'I am home only here[*]; elsewhere I am camping out.'
> *Salvador Dalí*[1]

CAMPING OUT
IN AMERICA

*Port Lligat/Cadaqués

Dalí with Gala, sketching one of the famous cypress trees at Monterey, California.

When German troops entered Bordeaux at the end of June 1940, the Dalís travelled via Lisbon to their new life of exile in the United States, where they would stay until 1948. The Second World War saw many other creatives fleeing across the Atlantic to America. Later in 1940, he wrote in *Times-Dispatch*, 'I try to create fantastic things, magical things, dreamlike things. The world needs more fantasy. Our civilisation is too mechanical. We can make the fantastic real, and then it is more real than that which actually exists.'[2]

On 16 August 1940, when Dalí disembarked from the *Excambion* in a smart, pinstripe suit, he announced to the press that the Surrealist movement was now dead. For ten days, the Dalís stayed at the St Regis Hotel and then travelled south to Virginia to stay at Hampton Manor, owned by Caresse Crosby. Searching for an old plantation house, smothered in roses, she had accidentally discovered Hampton Manor when her car broke down. It was then a dilapidated Greek Revival brick mansion on a Hereford cattle farm, which had originally been built in 1838, based on Thomas Jefferson's plans, by his friend John Hampton DeJarnette. The old plantation house sat on an expansive 486 acres of fields and woodland, set in a landscape which Dalí compared to Touraine. In a letter to Anna Maria, he wrote, 'We've been installed for a few weeks now in this tranquil spot in the middle of an ancient forest.'[3] He threw himself into his work, and as well as writing his autobiography prolifically, he produced four or five paintings.

While still in full flow working on his autobiography, he exhibited from 22 April until 23 May 1941 at Julien Levy's gallery. However, on this occasion, business was non-existent and the reviews were not that positive, with a number of critics questioning Dalí's announced conversion to Classicism and its sincerity. In retrospect, it seems that both then and for numerous decades afterwards, the judgement of many experts may have been clouded by the artist's immense desire for money and his rather outrageous public persona. In 2005, Charles Stuckey, a champion of Dalí's later work, observed, 'What we need to do with the late work is to look at the art. The late work is so different from what most artists were doing at the time . . . Nobody else in the world could have done what Dalí was doing when

he was doing it.'[4] However, Levy had to deal with the reality of the day, so he took the Dalí show on the road, beginning in Chicago and then travelling on to San Francisco and Los Angeles.

It may have been Julien Levy who suggested that the artist spend that summer in Monterey, at the Hotel del Monte, one of North America's finest luxury hotels of that period. This unique, beautiful, immense hotel for the rich and famous, on the west coast, was the perfect choice for the Dalís. They stayed there in the summers of 1941 and 1942, moving to the then Cottage Row at the Del Monte Lodge, after the navy took over the hotel in 1943, continuing to live there part-time until their return to Catalonia in 1948. This coastal area of America was the most reminiscent of the artist's favourite landscape in his homeland of Catalonia, with its rocky coastline overlooking the Pacific Ocean.

Del Monte was constructed on spacious grounds in a blend of nineteenth-century Swiss Gothic and twentieth-century Spanish Revival styles. The neighbouring landscape on the famous 17-mile drive from the Del Monte is punctuated with mystical forests, snow-white beaches and dramatic coastal cliffs. While it is certainly not a photocopy of Port Lligat and Cadaqués, it was the best substitute that Dalí found during his exile in America. There he finished his autobiography in 1941, and worked his customary long hours in his studio painting. He also became a member of the Carmel Art Association and generously gave his time helping to jury competitive high school art exhibitions. During the summer of 1941, he designed costumes and sets for his ballet production, *Labyrinth*, which was to open in New York in autumn. On 2 September 1941, the couple organised a costume ball, which was a benefit for European artists in exile. The costume ball, 'A Surrealist's Night in an Enchanted Forest' was attended by over a thousand people, including a number of important celebrities such as Ginger Rogers, Bob Hope and Gloria Vanderbilt. The guests dined and danced surrounded by a selection of animals, which were on loan from the local zoo, mannequin dolls and around 2,000 pine trees. The hosts placed themselves strategically at the head of

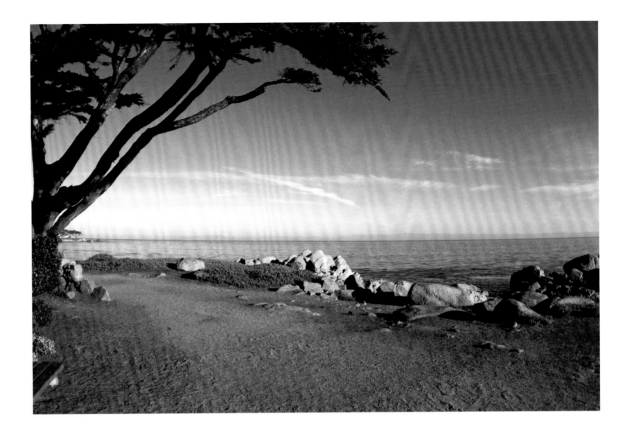

Lovers Point, Monterey,
California.

the table, in Hollywood's largest bed. Although the event was a financial failure, it was a great success in terms of publicity.

Dalí's interest in jewellery design began at this time, and he created some works with Duke Fulco di Verdura, the revolutionary jeweller from Palermo. Dalí's enthusiasm for jewellery would continue for the rest of his artistic career. In 1959 he would explain that, 'My jewels are a protest against the emphasis upon the cost of the materials of jewellery. My object is to show the jeweller's art in true perspective – where the design and craftsmanship are to be valued above the material worth of the gems, as in Renaissance times.'[5] The same year his professional relationship began with the photographer Philippe Halsman – a collaboration that would continue until Halsman died in 1979.

His ballet, *Labyrinth*, opened at the Metropolitan Opera House, performed by the Ballet Russes de Monte Carlo. However, Dalí didn't like it much himself; nor, it seemed, did the critics. It did serve for publicity purposes for the joint retrospective exhibition with Miró at the Museum of Modern Art in New York, which was inaugurated on 18 November, and ran from 19 November 1941 until 11 January 1942. The show was a huge success and Dalí was the undisputed star of it. From

New York, the exhibition toured to eight other cities. In the Cleveland Museum of Art, in March 1942, it was attended by businessman Reynolds Morse and his fiancée, who would later become the greatest collectors of Dalí in America, after purchasing their first work in April 1943.

A woman who fascinated Dalí during this period was Helena Rubenstein. He had painted her portrait, after which she commissioned three frescoes for her apartment in Manhattan that were featured in *Vogue* magazine. Portraits were becoming big business for Dalí at this time. In May, *El Café de Chinitas*, the new ballet that he had designed, which was based on a true story adapted by Federico García Lorca, was performed at New York's Metropolitan Opera House and in Detroit.

While he may have only been camping out in America, he was certainly taking advantage of his situation, by making a lot of money; it seems that the American vitality suited him.[6] In September 1941, he launched a promotional campaign prior to the release of his autobiography. *The Secret Life of Salvador Dalí*, published in 1942, sold out quickly and received multiple mixed reviews, which considering how the book weaves together fact and imagination, was to be expected. It is a superb piece of writing, infused with an abundance of his special, outboard-motor imagination. The great Catalan writer Josep Pla wrote that 'the tenor of the writing was authentically Empordanese in its irony and in its mixture of mental freedom and "biological timidity".'[7]

The reaction to his autobiography encouraged him to start writing his next book – a novel called *Hidden Faces*. No doubt he had appreciated the environment of Hampton Manor as being conducive to writing, so this time he stayed at the Marquis de Cueva's estate, nestled near the White Mountains, in Franconia, New Hampshire. Dalí wrote in the foreword that 'I have wished to react against this by writing a long and boring "true novel" . . . to approach the new times of intellectual responsibility which we will enter upon with the end of this war.' Although more recently it has been asserted that the book 'constitutes a dramatic vehicle for Dali's unique vision',[8] in April 1944 when *Hidden Faces* made its

OPPOSITE Bandaging a
dancer for 'A Surrealist's
Night in an Enchanted Forest'
costume ball at the Hotel del
Monte, 2 September 1941.

ABOVE Dalí on the set of
Alfred Hitchcock's *Spellbound*,
1945.

appearance it was generally not so positively reviewed. The prolific writer and reviewer Mark Schorer penned his review for the *New York Times* with the title 'It's Boring, but Is It Art?' and ended his first paragraph, 'His sofa in the shape of lips showed more "intellectual responsibility" than this.'[9]

During 1944, the ballet *Sentimental Colloquy,* for which Dalí designed the sets, and *Mad Tristan,* which he wrote, were staged in New York. He also wrote some articles for *Life,* designed a cover for *Vogue* and produced some advertisements for Bryans Hosiery nylon stockings. Perhaps a little more exciting than the advertisements was his trip to Hollywood in September 1945 to work with Hitchcock, on dream sequences for the film *Spellbound.* One scenario planned by Dalí worked out too expensive to execute, so miniature props were supplied instead.

In total, he had crafted more than twenty minutes of footage. In the final cut, around four and a half minutes of this is featured, with its phantasmagoric landscapes, slashed eyeballs and naked women.[10] In 1937, the artist had described Hollywood as 'an ideal incubator of Surrealism whether Hollywood knew it or not' in *Harper's Bazaar*.[11]

From 20 November until 29 December 1945, his first show for a number of seasons, 'Recent Paintings by Salvador Dalí', ran at the Bignou Gallery in New York. 'I feel myself to be more capricious than ever!' he wrote in the foreword of the exhibition catalogue. The art critic Edward Alden Jewell interviewed Dalí at the opening, and described him as 'the high priest of Surrealism or of something or other', discussing some of the eleven new works, which had been produced 'during nine months of strict seclusion'. His review stated that 'Among the paintings certain to attract particular notice are two for which Dalí's wife, Gala, posed. The more elaborate of these is titled: *My Wife, Nude, Contemplating her own Flesh Becoming Stairs, Three Vertebrae of a Column, Sky and Architecture*.'[12] In a review in the *New York Times*, Jewell stated, 'Yes, Dalí has at length humanised the Unconscious, and the Unconscious, in gratitude, (it could not be in spite), has made Dalí's art seem as comfortable as a pair of scuffed old-fashioned slippers . . . He has put Surrealism in curl papers for the night and given it a glass of milk.'[13] Jewell felt that even though Dalí had publicly declared his move to Classicism, this did not mean that he had, in any way, abandoned the subconscious.

He released the first issue of the hilarious, self-promotional spoof *Dalí News* to coincide with the show, and unsurprisingly it was packed with features, advertisements and short articles, all about him. Also just before the exhibition had opened, Walt Disney had been in contact with him to collaborate on *Destino*, an animated short film, which would be part of a package series. For eight months from late 1945 into 1946, Dalí worked with Disney studio artist John Hench to storyboard the film. However later Disney decided that the package approach would not be successful; *Destino* was eventually produced in 2003.

His next phase, which would be named Nuclear Mysticism, was triggered predominantly by the dropping of the atomic bomb. A few years after, communicating with the writer, André Parinaud, Dalí said,

> The atomic explosion of 6 August 1945 seismically struck me. Since that time, the atom has become my favourite subject of reflection. Many of the landscapes painted over this period express the great fear I felt at the news of that explosion. I was applying my paranoiac-critical method to the exploration of that world. I want to see and understand the power and hidden laws of things so as to gain control over them. In order to penetrate into the marrow of reality I have the genial intuition of having an extraordinary weapon available to me – mysticism, the deep intuition of what is, an immediate communion with the whole, absolute vision through the grace of truth, by divine grace.[14]

Dalí's second exhibition at the Bignou Gallery ran from 25 November 1947 to 5 January 1948. One of the works exhibited was a study for the painting *Leda Atomica*. Dalí had collaborated on this with the mathematician Matila Ghyka. The second and last issue of the *Dalí News* was distributed at the opening. Early in 1948, his book *50 Secrets of Magic Craftsmanship* was published, in which he pays tribute to the Old Masters' craftsmanship, interspersed with his interesting advice for would-be artists, some of which is clearly inspired by the landscape of his native Catalonia, where he would soon return.

> 'Mistakes are almost always of a sacred nature. Never try to correct them. On the contrary: rationalise them, understand them thoroughly. After that, it will be possible for you to sublimate them.' *Salvador Dalí*[1]

RELIGIOUS & POLITICAL METAMORPHOSES

Early in July 1948, the Dalís made their way back to their beloved Catalonia, setting foot on European soil once again in Le Havre, France, on 21 July.[2] They were returning to a place that had changed significantly during their years of exile. Since 1939, Spain had been ruled by the dictator Franco, who had created 'a regime of state terror and national brainwashing through the controlled media and the state education system'.[3] Additionally, Franco's Fascist government had aligned itself with the Catholic Church, and under the guise of religion connected nationalism and religion to promote its Fascist agenda.[4] Dalí had started to shift his attitudes about Catholicism while still in America. Having grown up with a mother who was a devout Catholic, and a father who was a staunch atheist, his introduction to religion was contradictory and divided. He blamed Catholicism for his deep sense of guilt about sex, although the books on venereal disease that his father left around for him to see would also have played a part in this. From the 1940s onwards, he began to explore his religious roots and studied Spanish medieval mystics for whom art, religion and science were all one. Returning to his homeland, now under the rule of Franco, at least pragmatically, he knew he had to be seen to embrace Catholicism, as well as the politics of the day.[5] It poses a challenge, however, to separate the artist's practical behaviour from what he was already experiencing and experimenting with, since the atomic bomb had been dropped.

Not long after the Dalí couple were back in Port Lligat, a journalist writing for the Catalan publication *Destino*, Ignacio Agustí, came to interview him. Agustí, who spent three days in Cadaqués, saw Dalí in the bosom of his family, but especially observed how delighted the artist was to be back in the landscape that he loved most in the whole world.[6] In those early months after his return to Catalonia, the relationship with his father was good; in fact, Dalí senior even enjoyed trips to the countryside with Gala, in the couple's Cadillac. His sister, Anna Maria, who was writing her memoirs, found it a challenge to have Gala in the house, but she managed not to let this show outwardly. Perhaps it helped her to know what she planned to publish in the not too distant future.

At this time, Dalí was keenly focused on convincing the authorities of his allegiance to both General Franco and the Catholic Church. He painted his first religious painting, *The Madonna of Port Lligat*, in 1949, having conceived the work while still in America. He created two versions of this painting: one in 1949 and the other in 1950. They are nuclear visions for a post-war world, incorporating the Renaissance iconography of Piero della Francesca. It is clear that the artist has used his wife's face in his representation of the Mother of God, which could easily be perceived to be a cynical choice, although he did, of course, regard Gala as divine. Madonna and infant sit in the coastal landscape of Port Lligat, while some chunks of masonry fly in the skyline, and traditional symbolism is portrayed by items such as the loaves and the fish. The rectangular holes cut into their torsos may suggest their transcendental status. The 1950 painting is more complex than the 1949 work, with a greater use of symbols, but the light is foreboding when compared to its predecessor.

During the summer of 1949, he was also working on costumes and sets for three stage productions, all of which were due to open in November. One of these was Shakespeare's *As You Like It* in Rome. The couple decided to travel to Rome, not only for the premiere on 26 November but to attend a private audience with Pope Pius XII, who Dalí hoped would put his Papal seal of approval on *The Madonna of Port Lligat*. He brought along a small version of the painting to show to His Holiness, who may have been puzzled by some of its Surrealist details, but he approved it nonetheless. He couldn't, however, help on the issue of a Church marriage for Gala and Salvador, as she had previously been married to Paul Éluard, in a Roman Catholic ceremony. The following year, Dalí announced himself a Catholic, although he did describe himself as a 'Catholic without faith.'

From 1949 onwards, Dalí spent autumns and winters in New York, where he always stayed at the St Regis Hotel. Salvador not only arrived with Gala in tow, although she didn't go each season, but 'also a bizarre retinue of associates and animals,

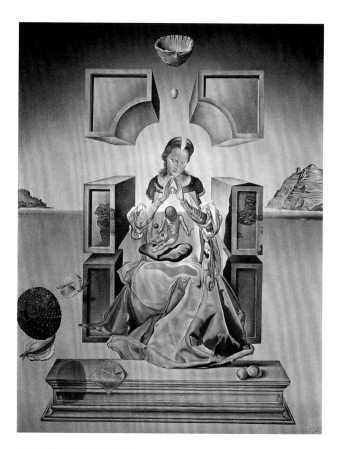

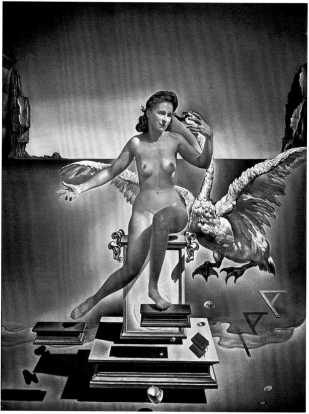

including his pet ocelot named Babou. Here he would happily swish around in his golden cape of dead bees or "accidentally" let loose a large box of flies'.[7] Andy Warhol was a regular visitor: 'Every Sunday afternoon they have people in for tea – champagne tea. Then Dalí takes everyone to dinner at Trader Vic's. He's very generous. There are never less than twenty people – all the starving young beauties and transvestites in town. I'm never sure whether Dalí copied transvestites from me or I copied transvestites from Dalí.'[8] In his memoirs, Dalí's friend, model and muse Carlos Lozano would later say, 'I only saw the ocelot smile once, the day it escaped and sent the guests at the Meurice scurrying like rats for cover.'[9] Separate from Suite 1610, where Dalí lived when at the St Regis, was his studio, another suite. His muse, student and assistant, the American-French artist and author Ultra Violet, recalls a scene from his studio, in her 1988 memoir: 'An immensely tall nude female model is reclining on a couch draped with burgundy velvet, the fabric shimmers under a lamp shaded by an antique shawl. A large lobster shell, dipped in a bath of gold, rests on the arm of the couch ready to be incorporated into the portrait of *Venus Awaiting a Phone Call*, the about-to-be painted masterpiece.'[10] In the 'Dalí Years' chapter, she describes an erotic scenario that plays out between her and the artist in the St Regis studio. She attempts to lure him on further, but Dalí signals not yet to her. The scene is brought to its conclusion when the scenario's main prop, a golden lobster telephone, is thrown across the room by him, sailing right out the open window. Ultra Violet concludes: 'The good thing about it is that it is safe – there is no way I can get pregnant.'[11]

A painting Dalí started while in America once again features aspects of his native landscape. Exploring the myth of Leda, *Leda Atomica* was completed in 1949 and inspired by Gala. 'I started to paint the Leda Atòmica to exalt Gala, the goddess of my metaphysics, and I succeeded in creating the "suspended space".'[12] In order to achieve divine proportion, Dalí followed the rules of the mathematician Matila Ghyka to calculate the harmony of the references. This work is ethereal, with no contact between the various elements; in

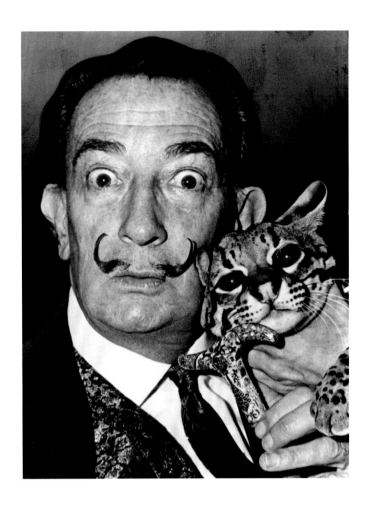

OPPOSITE ABOVE *The Madonna of Port Lligat*, 1949, oil on canvas, 144 × 96 cm, Marquette University Fine Art Committee, Milwaukee, Wisconsin.

OPPOSITE BELOW *Leda Atomica*, 1949, oil on canvas, 61.1 × 45.3 cm, Dalí Theatre-Museum, Figueres.

ABOVE Dalí with his pet ocelot, Babou, in 1965.

fact, the sea does not even touch the land. With Gala as his model, he depicted Leda sitting on a pedestal face-on, caressing a swan with her left hand, which is approaching her, perhaps to kiss her. The background features the rocks of Cape Norfeu, which lie between Cadaqués and Roses. There are a variety of objects around Leda, which include an egg, book and a set-square.[13]

In December 1949, his sister Anna Maria released her memoirs, *Salvador Dalí as Seen by his Sister*, which delighted their father, who wrote a short introduction for the book. Her famous brother, on the other hand, was absolutely livid about what he perceived as the hypocrisy of the work. The book's theme was focused on how Surrealism and especially Gala – although Anna Maria never named her outright – had ruined her brother and the entire family.[14] Dalí vowed to inform people of the true family story, so he printed up cards which explained how he was expelled from the family in 1930, without a cent, and when they accepted a reconciliation, he was already famous. These cards, which were widely distributed in January 1950, additionally served the purpose of warning biographers and collectors about the situation. He also wrote to his father, but sent the letter via a friend so that his sister would not intercept it. Whatever the letter said, Dalí senior changed his will on 30 January, making Anna Maria the main beneficiary, leaving a mere 60,000 pesetas to Salvador, the equivalent of around £6,000 today.[15]

That summer, when working on the illustrations for Dante's *Divine Comedy*, which had been commissioned by the Italian government, and on the larger version of *The Madonna of Port Lligat*,

he heard that his father was seriously ill. He rushed over to Cadaqués to see him. Emilio Puignan, who had accompanied him, heard his father say, 'I think it's the end son.'[16] Señor Dalí passed away on 22 September 1950. His son went to visit and kiss his father's corpse, but didn't attend the funeral or burial. Anna Maria was too distraught to go, so Montserrat Dalí, their cousin, represented the family, but was blown down onto the ground twice by the ferocious Tramuntana wind.

In 1950, he wrote and illustrated the Dalí two-week itinerary in Spain; his own personal travel recommendations, complete with illustrations, for *Vogue*. In October, at the Ateneu Barcelonès, in Barcelona, he gave a talk on 'Why I Was Sacrilegious, Why I Am Mystical'. The lecture aimed to explain his metamorphosis from an extreme anti-cleric to a devoted Catholic. He tried to convince his audience that he was a true religious mystic, who perceived and understood the Catholic religion through the lens of the latest scientific discoveries.[17] This talk marks another shift in his work, as he begins to handle religious themes from the perspective of the scientific advances of that era. He felt part of the mystic tradition made up of St John of the Cross, Francisco de Zurbarán and some others, while also believing that he was starting a rebirth of European religious painting.

In April 1951, his *Mystical Manifesto* was published, based on the talk he had given in Barcelona. It fuses the latest advances of science with metaphysical spirituality, recommending the use of mystical reverie for an artist to attain mysticism. 'Mysticism is the paroxysm of joy in the ultra-individualist affirmation of all man's heterogeneous

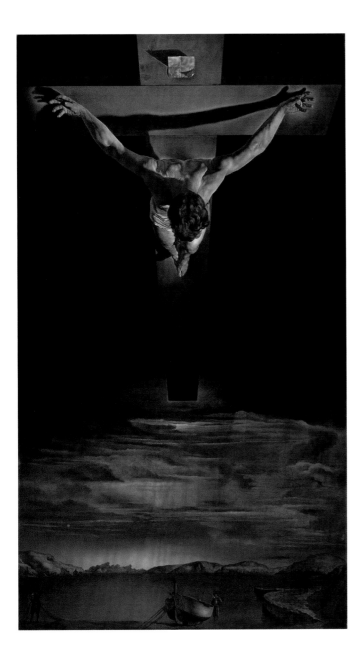

Christ of St John of the
Cross, 1951, oil on canvas,
204.8 × 115.9 cm,
Kelvingrove Art Gallery and
Museum, Scotland.

tendencies within the absolute unity of ecstasy.'[18] One of his most important paintings of this period is *Christ of St John of the Cross*, which was reviewed by the art critic Jonathan Jones in the *Guardian*: 'It is, for better or worse, probably the most enduring vision of the crucifixion painted in the twentieth century.'[19] The male on the cross appears to be trying to defy gravity, as he floats above Port Lligat harbour. 'Dalí sets it above Port Lligat where he made his home. In the end, a loyalty to his Catalan landscape was Dalí's only virtue.'[20] This painting and *The Madonna of Port Lligat* were shown in London, in December, in the Alex Reid and Lefevre gallery.

In September, the Dalís attended a fancy dress ball in Venice, thrown by the eccentric art collector and multi-millionaire Carlos de Bestegui. Their costumes had been designed by Christian Dior with Gala's help, and they dressed up as seven-metre-high giants. Although this garnered good publicity, Dalí's *piéce-de-resistance* of that season in terms of self-promotion was his lecture in Madrid, in the María Guerrero theatre, entitled 'Picasso and I'. Some parts of this speech became famous overnight, such as, 'Picasso is Spanish; so am I. Picasso is a genius; so am I. Picasso is about 74; I'm about 48. Picasso is known in every country in the world; so am I. Picasso is a Communist; *nor am I*."[21]

In May 1954, there was an exhibition of his illustrations for Dante's *The Divine Comedy* at Rome's Palazzo Pallavicini. He felt a deep desire to be re-born in the Holy City, so he called a press conference, at which he duly burst out of a metaphysical cube.[22] Reynolds and Eleanor Morse, who had come to Italy to help set up the exhibition, travelled for their first time ever to Port Lligat and Cadaqués. The couple, who had only known these places from the Dalinian art they had collected, were absolutely overcome by the scenery. Morse would later write about it, 'Strange as it now seems, in 1954, Dalí's Surrealism was popularly supposed to represent only an imaginary dream world peopled by subconscious hallucinations. The idea that such a landscape as seen here actually existed and was a living part of Dalí's Surrealism had not yet penetrated to the effete world of modern art in Paris and New York.'[23]

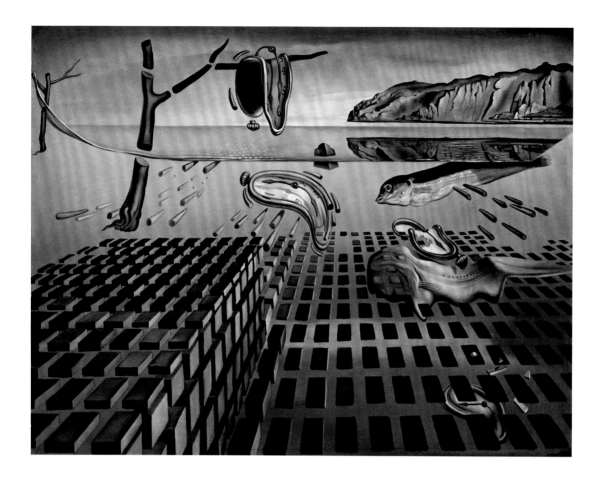

During 1954, Dalí illustrated some books, *The True Story of Lídia of Cadaqués* by Eugeni d'Ors and *Ballad of the Cobbler of Ordis* by his lifelong friend Carles Fages de Climent, for which he wrote the epilogue. *Dalí's Mustache*, a book collaboration with photographer Philippe Halsman, was published. Also that year, twenty-three years after he created *The Persistence of Memory* in 1931, Dalí completed *The Disintegration of the Persistence of Memory*, which he had begun in 1952. The work includes some recurring objects and landscapes from *The Persistence of Memory*, however the colours are more metallic in tone. The landscape is the same seascape of his native Catalonia, with golden cliffs, but the land has been filled with water, and the floating objects are breaking up into their atomic parts, with the exception of the cliffs and the fish. Yet the water is sufficiently calm to mirror the distant golden cliffs. The lower half of the painting is dominated by bricks, some of which form a mortar-less wall or table, on the left, while others are depicted in orderly rows both above and below water. The wall appears to disintegrate on the far left-hand side. This work, which was originally named *The Chromosome of a Highly-Coloured Fish's Eye Starting the Harmonious Disintegration of the Persistence of Memory* features Dalí's famous melting clocks, as well as a bleached version of the same creature that we first saw in *The Persistence of Memory*. A large fish seems to swim along unperturbed, in a landscape which is more disturbing, although essentially the same, as in *The Persistence of Memory*. When he painted this in 1931, the atomic bomb had not been dropped, the Spanish Civil War had not occurred, nor had the Second World War.

The Disintegration of the Persistence of Memory, 1952–4, oil on canvas, 25.4 × 33 cm, Dalí Museum, St Petersburg, Florida.

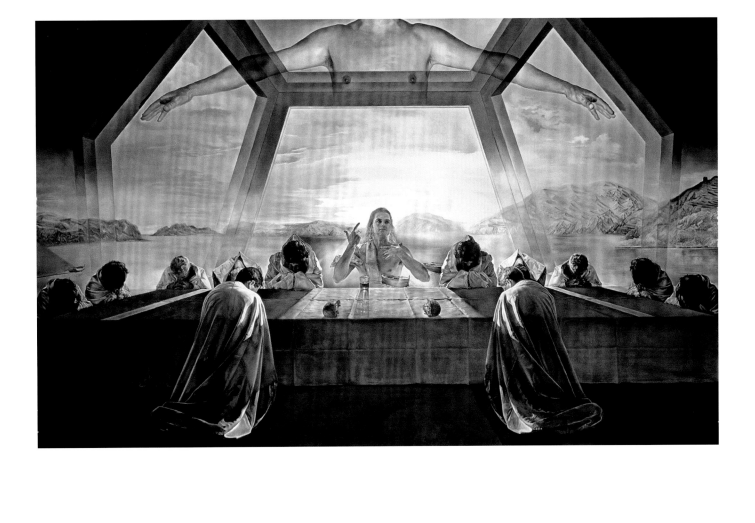

The Sacrament of the Last Supper, 1955, oil on canvas, 166.7 × 267 cm, National Gallery of Art, Washington DC.

His most local landscape featured in an important work he produced in 1955, *The Sacrament of the Last Supper*. The symmetrical structure of this Dalinian representation of the Last Supper draws the viewer in immediately. Here he has used the luminous beauty of the craggy bay of Port Lligat as a straightforward backdrop, once again relocating a major religious event, to Port Lligat, just as he had done in *Christ of St John of the* Cross and other works. The entire scene has been planned in the mathematical form of a precisely executed dodecahedron, about which Dalí said, 'I wanted to materialise the maximum of luminous and Pythagorean instantaneousness based on the celestial communion of the number twelve: twelve hours of the day – twelve months of the year – the twelve pentagons of the dodecahedron – twelve signs of the zodiac around the sun – the twelve

apostles around Christ.' Christ is placed perfectly at the heart of all of the symmetry and geometry, so that not only does he hold together the structure of the painting, but artistically and spiritually, he is holding the universe together as God.[24] The light, which is beautifully painted and perfectly distributed, suggests to the viewer both the dawn heralding a new day and the dawning of enlightenment. No doubt in Dalí's consciousness and subconsciousness, there was no place more perfect in the world for this to occur than at Port Lligat.

In less enlightening matters, however, the artist's relationship was blooming with the Fascist dictator Francisco Franco. Regardless of Dalí's original motivation for supporting Franco's regime, a mutual admiration had grown between the two men over the years. On 16 June 1956, Franco received the

artist at the Royal Palace of El Pardo, in Madrid. The dictator had developed a passion for painting since the 1920s and impressed Dalí with his in-depth knowledge about Vermeer and his treatment of light.[25] From Franco's perspective, there were not so many famous creatives who wished to reside in Spain at that time, so embracing Dalí was a priority from that angle. On 2 April 1964, he would award the artist with the Great Cross of the Order of Isabella the Catholic, which is given in recognition for services that have benefited Spain. At the end of the 1960s, Salvador would tell his friend Carlos Lozano, 'In the next century when children ask: who was Franco? They will answer: he was a dictator in the time of Dalí.'[26] In 1956, he gave a talk in Güell Park, Barcelona, paying homage to Gaudí, while creating a work live, however he didn't honour Picasso in the same way. As if his political and religious metamorphoses had not caused enough upset, he published his treaty, *The Cuckolds of Antiquated Modern Art,* also in 1956, in which, among other outrageous criticisms, he made Picasso responsible for 'general ugliness'.[27]

Beauty in all its forms was an essential tonic and muse for Dalí. At an elite ball in New York, in February 1955, an occasion which only the most beautiful, famous and rich people could attend, he was transfixed by a stunning blonde, with amber eyes like a cat, wearing a red evening gown. He approached this ravishing creature, and told her, 'I

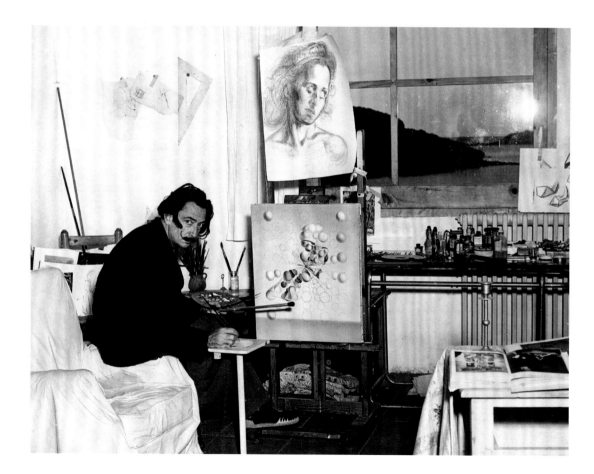

Dalí painting *Galatea of the Spheres* in his studio in Port Lligat, 1952.

am Dalí, I want to see you every day for the rest of my life. Who are you?'[28] The lady in red turned out to be the daughter of a semi-pornographic novelist, whose books he had secretly read when younger, and she had actually lived only moments away from the Academy in Madrid. This wicked and wonderful beauty, whom he came to love, was Nanita Kalaschnikoff, whom he later nicknamed Louis XIV, because of her regal presence. She would become his true friend and muse.[29] Nanita developed a genuine affection for him, but for the real Dalí, 'the private man, the engaging person hiding under the onion-layers of disguise'.[30] Not only were they great friends, but Nanita, who was sexually uninhibited, offered him more erotic complicity than Gala. Although they didn't have an overtly sexual affair, they did have some fun and games. When the author Ian Gibson interviewed her in 1995, Nanita said, 'Sexuality for him was always a monster and he never overcame the anxiety it produced in him. That was his tragedy.'[31]

Another friendship, born out of mutual admiration, was with Walt Disney. Theirs was a simple kinship, based on their similar interests and talents; they were two small-town boys who had made it very big. In 1957, Disney came to visit Dalí in Port Lligat, to plan a film about Don Quixote. However, the film was never made.[32]

Although Dalí didn't always have the best luck regarding his film collaborations being produced,

Gala and Dalí in his studio in Port Lligat, 1955.

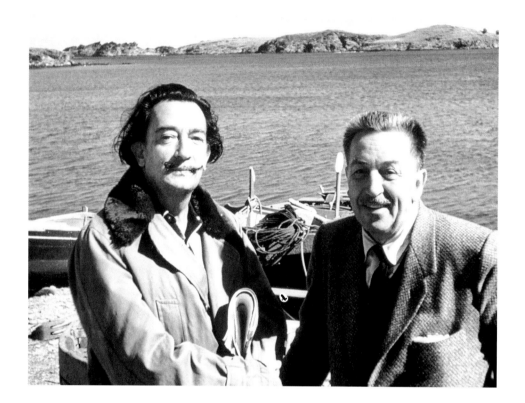

he certainly had no problems in creating fantastic publicity. During that period of his life, both rhinoceros horns and cauliflowers were fascinating to Dalí, both of which are formed by logarithmic spirals, which he believed were a form of divine, natural perfection. When in Paris, in April 1955, the great artist decided to do a study by painting a rhinoceros in the zoo, while balancing some bread on his head. In *Diary of a Genius*, he wrote, "'Let them speak of Dalí, even if they speak well of him.' I have been successful for twenty years, to the extent that the papers publish the most incomprehensible news items of our time, sent by teletype.' To continue to have this desired effect, he delivered a lecture on Vermeer's *The Lacemaker* and the rhinoceros, in the Sorbonne, in Paris, in 1958. He made his entrance in a white Rolls-Royce, which was packed with a thousand white cauliflowers. The same year, in Rome, he was re-born again, this time in the setting of the torch-lit gardens of the Princess Pallavicini's palace. He emerged suddenly from a cubic egg, which was embellished with magic inscriptions

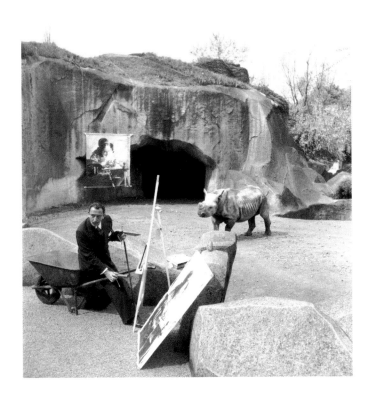

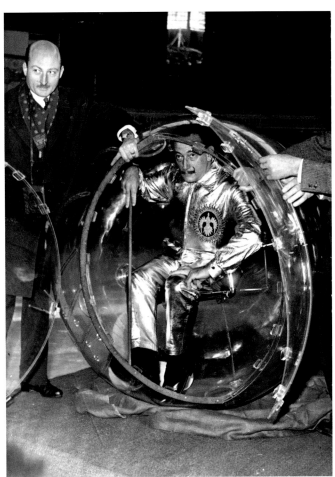

LEFT Dalí painting a
paranoiac-critical version of
Vermeer's *The Lacemaker* with
a rhinoceros at the Vincennes
Zoo, Paris, 30 April 1955.

RIGHT Arriving by
Ovocipède at the Palais de
Glace, Paris, on 7 December
1959.

by Raimondo Lulio, and delivered an explosive
oration in Latin.[33]

Unlike these public shows for the press, which
could be regarded as performance art, Dalí married
Gala in an extremely private church ceremony, on 8
August 1958, at the Els Àngels shrine in Sant Martí
Vell, near Girona. Dalí had fallen in love with this
beautiful spot; a little piece of paradise, with panoramic
views over almost all the counties of Girona.

In May 1959, he had an audience with Pope
John XXIII, during which he told him about his
commission to design a cathedral in the Arizona
desert which, he informed his Holiness, would be
in the shape of a pear, as it was symbolic of the
Resurrection during the Middle Ages. The Pope's
response was not documented.[34] At the end of the
year, Dalí presented his Ovocipède in Paris, and then
in New York. The contraption, which appears like
a glass bubble that is meant to contain the book
of the Apocalypse, he declared, was a new form of
locomotion and a completely new sport,[35] bringing
the decade to an end in typical Dalinian style.

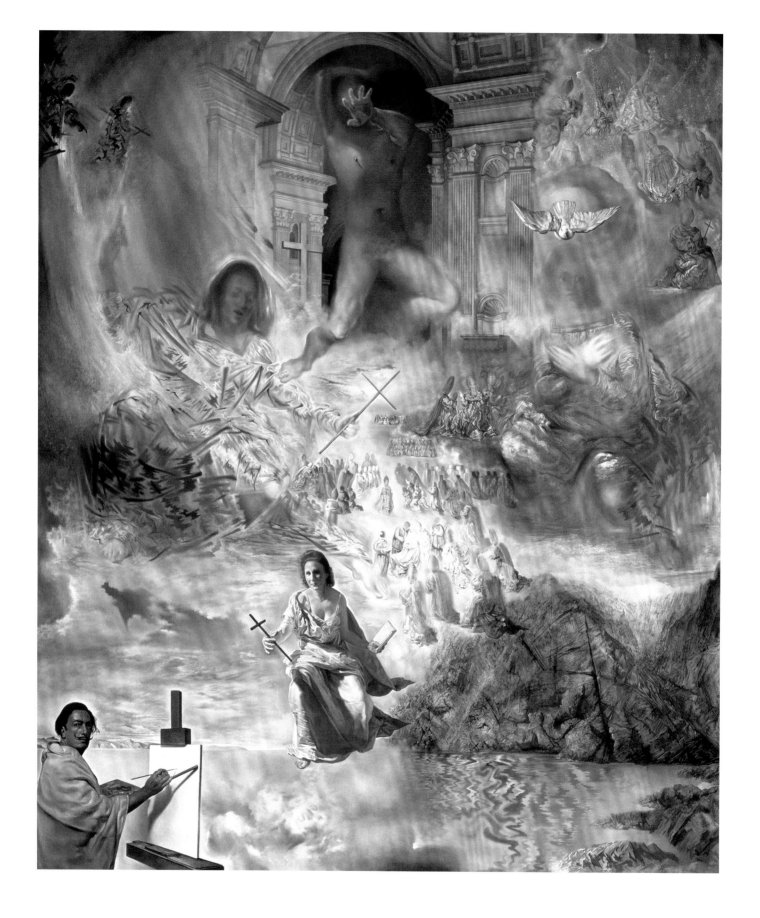

'Everything celebrates the cult of Gala, even the Round Room, with its perfect echo that crowns the building as a whole and which is like a dome of this Galactic cathedral.' *Salvador Dalí*[1]

SCIENCE, SPIRIT & THE SOVEREIGNTY OF GALA

The Ecumenical Council, 1960, oil on canvas, 302 × 254 cm, Dalí Museum, St Petersburg, Florida.

To open the 1960s with panache, Dalí collaborated again with Philippe Halsman, on *Chaos and Creation*. The eighteen-minute documentary-style video,[2] produced in time for April 1960, was conceived to address the avant-garde attendees of the Fifth Annual Convention on Visual Communications at the Waldorf Astoria in New York. The video's central theme was the paranoiac-critical method. The sequence begins as a lecture, which next explores the planning, development and execution of a performance by the artist, and culminates in the creation of a work of art. Dalí holds an easel with a Piet Mondrian painting which, as he talks, dissolves into a pigsty, complete with real pigs, a model dressed in an evening gown and a motorcycle.[3] During the video, Dalí speaks about contemporary art, and introduces his new concept of post-Freudian artistic creation, which has been influenced by his scientific interests, especially his reading of Heisenberg. It focuses on new ways of artistic production, made possible by technological advances. On 29 January 1961, he presented a new painting technique on the Ed Sullivan show,

shooting a number of times at a large canvas, with a pistol loaded with a paint-filled capsule.[4]

By 1962, we can see the important influence that genetics, DNA and its structure, were beginning to have on his work. When attending a book signing of Robert Descharnes' *The World of Salvador Dalí* in 1963, he lay in a bed in the shop window, wired up to an electromyograph that was registering his brain waves. The printouts accompanied each book as a gift. His fascination with Jean-François Millet's painting *L'Angelus* (1857–9), which had begun in the 1930s, culminated in 1963 when he published the essay 'The Tragic Legend of the Angelus by Millet', in which he applies his paranoiac-critical method to the painting. In it he clarifies his concept of the function of the molecule. 'Moral law must be of divine order, for even before it was set down on Moses' tablets it was contained in the codes of the genetic spirals.' This reference to DNA shows us that he related the molecule with immortal life.

At the end of the year, at the Knoedler Gallery in New York, Dalí presented *Galacidalacidesoxyribonucleicacid*, the most important work on show; a

homage to Crick and Watson, the Nobel Laureates, who discovered the structure of DNA.[5] In an article, which he wrote to accompany his works, he said, 'GALACIDALACIDESOXYRIBONUCLEICACID. It is my longest title in one word. But the theme is even longer: long as the genetical persistence of human memory. As announced by the prophet Isaiah-the-Saviour contained in God's head from which one sees for the first time in the iconographic history his arms repeating the molecular structures of Crick and Watson and lifting Christ's dead body so as to resuscitate him in heaven.'[6]

His muse, student and assistant Ultra Violet travelled with him to Paris in spring 1962, where they stayed at his Paris hotel, Le Meurice. In her memoir, *Famous for 15 Minutes: My Years with Andy Warhol*, she wonderfully describes his environment there: 'At the Hotel Meurice, on the Rue Rivoli, Dalí occupies a magnificent first-floor apartment that was formerly reserved for King Victor Emmanuel of Italy. Many other royal heads of state have occupied this suite. The living room ceiling is richly ornamented with a fresco of white rococo cupids. There are engraved mirrors seventeen feet high, a white stone balcony overlooking the garden of the Louvre. Rich, faded gold silk covers every wall. The doors are immense, carved out of wood. The room is a relic of turn-of-the-century splendour.'[7] Ultra Violet spent the summer with Dalí in Cadaqués and in autumn they returned to Paris, where they lived the life of millionaires, eating lunch almost every day at the exceptional Restaurant Lasserre, in its elegant, theatrical dining room. After lunch, Dalí returned to Le Meurice for his customary siesta, which is 'how he keeps going well into the night with sparkling energy'.[8] Maxim's was another great favourite of Dalí's in Paris.

Around this period, his life with Gala started to become a little complicated. Gala had been born in 1894 and was ten years older than her husband. From the age of sixty, she started to become obsessed with a fear of growing ugly and old. To some extent her dalliances with younger lovers went some way to remedy this, which Dalí was both

Dalí appearing on the *Ed Sullivan Show*, New York, 29 January 1961.

Galacidalacidesoxyribonucleic-
acid, 1963, oil on canvas,
305 × 345 cm, Dalí Museum,
St Petersburg, Florida.

aware and accepting of, until a situation became too much for him in 1964. In New York Gala had met and cleaned up a twenty-two-year-old drug addict, William Rothlein. Struck by his resemblance to her husband when younger, Rothlein evoked both maternal and sexual feelings in her. Gala, who was almost fifty years older than Rothlein, had an affair with him, which he made public by kissing Gala openly while they were in Italy. Luckily their patrons and friends, the Albarettos, were able to carry out damage limitation with the press. Even though Dalí felt a fatherly affection towards young Rothlein, who modelled for him, he simultaneously recognised this affair as a threat to his marriage. It was apparent to people close to them, such as the Albarettos, that Gala and William were at that time obsessed with and in love with one another. At the height of this Dalí reached a point when he wasn't able to create for fear that Gala was going to leave him. By 1965, Gala's interest in William started to diminish, and by 1966, she shipped him back to the States, on a one-way ticket.[9] Although

the affair had come to end, it had put a strain on the Dalís' relationship, that was never to be fully healed. Interestingly, Rothlein told Torsten Otte, author of *Salvador Dalí and Andy Warhol*, that Gala 'liked to have power over people. I saw it in her dealings with various people who were around Dalí. She had control all the time of the situation and kept people away from him very often.'[10] He also described Salvador as a thoughtful and kind human being, when he let down his public mask.

In 1965, Dalí met Amanda Lear, who had arrived in London during the 1960s from France. She became part of the Chelsea Girl set and had relationships with a number of famous men, including David Bowie. Her background remained mysterious for many years – perhaps a skill she learned from Dalí – but according to Ian Gibson's book, *The Shameful Life of Salvador Dalí*, she had undergone sex change surgery, although Gibson's book does not confirm if Dalí paid for her 'Operation Pussycat'.[11] In her memoirs, Amanda places the first meeting with Dalí at Chez Castel's, one of the most exclusive Parisian clubs of the day, located on rue Princesse. 'He liked to surround himself with the eccentric and the remarkable, and loved to stand out in a crowd, playing the role of King, his devoted courtiers around him.'[12] He invited her for lunch the following day, at one of his favourite Parisian haunts, Lasserre's, where he told her, 'You have a very pretty skull. Your Majesty,

Tuna Fishing, 1966–7, oil on canvas, 304 × 404 cm, Paul Ricard Foundation, Bandol, France.

just look at Amanda's beautiful skeleton,'[13] he said, addressing Nanita Kalaschnikoff. Their friendship blossomed, and before leaving for New York, Dalí gave Amanda an enormous fossilised agate as a parting gift, which he had bought in Deyrolles, his favourite shop in Paris.[14] Tragically Amanda's boyfriend Tara died in a car accident while the Dalís were in New York. Both Salvador and Gala were very kind to her on the phone, upon hearing the news, and Dalí continued to call her from New York during the winter months to try to

cheer her up. As time went on, and Amanda spent the summers in Cadaqués, she felt that Dalí was teaching her to see things through his eyes.

Over the summers of 1966–7, Dalí was painting *Tuna Fishing*, which is considered by many a later masterpiece. This beautiful, energetic work was inspired by another local place. Close to Roses lies a cove called L'Almadrava, which is a word of Arabic origin, that describes a place where tuna fish are caught and slaughtered. The artist drew on memories of his father's storytelling

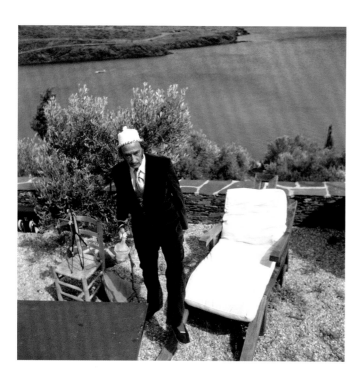

Salvador Dalí at home, 17
September 1968.

of tuna fishing, along with a print of a Swedish painting that Señor Dalí used to show to his son to further illustrate his tale. Additionally, the artist had recently read Teilhard de Chardin's theory that the universe is finite, and this is where energy comes from. Hence in describing his newest masterpiece, he said, 'that all the cosmos and all the universe converge in one point, which, in the present case, is the Tuna-Fishing. This accounts for the terrifying energy in this picture! Because all these fish, all those tuna, all the human beings in the act of killing them, personify the limited universe.' This visually explosive painting, filled with Dionysian figures, not only pays tribute to Dalí's immense skill, but also draws on a wide range of genres he had worked in; including Surrealism, Pointillism, Pop Art, Tachism, Action Painting, Geometrical Abstraction and Psychedellic Art. The viewer can palpably feel the frantic violence, in a scene where men whose appearances depict different eras in history, are killing fish with golden daggers. The sparkling blue Mediterranean starts to turn blood red. Both the men and fish represent the finite universe. While Dalí was painting this work, the French writer Louis Pauwels came to Port Lligat, for the first time. The two creatives had known each other for around fifteen years, but it was only by seeing Dalí in this landscape that Pauwels realised that the great creator could 'only be fully understood if one took into account this extraordinary landscape that had shaped his thinking'.[15]

From 27 March to 9 June 1968, Dalí exhibited in a collective exhibition of more than 300 works, spanning the Dada and Surrealist periods, in the Museum of Modern Art, New York. The press release said that

> Dalí's first mature works came in 1929 in a series of brilliant small pictures whose hallucinatory intensity he was never to surpass. In some of these, *The Lugubrious Game*, for example, the photographic realism of the painted passages is indistinguishable from those parts of the surface which are actually collaged bits

of photographs and colour engravings. In equating his painting technique with the verisimilitude and surface finish of photography, Dali here brought full circle the 'perversion' of collage that was initiated by Ernst.[16]

In 1969, Dalí bought a castle in Púbol for Gala. Located around 38 miles from Port Lligat, the Gala-Dalí Castle, as it is now known, was very run down when he purchased it, although it did have a romantic atmosphere. The couple had restoration work carried out, tackling collapsed ceilings and substantial cracks. Dalí created mysterious spaces of various sizes, making clever use of the semi-

collapsed ceilings and walls. The castle's interior was decorated using baroque textiles, romantic symbols, antiques, false architectural techniques and pictorial representations on walls. He succeeded in creating a haven of great privacy for Gala, that is somewhat austere and mysterious, yet with some very beautiful spaces. He also considered the castle to be a continuation of the house-cum-studio at Port Lligat, yet at the same time, this environment was clearly to be Gala's domain. In his 1973 book, *The Unspeakable Confessions of Salvador Dalí* he wrote:

Everything celebrates the cult of Gala, even the Round Room, with its perfect echo that crowns the building as a whole

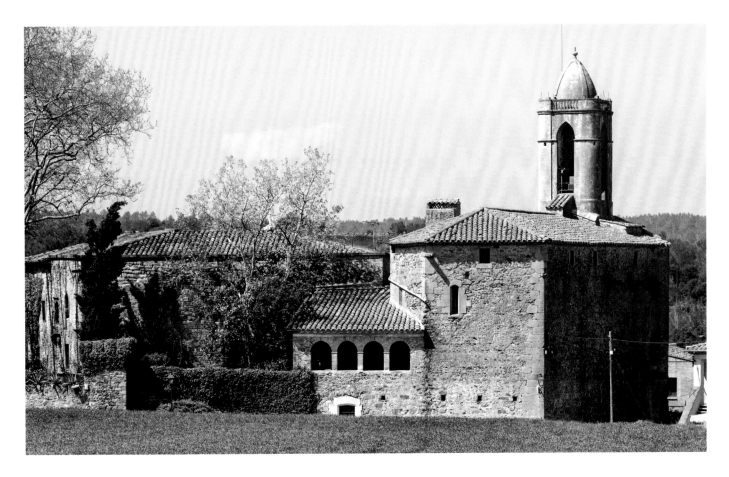

and which is like a dome of this Galactic cathedral. When I walk around this house I look at myself and I see my concentricity. I like its Moorish rigour. I needed to offer Gala a case more solemnly worthy of our love. That is why I gave her a mansion built on the remains of a twelfth-century castle: the old castle of Púbol in La Bisbal, where she would reign like an absolute sovereign, right up to the point that I could visit her only by hand-written invitation from her. I limited myself to the pleasure of decorating her ceilings so that when she raised her eyes, she would always find me in her sky.[17]

The Divine Dalí had created a kingdom for his Queen, which he could only access with her permission.

Since the mid-1960s Dalí had been increasingly fascinated by three-dimensional art and holography. He had started to explore the work of Gerard Dou, which features stereoscopic images. Part of Dalí's hope was to use holography, stereoscopy and double images to capture both the internal and external reality of the viewer, by inducing mental associations. Commercially in 1969, he created a logo for Chupa Chups, designed a poster for the Eurovision Song Contest and was involved in an advertising campaign for the airline Braniff, featuring celebrities. A major retrospective exhibition of his work was organised at the Museum Boijmans van Beuningen in Rotterdam, which went to the Staatliche Kunsthalle in Baden-Baden, Germany, in 1971. In 1970, at the Gustave Moreau Museum in Paris, Dalí held a press

conference to announce the creation of the Dalí Theatre-Museum in Figueres. The following year, the Morse collection was inaugurated into the Dalí Museum, in Cleveland, Ohio.

Dennis Gabor was awarded the Nobel Prize in Physics for his work on the laser, which further encouraged Dalí's passion for holography. At the same time, Selwyn Lissack, whose company International Holographic Corp. had produced and marketed the first commercial holographic products for 3D art, in alliance with McDonnell Douglas, was interested in the artist. Lissack and his colleagues knew that they needed a well-known artist, who understood the technical aspects of holography, on board with them, to be able to introduce it to the world as an art medium. Fascinated by Dalí since childhood, Lissack knew he was the perfect choice. He discovered that Dalí was staying at the St Regis in New York, so he took a chance and called him:

Never in my wildest dreams did I think we would be speaking to the legendary Dalí himself, and the very next day we were actually sitting in his suite, talking to him about holography. Dalí was thrilled with the notion of working with a medium which gave him the ability to create beyond the confines of linear space, and his hotel suite became our office. Over the next five years, we met often to discuss the many ideas he wanted to explore. From 1971 to 1976, Dalí and I collaborated to produce seven holographic works of art, which were to become some of the most important art holograms of the twentieth century.[18]

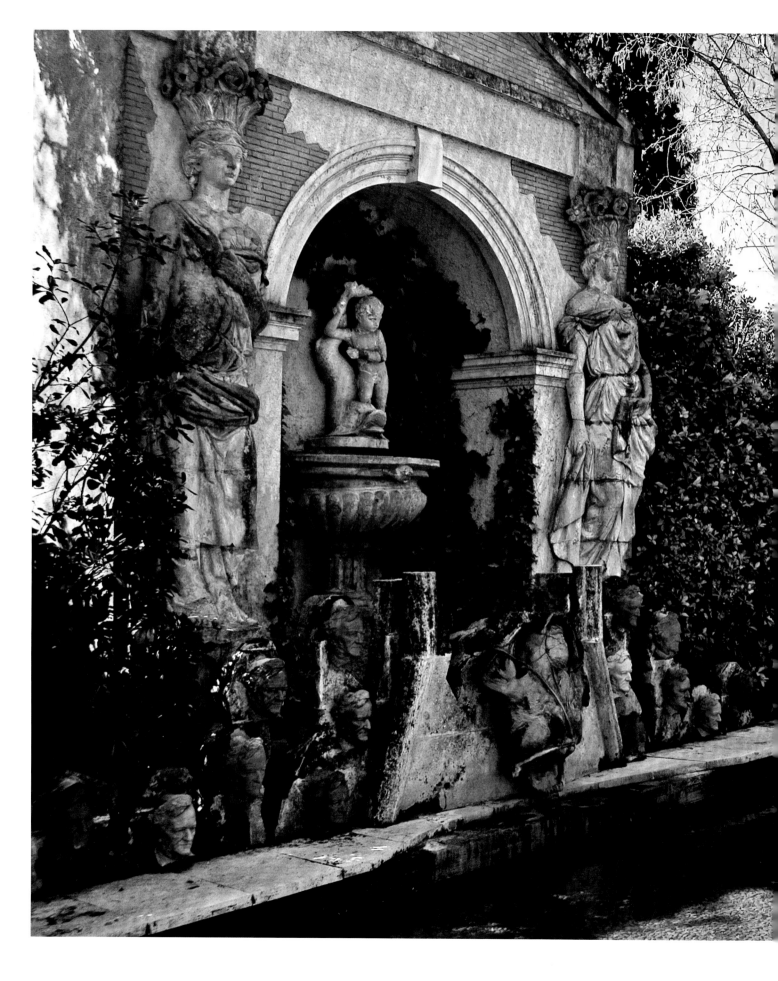

LEFT Madelle Hegeler
modelling jewellery
designed by Dalí in New
York, 23 May 1959.

The seven holograms created during this period were: *Brain of Alice Cooper*, *Crystal Grotto*, *Dalí Painting Gala*, *Holos! Holos! Velázquez! Gabor!*, *Submarine Fisherman*, *Polyhedron* and *Melting Clock*. Although *Melting Clock* was conceived in 1975, it was not constructed until LED technology made its playback system more practical, in 2003.

In April 1972, the Knoedler Gallery in New York staged a hologram exhibition, at which Dalí showed *Holos! Holos! Velázquez! Gabor!*, and an article with the same title was published in *Art News*. In it, Dalí pays tribute to both Gabor and Velázquez. Not only are the article and hologram another example of the master using different creative media to express the same theme, but the article additionally combined two of Dalí's passions.[19]

The Pitxot family, who had been influential in the artist's life since even before his birth, continued to play an important role, but this time with the next generation. The son of the cellist Ricard, the artist Antoni Pitxot, who was born in Figueres in 1924, came into Dalí's life in 1972. The great creator had heard that the younger artist was using the stones of Cadaqués in his work, so he went along to see his art and he liked it. He was delighted to be able

OPPOSITE ABOVE *Portrait
of My Dead Brother*, 1963, oil
on canvas, 175 × 175 cm,
private collection.

OPPOSITE BELOW
Moses and Monotheism, 1974,
gouache, watercolour,
coloured chalks, pen and ink
on paper, 64.7 × 49.8 cm,
private collection.

to help the nephew of his much-loved friend and mentor Pepito Pitxot, so not only did he invite Antoni to help him with the Theatre-Museum, he also exhibited Pitxot's work on the first floor of it, when it was later inaugurated.[20]

The exhibition 'Dalí: His Art in Jewels', was presented in the Dalí Theatre-Museum in 1973, a year before the museum's official inauguration. Another retrospective was organised, this time at the Louisiana Museum at Humlebæk, which later exhibited at the Moderna Museet of Stockholm. The books *How One Becomes Dalí* and *Gala's Dinners* were published. The same year, artist Jeff Koons, aged eighteen, found out that Dalí was at the St Regis, New York. Dalí agreed to meet the young artist, who later wrote about how he had inspired him: 'I remember that he was very patient while I was juggling my camera around. He was very generous to give his time to a young artist like myself. Meeting Dalí had a big impact on me. That evening, on the way back home, I thought to myself: "I could do this." Art could be a way of life.' While numerous critics over the years have questioned how Dalí's work developed after what has been regarded as his peak Surrealistic period, Koons makes an interesting observation about this in a 2005 article for the Tate Gallery:

> What I think is important about him is how he moved from a subjective realm into mass iconography – a higher calling. Dalí was in tune with mass consciousness. A good example of this is *Portrait of My Dead Brother* (1963), which is a pre-Pop painting. It's like a Warhol silkscreen ahead of its time. I believe this style had a huge influence on many artists. For example, right now computer graphics seem to be based on his vision – with image gradation, geometric pixellation and morphing. The world today is viewed through Dalí's vision.[21]

Another collaboration of importance, from 1970 to 1974 was with Ariane Lancell, whom Dalí

had originally met in 1968. She recalled the event in an interview with Julien Bouyssou in *La Dépêche* newspaper in August 2000, about their four-year collaboration. 'It was in New York, one evening in 1968. At the end of the premiere of the musical *Hair*, when people invade the stage to dance, I did, Dalí saw me and said, "I want to know that girl."' She described Dalí as '*un grand timide*', extremely shy. Lancell, who was born in the Parisian suburb of Neuilly, to Russian parents, became a ballerina aged five, took up painting at the age of twelve and was a model for the Italian surrealist Leonor Fini. She went into art publishing, and produced some of the twentieth century's most spectacular books, containing original prints. The striking, red-haired beauty fascinated Dalí, who nicknamed her the '*Etincelle*' (Spark). In her quest for unique, beautiful art publishing, she resurrected a number of ancient crafts, using recent technologies to bring them to life. Her rare editions, which have become sought-after collectors' items, were handmade in sheepskin, silks, satin, parchment and papyrus. Dalí's and Lancell's first collaboration was a special edition of Sigmund Freud's *Moses and Monotheism*, which included Dalí's valuable lithographs on lambskin, and he also wrote the book's prologue.[22] In this book, as well as on another of their collaborations, *Alchemy of the Philosophers*, we can see an historical innovation. Each lambskin sheet has been imprinted with lithography, engraving and relief serigraphy. *Alchemy of the Philosophers* is also inlaid with precious and semi-precious stones. Dalí's graphic works have been less explored than some of the other media he worked with, but he was very excited by the possibilities offered by

multiple reproduction. He saw it as an art form that could make him accessible to a far more diverse and greater audience.[23]

From 1972–3, Dalí was once again drawing inspiration from his local area, in a work which he based on a poem, *L'Empordà* by Joan Maragall. The poem reflects not only on the region, but also on its famous Tramuntana wind. Today this later masterpiece, *Central Panel of the Wind Palace Ceiling*, is one of the highlights of the Dalí Theatre-Museum. The painting was created in the Port Lligat studio, but was later placed in the Theatre-Museum using enormous scaffolding. In his Port Lligat studio, one of the windows had been designed with exactly this type of operation in mind, as it was impossible to transport such a large piece through the labyrinthine house. With himself and Gala represented in the work's centre, the viewer gets the impression that the couple are walking through the dreams of life. Familiar symbols are revisited, such as money, in the form of golden coins, one of which Dalí said was real, and elephants with insect legs. There are also some sketched silhouettes, a prince and princess in the form of King Carlos I and Queen Sofia, who were the reigning monarchs at that time. Another silhouette is of a good friend, the photographer Melitó Casals. Gala and Salvador are portrayed at the end, observing the ship of destiny, which is about to set sail.[24]

> 'It is of course obvious that other worlds exist but, as I have often said, these other worlds exist within our own, they reside on earth in the very centre of the dome in the Dalí Museum, where there is the whole unsuspected, hallucinating new world of Surrealism.' *Salvador Dalí*[1]

IMMORTALITY & DEATH

Gala Contemplating the Mediterranean Sea which at Eighteen Metres becomes the Portrait of Abraham Lincoln (Homage to Rothko), 1976, oil and photography on plywood, 445 × 350 cm, Dalí Theatre-Museum, Figueres.

The red tape of Spanish officialdom, along with some of the artist's own ideas, meant that manifesting Dalí's dream of the Dalí Theatre-Museum in Figueres took thirteen years from its inception. At one stage, Dalí informed city officials that he had decided to fill the museum with photographs of his works rather than the originals because photographs 'are better than the original works'. His supporter in the project, Figueres' ex-Mayor Ramón Guardiola Rovira, later wrote in his memoir, 'The general feeling was that he was crazy.' When the Ministry of Culture in Madrid heard about this idea, funding for the project was stopped until Dalí relented.[2]

The wheels got back into motion, but on 3 June 1974, Dalí had to have a hernia operation, from which he apparently recovered well. However, the Dalís' then business manager, Captain Peter Moore, would later state in a 1998 interview with *Cap Creus Online*, that 'At the age of seventy, Dalí, who until then had had excellent health, had to be operated on and this operation was not very successful. From that moment, he lost his mental and physical strength day after day.'[3] Perhaps this

meant he was starting to doubt his own immortality after all. In 1958, when Mike Wallace had asked him, 'You will not die?' Dalí replied, 'No, no believe in general in death but in the death of Dalí absolutely not. Believe in my death becoming very – almost impossible.'[4] Moore, who had been Dalí's secretary for around twenty years, stated in the same interview with *Cap Creus Online* that 'I accompanied him during the period of his great creativity.'[5] However, that said, Moore was involved with the couple at the time of the famous scandal of Dalí signing thousands of blank sheets of paper, which came to light because of a routine customs search in 1974. Additionally, Moore was convicted of re-working a Dalí in 2004 and at the time when police searched his home and workshops, they found 10,000 faked Dalí lithographs.

On 28 September 1974, Dalí's dream of the Dalí Theatre-Museum came true. When the initial seeds had been planted, in a conversation with Guardiola, he had said, 'Where, if not in my own town, should the most extravagant and solid of my work endure, where if not here? The Municipal

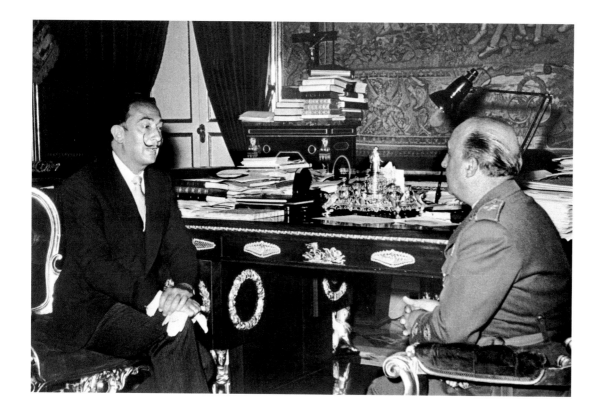

Theatre, or what remained of it, struck me as very appropriate, and for three reasons: first, because I am an eminently theatrical painter; second, because the theatre stands right opposite the church where I was baptised; and third, because it was precisely in the hall of the vestibule of the theatre where I gave my first exhibition of painting.'[6] The Dalí Theatre-Museum is considered by many to be his last great masterpiece, and it is just as he intended, a holistic Surrealistic experience.

After Peter Moore left the Dalís' service, the Empordanese ex-footballer and journalist Enric Sabater took over, just as Gala had wished. However, he didn't keep the same type of professional distance Moore had, at least partially because the older couple needed someone with them almost constantly. Yet Sabater's motives were questionable.

On 27 September 1975, General Franco, who was very unwell, executed what would be his final five victims. In the middle of worldwide uproar and protests, Dalí made a supportive statement to *Agence France-Presse* about the executions and their aftermath.[7] The next day he toned it down a little. However, he was also deeply worried about Franco's ailing health, having referred to him in the statement as 'a wonderful person'. In fact, once he returned to New York, he went each day to St Patrick's Cathedral to pray for General Franco. The concern was not purely on a personal level. On 20 November, when he heard about Franco's death, he almost collapsed. I believe that Ian Gibson, in *The Shameful Life of Salvador Dalí*, correctly surmised, that 'he feared that if the monarchy failed and the Left gained power, he might never be able to return home'.[8] However, the

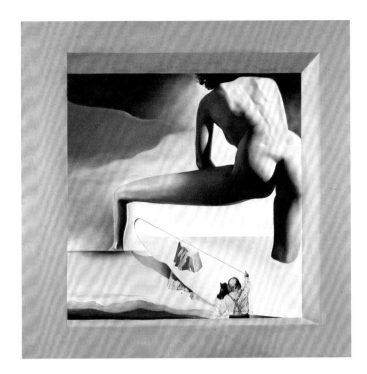
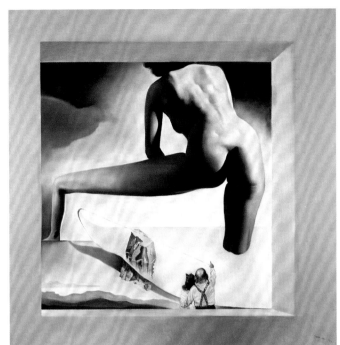

transition to monarchy was relatively smooth, which was a great relief to Dalí.

In 1976, he produced a painting that utilises the interplay between high and low frequencies, employing a technique that triggers perceptual processes that come into play if you look at a computer-generated photo-mosaic, whereby depending on how you view it, you may see only one photo or the entire mosaic. The visual experience is based on the fact that the photo-receptors in the retinas are an actual mosaic of individual light detectors. So from a distance you can see one single large image, but when viewed closer up, or squinting, you start to distinguish different images within the whole.[9] *Gala Contemplating the Mediterranean Sea which at Eighteen Metres becomes the Portrait of Abraham Lincoln (Homage to Rothko)* pays homage to the

leading abstract expressionist Mark Rothko, who committed suicide in 1970. The painting's multiple blocks of colours, with gradual hue progression, are evocative of Rothko's meditative colour fields. At the same time, the viewer can observe Dalí's fascination with perception, while additionally he has merged what over time became his second most important environment, America, with his homeland of Catalonia. He created this work while staying at the St Regis in New York, and on top of paying homage to Rothko, one can also consider that it pays homage to America; the country that not only offered him refuge during the war but also helped him to make the money that he so desired. This work is based on a photograph that he originally saw in the *Scientific American* in November 1973 alongside the article 'The Recognition of Faces' by Leon D. Harmon, featuring

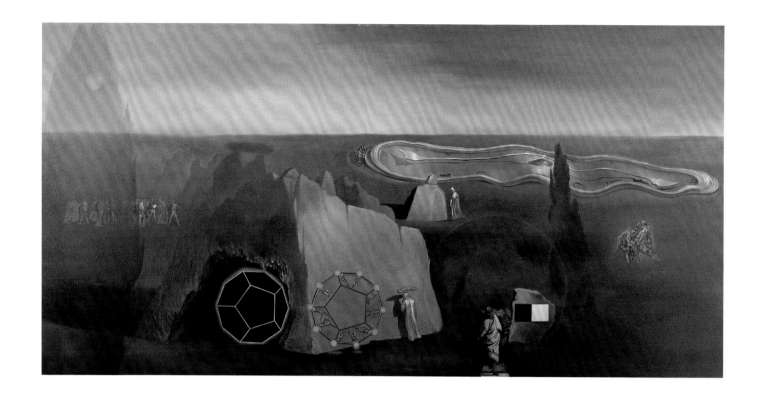

a low-resolution reproduction of the monochromatic photograph of the face of Abraham Lincoln, which appears on the American five-dollar bill.[10]

Years of deep fascination, research and practice resulted in Dalí's first hyper-stereoscopic painting, *Dalí Lifting the Skin of the Mediterranean to Show Gala the Birth of Venus*, which he presented at the Solomon R. Guggenheim Museum in New York, in 1978. Hyper-stereoscopic painting is achieved by how we visually receive two flat images of the same object or scene, taken from different perspectives. In Dalí's works in this genre, he created pairs of paintings, which are almost identical, but he has slightly shifted each scene's centre moving the focal points. The colours are also different in each painting of the pair, in places subtly and elsewhere very obviously. The human brain automatically adds these images together, perceiving a sensation of depth, which produces a three-dimensional composition, like the kind we see in virtual reality games these days. In this premiere painting of this genre, Dalí has featured his favourite local landscape, once again.

In *In Search of the Fourth Dimension*, one can still observe his local seascape, with an especially large limp clock present, but in this painting a pentagram seems to both merge into and emerge from a cliff face. The scene includes further use of the pentagram, and he has worked in his version of the Last Supper. He began this work in 1978 and completed it during 1979, the year he turned seventy-five, executing it with his trademark Dalinian precision. The same year, he had been appointed as an Associate Overseas Member of the Académie des Beaux-Arts of the Institut de France. He delivered a Surreal investiture speech,

In Search of the Fourth Dimension, 1979, oil on canvas, 122.5 × 246 cm, Gala-Salvador Dalí Foundation, Figueres.

which covered a wide range of topics, including the Perpignan train station, which he believed to be the centre of the universe. He ended up on a high with, 'Long live Perpignan station and Figueres!'[11]

However, not long after the high of this honour was to come a serious low. The man who was to be Gala's last love of her life, Jeff Fenholt, star of *Jesus Christ Superstar*, had been spending long periods of time in Gala's Castle and she also saw the young performer in New York. Fifty-seven years her junior, Fenholt was a very handsome twenty-one-year-old, with long auburn hair. He posed another threat to Dalí, who had historically been tolerant of his wife's affairs, unless he feared he may lose her altogether. Dalí had once said, 'I would polish Gala to make her shine, make her the happiest possible, caring for her more than myself, because without her, it would all end.'

In February 1980, when staying at the New York St Regis, both of the Dalís caught a bad 'flu, which Salvador couldn't shake off. This made him depressed, as hadn't suffered a long illness up until then. Gala decided to calm him down with some sedatives and Valium, but of course, these made him feel lethargic, so then she chose to sort out the problem by administering amphetamines. It was some time after these non-prescribed medication cocktails that his right hand and arm began to tremble badly. A medical report confirmed these symptoms, and also stated that the artist had difficulty in swallowing and walking, and had been suffering from arteriosclerosis for around ten years.[12] According to one of the artist's doctors, Albert Field, the unsupervised concoctions of uppers and downers caused irreversible brain damage.[13] On 20 March, the couple returned to Spain, not to Port Lligat, but instead to the Incasol, a health farm for the rich and famous in Marbella, where they stayed until mid-April. Dalí's close friend Nanita, who had seen him in New York, visited him at the Incasol, and had a huge shock when she saw how he was. The artist was in a state of deep depression and he was only

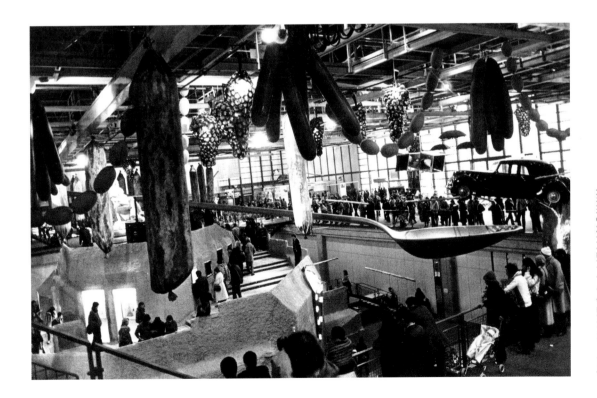

bones. Nanita felt it was the fault of Sabater – the secretary who carried a gun apparently for the artist's protection, who was making millions out of Dalí in dubious ways. Sabater certainly had a role to play in Dalí's overall deterioration, but so did his muse and wife Gala. In fact, around this time Dalí started to ask his chauffeur to taste his food before he ate it.[14]

After their return from the clinic, a group of friends – Descharnes, Morse and the lawyer, Michael Stout – clubbed together to try to help save Dalí from further ruin by the hand of Sabater. Morse went to Port Lligat to see Dalí, but Gala refused him entry. Stout and Morse met with Sabater to try to persuade him to leave Dalí's service voluntarily, which it seems he agreed to in the end, but it took some time for this to transpire. Most likely at this stage, Sabater felt he had made enough money, during which time he had put the artist in a very questionable tax situation. Both the national and international press were accusing Sabater not only of making a fortune at the artist's expense, but also of stopping his friends from visiting him. The artist went to a Barcelona clinic in May to be examined, but the medics concluded his problems were more psychological in nature. He left the clinic in June, at which stage his psychiatrist, Joan Obiols, came to Port Lligat to see him once a week. However, this only lasted for a few weeks, because on 17 July, poor Obiols dropped dead of a heart attack while talking to Gala at the feet of the erect, stuffed white bear. Strangely enough, the psychiatrist's replacement broke his leg on his very first visit to the Dalís' home.

From December 1979 to April 1980, he had been honoured with a major retrospective at the Centre Georges-Pompidou in Paris, the most comprehensive up to that time, with 168 paintings, 38 objects, 219 drawings and 2,000 documents. Almost one million people came to see it, and the show moved to the Tate Gallery in London, showing from 14 May to 29 June 1980. In better days, the Dalís would no doubt have travelled to London. However, a little later that year, after seven months out of the public eye, Dalí gave a press conference at the Theatre-Museum, on 24 October 1980. For those who hadn't seen him, he appeared a shadow of his former self.

The couple went to Paris for Christmas, but sadly it seems that the great artist was declining even further. Dr Pierre Roumeguère, his psychoanalyst, said in an interview the same year that 'The truth is that Dalí has lost his will to live. What we're seeing is a suicide. Simply because Gala no longer looks after him.'[15] When his builder Emilio Puignau turned up to visit him at the Meurice, Dalí told him, 'I'm finished, I'm in despair! You probably know already, they've robbed me of everything!'[16] Of course, he would have felt robbed by Sabater, but was he also referring to Gala, in terms of her diminished love and his own deteriorating health? The abusive behaviour, however, wasn't limited to one side. The Albarettos had previously seen Dalí furious and screaming at Gala, about how she wasted money on her boys, which was true. On 17 February 1981, in the Meurice, Dalí went to Sabater, desperate for help. The artist had a black eye, but Gala was in a worse state, with nasty bruising on her limbs and two broken ribs.[17] A little over a month later, on 18 March, Sabater finally left the Dalís.[18]

With Sabater gone, Robert Descharnes took over as secretary, and legal work commenced to resolve the tax issues that had been created by Sabater. The couple could return to Spain, which they did via Perpignan on 6 July 1981. Both the Catalan Prime Minister and the King and Queen of Spain came to visit him soon after his return. These warm welcomes back to his beloved homeland perked up the ailing artist, and during this period he was continuing to explore his ongoing passionate interests: the Old Masters, optical illusions and science. In some of his later works, the viewer can

see the influence of Velázquez and Michelangelo. The same year, the Salvador Dalí Museum, owned by the Morse couple, was inaugurated in St Petersburg, Florida.

In December 1981, Gala had undergone gall bladder surgery, from which she recovered. However, two months later, in February 1982, she had a fall on the stairs, and two days later, slipped in the bath, breaking one of her femurs. After that operation, serious complications arose, but she pulled through. On her return to Port Lligat, she refused to eat and her eyes had lost their normal expression. Her daughter Cécile came to see her, but both Gala and Salvador refused to let her enter. The couple had changed their wills again. This time, Gala had attempted to disinherit her daughter, which is illegal in Spain. She died on 10 June 1982 in Port Lligat. She had wished to die in the Castle and to be interred there, so in order to try to fulfil her wishes, Dalí and his entourage made the necessary arrangements to fake that she had died at the Castle, and a plague law was broken in order to transport her body there. Her corpse was wrapped in a blanket and she was seated, as if still alive, on the back seat of their 1969 Cadillac de Ville.

Although there was some talk after Gala's death that Dalí would return to Port Lligat to paint, he never did. One of the psychiatrists who came to treat him at the Gala-Dalí Castle, Carlos Ballus' analysis of him after Gala's death was, 'The death of Gala marked the end of an epoch, and initiated a state of renunciation . . . the process of inversion, reclusion

The Dalí Theatre-Museum in Figueres, adorned with loaves of bread and giant eggs.

OVERLEAF The Mae West Room at the Dalí Theatre-Museum.

and renunciation is already manifesting itself. For Dalí, the loss of Gala is an immense sadness.'[19] He didn't paint and often closed himself in the dining room, with the shutters closed. According to Robert Descharnes, it appeared that Dalí was attempting to commit suicide by dehydrating himself. Apparently his intention was to return to a pupal state, which he felt would assure him of immortality.[20]

In July 1982, the King made him Marquis of Púbol, and also awarded him the Grand Cross of the Order of Charles III, the State's highest decoration. In September, a collection of 1,211 of his works were flown back to Barcelona, from New York, arranged by the Spanish State. By early 1983, Dalí seemed to perk up a little and started to paint again, but sadly he would often get frustrated and angry, throwing his brushes on the floor and later in the afternoon, coming back to his work, he sometimes destroyed the canvas itself. Even at this stage, he chose to paint in semi-darkness.[21] This slightly improved phase only lasted until the end of February, when his deteriorating mental health took a stronger grip on him. After May 1983, the Great Creator never painted again. It seemed he was now waiting for death to come, spending time in his bed, crying in the dark. He did sometimes have good days, when his mind was clear and he talked enthusiastically about new projects. In fact, around the time of his eightieth birthday, 12 May 1984, there were enough good days to give hope of a sustained improvement. Previously he had been refusing food, except for a special mint sorbet, but at this time he started to ask for omelettes and even had the odd glass of wine. By June, he had improved sufficiently to go to his Theatre-Museum for a couple of hours, accompanied and assisted. A major anthological exhibition, '400 works by Salvador Dalí from 1914 to 1983', was held in Madrid, Barcelona and Figueres.

He still needed attention and to dominate his court of attendees in Púbol, so he often rang the little bell he had, day or night, and even more so on good days. The sound of the bell exasperated his staff in the castle, so they changed it for a buzzer, which switched on a light for the nurses to see. Through his own frustration, he short-circuited the system,

by pressing on it continuously, on the night of 30 August 1984, which set fire to his huge four-poster bed. Descharnes, who had been alerted by the nurses, found him crawling under the smoke towards the bedroom door. He had sustained 80 per cent burns and needed to have skin grafts, but amazingly, he recovered and even gained weight as he was being fed through a tube. From the clinic in Barcelona, he went to live in the Torre Galatea at the Theatre-Museum, and he never returned to the Castle. His recovery was so good that he managed to give an enthusiastic interview with one of Spain's top newspapers, *El País*, in February 1985. Despite his age and health issues, he was once again mentally far more himself and he even did some drawings as gifts for a few people, including King Juan Carlos, in 1986. He was no longer reclusive, and visitors were encouraged to call on him. Dalí was even photographed and interviewed by *Vanity Fair* that year.

Sadly, the following year this energy started to slip away. From 1987 onwards, he only wanted to spend time with his friend and collaborator, Antoni Pitxot, his faithful servant Artur Caminada, and Robert Descharnes. Sleeping much of the time, as his spirit and body ebbed away gradually, he enjoyed some wakeful hours, bringing back happy Parisian memories, by listening to an old record of music that had been played at Maxim's. He suffered heart failure in November 1988, so he was brought to the Quirón Clinic in Barcelona, where he asked for a television to see the coverage of his impending death. King Juan Carlos visited him on 5 December, which improved his mood, and he told the King that he would make a recovery and start painting again. However too much of his Dalinian energy and soul had already dissipated. Although Dalí did spend time back in his Theatre-Museum in December, he had to return to the clinic, where he passed away on 23 January 1989. His corpse was taken, as he had requested, to be embalmed in the Dalí Theatre-Museum, where he lay in state for a few days, before his interment there. His remains lie in the environment where he had his first collective exhibition; one of the best places where visitors, today, can enjoy a wonderful culmination of his legacy.

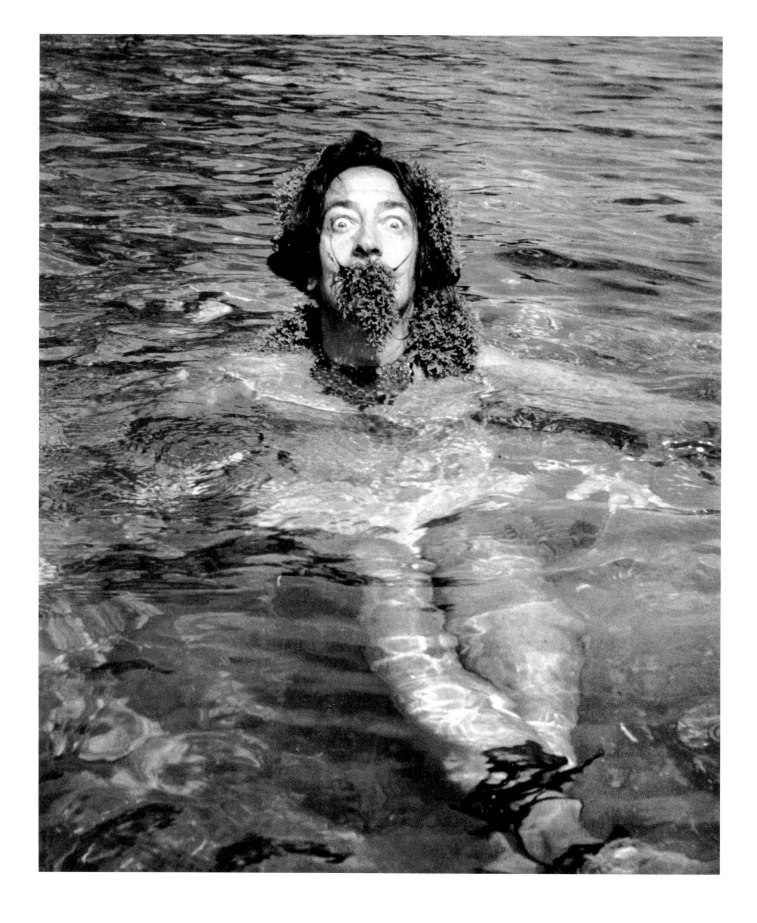

THE DALINIAN LEGACY

Dalí covered in seaweed near his home in Cadaqués, photographed for 'A Day with Salvador Dalí', *Picture Post*, 8 January 1955.

The flamboyant legend Salvador Dalí left a legacy as Surreal as his life and his creative endeavours. The Great Creator, who in 1929, portrayed himself in the eminently autobiographical painting as *The Great Masturbator*, left this world as much of an enigma as during his life, accompanied by one of his numerous canes, in a final, mischievious publicity stunt.

In his latter years, he had started referring to himself as the Divine Dalí, but regardless of his immense talent, Salvador Dalí was as human and flawed as anyone else. Like many creative people, he experienced a thin line between sanity and madness, throughout his lifetime suffering from a range of phobias and fears. In 1929, before Gala came into his life and saved him, he was deeply fearful of going mad. Later in life when he felt her love wavering, he struggled to create. On one hand, it was his paranoiac-critical method that enabled him to produce some of his most-loved works, but on the other hand it is possible that his own fears and paranoias were genetically inherited from his grandfather, Gal, who had sadly taken his own life. This aspect of Salvador Dalí, an artist with such an

important, prolific output, should be considered to be part of his legacy. It should serve as a reminder that this thin line can be both a blessing and a curse, and is best observed and used, but not stepped over: 'The only difference between me and a madman is that I'm not mad.' Yet he had openly recognised the threat of impending madness before meeting Gala in 1929.

Despite their unusual relationship, Gala was not only his muse and wife, but his all-important grounding force. Studying his life and works, it is clear that Salvador Dalí had a second element that rooted him to the earth and triggered an almost endless source of creativity. This second element was the native landscape of his beloved Catalonia. Did his need to be connected to his permanent inspiration, the only place in the world where he felt loved, drive him to show support for General Franco? This display sickened many people, but as Dalí was such a great showman, I don't believe we'll ever know whether his support was sincere, purely pragmatic, or maybe somewhat dualistic. What is evident is that the artist recognised his own deep need to spend sufficient time

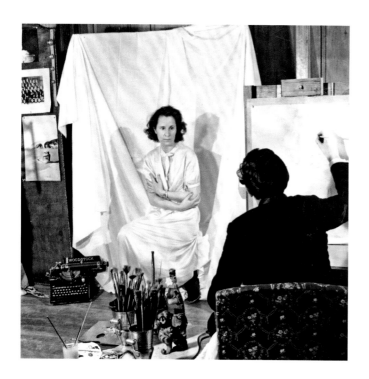

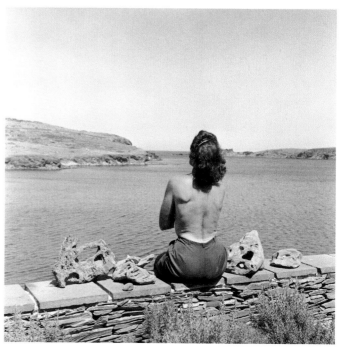

in this environment, which was the 'landscape that conditioned and stimulated the painter. I would even dare to say it gave him his identity. Dalí identified with it completely.'[1] *Guardian* art critic Jonathan Jones went so far as to describe this connection as a virtue. 'In the end, a loyalty to his Catalan landscape was Dalí's only virtue.'[2] Dalí's deep identification and connection to his local landscape could be likened to that of the Aboriginals or Native Americans. It highlights how important special environments can be, on a creative, nurturing and even spiritual level.

But what was Dalí's identity? Was he his public persona poking fun at the media and encouraging his fans to question the world as they knew it, armed with a two-metre loaf of bread, or making his entrance in a Rolls-Royce packed with cauliflowers? Or was Salvador Dalí 'the private man, the engaging person

hiding under the onion-layers of disguise', as described by his close friend, Nanita Kalaschnikoff.[3] I believe he was both. Part of his legacy was to introduce branding into the world of art. Dalí the showman had been a work-in-progress from his earlier days, when he admitted to having been shy and timid. His immense intelligence, blended with his acute sensitivity, resulted in a cocktail that at times was very fashionable but wasn't always pleasantly palatable. He asserted that there was no separation between Dalí the man and his Dalinian works across a wide range of media. This included the performance art he used to pull off his publicity stunts. He paved the way for other creatives to become seamless brands, encompassing both the person and their works. In this sense, he was Andy Warhol's most important role model, but as time went on they then served as mutual inspiration for one another.[4]

LEFT Dalí drawing Gala at Hampton Manor, Virginia, 1940.

RIGHT Gala Dalí at Cadaqués from 'A Day with Salvador Dalí', *Picture Post*, 8 January 1955.

In terms of his immense output across a wide range of creative media, Salvador Dalí also showed the world and other artists, that artistic talent did not have to be limited to a single medium. In fact, it was evident how his early work in film helped him to explore and sharpen his visual imagery. His symbols and fascinations were featured in his writing, films, paintings, Surrealist objects, holographic creations, sculpture, fashion, jewellery and designs for ballets. His hand touched a huge variety of places and products, introducing a viable practice that is commonplace today, enabling others to be more far-reaching, while further building their brand. Consider the fragrance business, and the host of names who have created their own perfume or aftershave.

However, his prolific output and experimentation with different styles and media may have added to the negative side of his reputation, which was not aided by his excessive love of money. In 2012, one of the largest and most comprehensive Dalí retrospectives attempted to bridge the chasm between what had traditionally been regarded as his good Surrealistic period and what many critics considered to be his bad commercial phase. The Dalí Retrospective at the the Centre Georges-Pompidou in Paris featured 200 works, including oil paintings, films, sculptures, and installations, which aimed to show Dalí's inner workings. The final paragraph of the *Time Out Paris* review of the show, sums it up rather well:

The exhibition conceals nothing in Dali's polymorphous nature, intelligently illustrating his journey from dreamlike figurative art to an approach that was more contemporary,

THE FASHION MAGAZINE FOR MEN · OCTOBER 1963 · ONE DOLLAR

GQ
GENTLEMEN'S
QUARTERLY

Dali foresees
fashion's
golden age

Tangier!
backdrop to
fall sportswear

conceptual and theatrical. And while he is presented in his different guises, taken altogether the whole offers us a profound coherence in Dalí's constant humour. Many artists have proclaimed that 'art is life'; far rarer are those who have absorbed the idea and turned it into an immense masquerade, with jubilant megalomania and imperious capriciousness. Dalí's life was a masked ball that lasted nearly a century, behind his unforgettable moustache.[5]

Dalí's oeuvre and legacy deserves to be considered, as the artist intended – both as a whole and holistically – with Dalí the man. He spent his life passionately creating, learning and experimenting, knowing that the creative process is a journey to be explored and discovered. His example has encouraged other creatives to follow this path, letting their creativity be an exploration.

The eccentric, household name derived much of his artistic grounding by studying the Old Masters voraciously, which was central to developing his superb Dalinian precision and draughtsmanship. He never lost his immense respect for them, during the decades when he experimented across many styles and in the latter years of his career, he gravitated back to his fascination with them. He has inspired numerous artists to do the same; to learn from and appreciate the precision and skills of the Old Masters, while at the same time finding their own interpretation and artistic style.

His study and immersion in the works of the Old Masters gave him the scope to do what he loved: turn the world upside down, parading the internal to the external and triggering the viewer's subconscious. It was precisely his exquisite precision, married with his favourite symbolic motifs, that enabled him to lay the dream world bare. Although he wasn't the official leader of Surrealism, internationally he was regarded to be not only this, but the prophet of the subconscious – the man capable of thinking the unthinkable. His works encouraged other artists to experiment with the mysterious, the personal and the emotional in their creations. The wildly juxtaposing objects he used in sculptures shook the traditional element of that medium, paving the way for great assemblage artists such as Joseph Cornell. Of course, his influence on those working in Surealist styles has been huge, but his legacy has spread through a range of illustration spectrums, contemporary visionary arts and digital art. As Jeff Koons wrote, 'What I think is important about him is how he moved from a subjective realm into mass iconography – a higher calling. Dalí was in tune with mass consciousness.'[6]

However, not only did his oeuvre influence a multitude of artists but the combination of Surrealism and psychoanalysis in his works gave people the permission to embrace themselves in all their 'human glory', warts and all. As art critic Edward Alden Jewell wrote, 'Dalí has at length humanised the Unconscious.'[7]

There's no better place to appreciate Dalí's legacy physically than in his homeland of Catalonia, but be sure to take your subconscious with you. Begin with his home town, Figueres: this is the place where you can feel how the Surreal artist came full circle. He was born there, had his first studio and art lessons there, and at the age of seventy, inaugurated his Theatre-Museum in Figueres, where his remains lie today, moustache

intact. After exploring the town and its Dalinian landmarks, the wonderful Dalí Theatre-Museum in Figueres is where you can enjoy the widest selection of his works. The Dalí Theatre-Museum, which many experts regard to be his last great masterpiece, needs to be considered as a whole. It is, exactly as Dalí intended, to be enjoyed as a complete Surrealist experience, where one moment the visitor may feel they are experiencing a great work of art, but the next moment it is time to come face to face with the bizarre, perhaps even kitsch, created by the Great Master of Illusion.

Spending time in these places allows you to get a feel for the area that was his permanent inspiration. The house-cum-studio at Port Lligat is where Dalí's spirit lingers on. Its construction spanned over forty-two years. The artist regarded it to be 'like a real biological structure'. One enters via the Bear Lobby, which then opens up into various spaces, linked by corridors, throughout a labyrinthine entity. Port Lligat bay is framed through the property's windows, which are different proportions and shapes. Inside you can almost still feel the presence of the artist, through the objects, décor and the energy of the building, and its lingering memories. This place is also where the couple received lots of famous and interesting visitors. As Dalí said, 'Port Lligat is the place of production, the ideal place for my work. Everything fits to make it so: time goes more slowly and each hour has its proper dimension. There is a geological peacefulness: it is a unique planetary case.'[8] Exploring his dreamy summertime town of Cadaqués, a fifteen-minute walk away, allows one to marvel at the dramatic, inspirational landscape of

the Cap de Creus Natural Park and the Empordà plain.

The famous Dalinian Triangle is completed by the Gala-Dalí Castle at Púbol. The artist considered it to be a continuation of Port Lligat after the restoration work was carried out, yet this site has been stamped with Gala's personality more than the other angles of the Triangle. While Dalí was responsible for some of the clever designs integrated in the Castle's refurbishment, this was Gala's domain, not his, with the exception of the sad years he lived there after her demise. Its importance is as a place to enjoy Dalí's creativity in this romantic and austere environment, while also, perhaps, marvelling at how much he must have loved and needed Gala, to buy the castle and accept that he could only visit her there by written invitation.

Salvador Dalí had a Surreal beginning in life, being told that he was the reincarnation of his dead brother, and in his later life his most important relationship grew more Surreal as time passed. He spent numerous decades performing as the questionable showman who created unquestionable masterpieces. The Surreal legacy he left permeates around us – as a child I knew Dalí's work before I knew his name, because of its immense presence in the world. Perhaps he was right, when he said, 'In the next century when children ask: who was Franco? They will answer: he was a dictator in the time of Dalí.'[9] For now, the time of Dalí continues, somehow resembling one of his melting clocks. Like the legacy of Salvador Dalí, they have a sense of eternity as they blend into their elected landscapes. These melting clocks are enigmatic much like their creator – a man who created his own myth over his lifetime, leaving a trail of question marks behind him. One wonders, however, if Salvador Dalí would have achieved his full potential without his Empordanese connection? His art and roots were so deeply enmeshed in his beloved region's unique landscape, light and colours[10] that it seems impossible to separate the Great Creator and his prolific, creative output from his native landscape.

ABOVE Dalí at Port Lligat, 1960.

OPPOSITE The swimming pool (above) and sculpture garden (below) at Port Lligat.

OVERLEAF Cap de Creus rock formations.

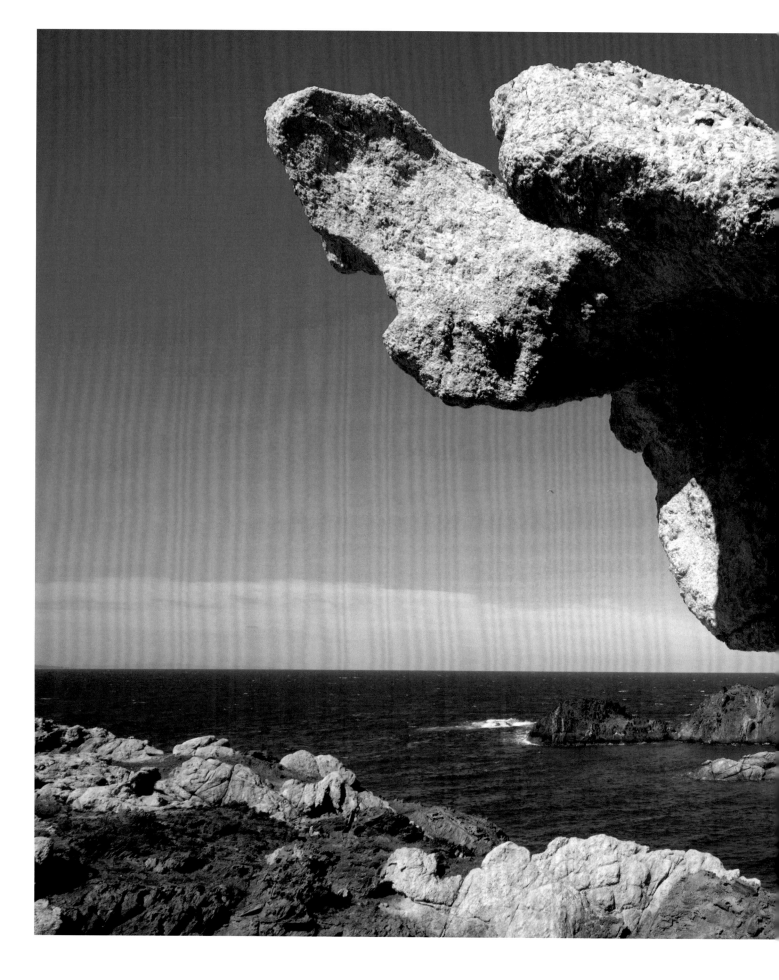

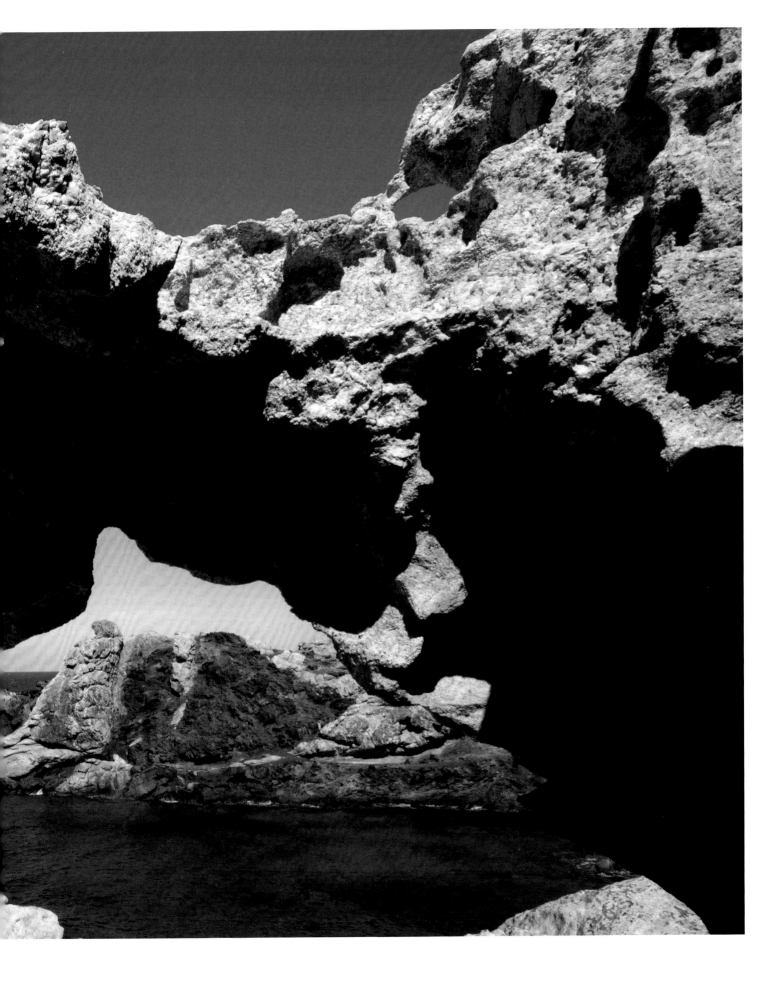

TIMELINE

1817
Pere Dalí Raguer, Dalí great-great grandfather, relocates to Cadaqués

1849
1 July, Gal Josep Salvador Dalí, Dalí's grandfather, is born in Cadaqués

1872
25 October, Salvador Rafael Aniceto, Dalí's father, is born in Cadaqués

1881
Gal relocates the family to Barcelona to escape the Tramuntana wind

1886
16 April, Gal commits suicide

1893
Dalí's father graduates in law from Barcelona University

1900
Dalí's father relocates back to the Alt-Empordà, Catalonia and marries Felipa Domènech i Ferrés

1901
12 October, birth of Dalí's older brother, the first Salvador

1903
1 August, death of the first Salvador

1904
11 May, Salvador Dalí is born

1908
6 January, Dalí's sister, Anna Maria, is born
Dalí is enrolled in the State Primary School

1909
Dalí's parents tell him he is a reincarnation of his dead brother

1910
Dalí's first known work, aged six: *Landscape Near Figueras*
Enrollment in the Christian Brother's school

1912
Dalí sets up his first small studio in new family apartment

1913
Dalí creates a series of tiny landscapes in his miniature studio

1916
Summer, spends time in the Pitxtot family's country estate, El Molí de la Torre
Autumn, studies at the Figueres Institute under Juan Nuñez

1919
Dalí's first collective exhibition, at the Concert Society, located in the Figueres Main Theatre

1920
Rents a studio at 4 Carrer Muralla

1921
February, death of Dalí's mother

1922
September, Dalí sits the entrance exam for the Real Academia de Bellas Artes de San Fernando

1923
Becomes firm friends with the group including Federico García Lorca and Luis Buñuel
Autumn, suspension from the Academy

1924
May/June, spends around one month in jail
Autumn, returns to the Academy

1925
Lorca Period begins
November, first ever solo exhibition in the Dalmau Gallery in Barcelona

1926
April, travels to Paris for the first time, meets Picasso
June, expulsion from the Academy and return to Figueres

1927
Nine months' compulsory military service

1929
Collaborates with Buñuel on the Surreal film *Un Chien Andalou*
Meets fellow Catalan artist Joan Miró in Paris
Paints *The Great Masturbator* and *The Lugubrious Game*
September, begins affair with Gala Éluard
November–December, first solo exhibition in Paris

1930
La Femme Visible published by Éditions Surréalistes
Second collaboration with Buñuel, *L'Age d'Or*
March, buys a tiny fisherman's cottage at Port Lligat

1931
First exhibition at the Pierre Colle Gallery in Paris
Paints *The Persistence of Memory*
Publication of *L'amour et la mémoire* and *Rêverie*

The Rose, 1958, oil on canvas, 37.5 × 30 cm, private collection.

1932

January, 'Surrealism: Paintings, Drawings and Photographs' opens at Julien Levy's new gallery in New York

Completes *Birth of Liquid Desires*, which he had commenced in 1931

Publication of *Babaouo*

July, Dalí and Gala move to the artist's colony of Villa Seurat; financial worries

1933

Collective exhibition at the Pierre Colle Gallery, Paris, followed by solo exhibition there from 19 to 29 June

21 November to 8 December, first solo exhibition takes place in the Julien Levy Gallery, New York

1934

January, marries Gala in a civil ceremony

October, political uprising in Barcelona

November, the Dalís sail to the United States

1935

Initial reconciliation with his father

July, publication of 'The Conquest of the Irrational', explaining the paranoiac-critical method

Paints *Suburbs of a Paranoiac-Critical Town*

Autumn, the Dalís meet Edward James and travel with him to Italy, staying at Villa Cimbrone in Ravello

1936

The Dalís purchase another fisherman's cottage at Port Lligat

International Surrealist Exhibition at New Burlington Galleries, London

Creation of the *Lobster Telephone* for Edward James

17 July 1936, outbreak of Spanish Civil War

19 August 1936, murder of Lorca by Fascist firing squad

1937

Visits Hollywood

Completes *Metamorphosis of Narcissus* and *Swans Reflecting Elephants*

1938

Exposition Internationale du Surréalisme in Paris, featuring his elaborate Surrealist Object, the *Rainy Taxi*

September, stays at Coco Chanel's property, La Pausa, on the French Riviera

1939

1 April, end of the Spanish Civil War

Designs *Dream of Venus Pavilion* for the New York World Fair

Designs costumes and sets for the ballet, *Bacchanale*

1940

The Dalís flee to America after German troops enter Bordeaux

1941

Exhibits at Julien Levy's gallery; critics question Dalí's conversion to Classicism

Summer, the Dalí's first summer stay at the Hotel del Monte in Monterrey

2 September, the costume ball 'A Surrealist's Night in an Enchanted Forest'

1942

Dalí's autobiography, *The Secret Life of Salvador Dalí*, is published

1944

Dalí's novel, *Hidden Faces*, is published

Paints *Dream Caused by the Flight of a Bee Around a Pomegranate a Second Before Awakening*

1945

September, works with Hitchcock on dream sequences for *Spellbound*

20 November to 29 December, 'Recent Paintings by Salvador Dalí' exhibition at the Bignou Gallery in New York

First edition of the spoof-style *Dalí News*

1946

Paints *The Temptation of Saint Anthony*

1947

25 November to 5 January 1948, second exhibition at the Bignou Gallery, New York

1948

50 Secrets of Magic Craftsmanship is published

July, the Dalís return to Catalonia from America

1949

Dalí completes religious painting, *The Madonna of Port Lligat*

Summer, works on costumes and sets for three productions

November, the Dalís travel to Rome and have an audience with Pope Pius XII

December, Dalí's sister, Anna Maria, releases her memoirs, *Salvador Dalí as Seen by his Sister*

1950

Summer, produces illustrations for Dante's *Divine Comedy*

22 September, death of Salvador Rafael Aniceto, the artist's father

October, delivers a talk in Barcelona: 'Why I Was Sacrilegious, Why I Am Mystical'

1951

Paints *Christ of Saint John of the Cross*

April, publication of *Manifeste Mystique* (Mystical Manifesto) based on the talk given in Barcelona

Gives his famous talk comparing himself to Picasso

1952

Series of American lectures on his Nuclear Mysticism technique

1954

Collaborates with Philippe Halsman on the book *Dalí's Mustache*

1955

February, meets Nanita Kalaschnikoff

30 April, Dalí paints a rhinoceros in the Zoo de Vincennes, Paris

1956

16 June, Franco receives the artist at the Royal Palace of El Pardo in Madrid

Pays homage to Gaudí in Güell Park, Barcelona, while creating a work live

Publication of *The Cuckolds of Antiquated Modern Art*

1957

Visited by Walt Disney in Port Lligat

1958

Dalí is reborn in Rome

8 August, Salvador and Gala are married in a private church ceremony in Els Angels, Catalonia

1959

May, has a private audience with Pope John XXIII

Presents his Ovocipède in Paris and New York

1960

April, second collaboration with Philippe Halsman, on short film, *Chaos and Creation*

1963

Paints *Galacidalacidesoxyribonucleicacid*

1964

Gala begins her love affair with William Rothlein

Mainichi Newspapers organises a retrospective exhibition in Tokyo

Diary of a Genius is published

1965

Dalí meets Amanda Lear

Andy Warhol films Dalí for his *Screen Tests* series

1966

Open Letter to Salvador Dalí is published, including thirty-three illustrations

Alain Bosquet's *Entretiens avec Salvador Dalí* (Conversations with Salvador Dalí) is published

1966

Completes *Tuna Fishing*

1968

27 March to 9 June, collective exhibition of more than 300 works spanning the Dada and Surrealist periods, at the Museum of Modern Art, New York

1969

Dalí buys a castle in Púbol, for Gala, which he then has renovated

1970

Press conference at the Gustave Moreau Museum in Paris to announce the creation of the Dalí Theatre-Museum in Figueres

1971

The Morse Collection is inaugurated into the Dalí Museum in Cleveland, Ohio

1972

Hologram exhibition at the Knoedler Gallery in New York, including Dalí's *Holos! Holos! Velázquez! Gabor!*

1973

'Dalí: His Art in Jewels' is presented in the Dalí Theatre-Museum

Gala begins her last great love affair with Jeff Fenholt

1974

28 September, official inauguration of the Dalí Theatre-Museum

The Dalí forgery scandal comes to light

1975

Creates a series of ten lithographs for *Romeo and Juliet*

20 November, death of General Franco

1978

Dalí Lifting the Skin of the Mediterranean to Show Gala the Birth of Venus is presented at the Solomon R. Guggenheim Museum in New York

1979

Appointed as an Associate Overseas Member of the Académie des Beaux-Arts of the Institut de France

Major retrospective at the Centre Georges-Pompidou in Paris

1980

Medication is administered by Gala, which may have caused irreversible brain damage

14 May to 29 June, retrospective at London's Tate Gallery

1981

Receives visits from both the Catalan Prime Minister and the King and Queen of Spain

1982

January, King Juan Carlos names Dalí Marquis of Púbol and awards him the Grand Cross of the Order of Charles III

The Salvador Dalí Museum is inaugurated in St Petersburg, Florida

10 June, death of Gala

1983

The Swallow's Tail – Series on Catastrophes, Dalí's final painting

Major exhibition in Madrid, Barcelona and Figueres: '400 works by Salvador Dalí from 1914 to 1983'

1984

After a fire at Púbol Castle, Dalí moves for good to Torre Galatea, Figueres

1989

23 January, death of Salvador Dalí in Figueres

NOTES

Roots & Environment (pages 8–19)

1 Néret, Gilles, *Dalí* (Taschen, Cologne, 2004), p.8
2 Etherington-Smith, Meredith, *Dalí* (Sinclair Stevenson, London, 1992), p.9
3 Gibson, Ian, *The Shameful Life of Salvador Dalí* (Faber and Faber, London, 1997), p.8
4 'Documentary on Dalí and his studio in Portlligat', Gala-Salvador Dalí Foundation, 1 July 2017, https://www.salvador-dali.org/en/services/press/news/343/documentary-on-dali-and-his-studio-in-portlligat
5 Gibson, Ian, *The Shameful Life of Salvador Dalí*, p.3
6 Thurlow, Clifford, *Sex, Surrealism, Dalí and Me, The Memoirs of Carlos Lozano* (YellowBay Books Ltd, 2011), p.15
7 Pollack, Rachael, *Salvador Dalí's Tarot* (Michael Joseph, London, 1985)
8 Gibson, Ian, *The Shameful Life of Salvador Dalí*, p.5
9 'Salvador Dalí', Tate Gallery, London, http://www.tate.org.uk/art/artists/salvador-dali-971
10 Gibson, Ian, *The Shameful Life of Salvador Dalí*, p.18
11 *Ibid.*, p.21
12 Etherington-Smith, Meredith, *Dalí*, p.9
13 Chaplin, Patrice, *The Portal: An Initiate's Journey into the Secret of Rennes-le-Château* (Quest Books, 2010), p. 255
14 Gibson, Ian, *The Shameful Life of Salvador Dalí*, p.22
15 Etherington-Smith, Meredith, *Dalí*, p.310
16 Dalí, Salvador, *The Secret Life of Salvador Dalí* (Dover, New York, 1993), p.27
17 Kocialkowska, Kamila, 'Five things you didn't know about Salvador Dalí', *New Statesman*, 20 November 2012
18 Dalí, Salvador, *The Secret Life of Salvador Dalí*, p.1
19 *Ibid.*, p.10
20 Etherington-Smith, Meredith, *Dalí*, p.2-3
21 *Ibid.*, p.4
22 Dalí, Salvador, *The Secret Life of Salvador Dalí*, p.12
23 *Ibid.*, p.5
24 *Ibid.*
25 *Ibid.*, p.1

Incomparable Beauty & Optical Illusions (pages 22–31)

1 Cristina Jutge, 'Portrait of the adolescent artist', Gala-Salvador Dalí Foundation, 12 September 2005, https://www.salvador-dali.org/en/research/archives-en-ligne/download-documents/9/portrait-of-the-adolescent-artist
2 Dalí, Salvador, *The Secret Life of Salvador Dalí*, pp.36–7
3 Dalí, Salvador, *The Secret Life of Salvador Dalí*, p.40
4 *Ibid.*
5 *Ibid.*
6 Dalí, Salvador, *The Secret Life of Salvador Dalí*, p.41
7 *Ibid.*
8 *Ibid.*
9 Cristina Jutge, 'Portrait of the adolescent artist', Gala-Salvador Dalí Foundation, 12 September 2005, https://www.salvador-dali.org/en/research/archives-en-ligne/download-documents/9/portrait-of-the-adolescent-artist
10 Descharnes, Robert/Néret, Gilles, *Salvador Dalí* (Taschen, Cologne, 1993), p.8
11 Dalí, Salvador, *50 Secrets of Magic Craftsmanship* (Dover, New York, 2015), pp.61–2

12 Dalí, Salvador, *The Secret Life of Salvador Dalí*, p.63
13 *Ibid.*, p.64
14 *Ibid.*, p.66
15 Gibson, Ian, *The Shameful Life of Salvador Dalí*, p.40

A Whole World of Aspirations (pages 32–9)

1 Keeley, Graham, 'Dalí's Bohemian Barcelona', *The Times*, 2 June 2007
2 Dalí, Salvador, *The Secret Life of Salvador Dalí*, p.71
3 *Ibid.*
4 *Ibid.*, p.72
5 Dalí, Salvador, *50 Secrets of Magic Craftsmanship*, pp.40–1
6 Dalí, Salvador, *The Secret Life of Salvador Dalí*, p.77
7 Gibson, Ian, *The Shameful Life of Salvador Dalí*, p.47
8 Dalí, Salvador, *The Secret Life of Salvador Dalí*, p.77
9 *Ibid.*, pp.88–9
10 *Ibid.*, p.140
11 Sala Reig, Neus, 'Ramón Reig and Salvador Dalí: Biographical Coincidences and Artistic Analogies Between Two Contemporary Painters Attached to the Empordà Landscape and to the "Empordanese Spirit"', *Barcelona, Research, Art, Creation* 4(3), pp.272–99
12 Gibson, Ian, *The Shameful Life of Salvador Dalí*, p.53
13 Dalí, Salvador, *The Secret Life of Salvador Dalí*, p.116
14 *Ibid.*, p.124
15 *Ibid.*, p.127
16 McNeese, Tim, *Salvador Dalí* (Ediciones Poligrafa, Madrid, 2003) p.36
17 Etherington-Smith, Meredith, *Dalí*, p.4
18 Gibson, Ian, *The Shameful Life of Salvador Dalí*, p.67
19 Dalí, Salvador, *Un Diari: 1919–20* (Gala-Salvador Dalí Foundation, Figueres), p.105
20 Jutge, Cristina, 'Portrait of the Adolescent Artist', Gala-Salvador Dalí Foundation, 12 September 2005, https://www.salvador-dali.org/en/research/archives-en-ligne/download-documents/9/portrait-of-the-adolescent-artist

From Hermit to Dandy in Madrid (pages 40–9)

1 Dalí, Salvador, *The Secret Life of Salvador Dalí*, p.176
2 Real Academia de Bellas Artes de San Fernando, http://www.ealacademiabellasartessanfernando.com/es/academia/edificio
3 Dalí, Salvador, *The Secret Life of Salvador Dalí*, p.151
4 *Ibid.*, p.160
5 *Ibid.*, p.159
6 Descharnes, Robert/Néret, Gilles, *Salvador Dalí*, pp.17-18
7 Shanes, Eric, *The Life and Masterworks of Salvador Dalí* (Temporis Collection, Digital Edition, 2010), Location 82
8 Dalí, Salvador, *The Secret Life of Salvador Dalí*, p.184
9 *Ibid.*, p.198
10 *Ibid.*
11 Aguer, Montse, 'Dalí and Fages: "that intelligent and most cordial of collaborations"', Gala-Salvador Dalí Foundation, https://www.salvador-dali.org/en/research/archives-en-ligne/download-documents/6/dali-and-fages-that-intelligent-and-most-cordial-of-collaborations
12 Dalí, Salvador, *The Secret Life of Salvador Dalí*, p.201
13 Esteban Leal, Paloma, 'Pierrot tocant la guitarra (Pintura cubista)', Reina Sofía National Museum Centre of Art,

1990, http://www.museoreinasofia.es/en/collection/artwork/pierrot-tocant-guitarra-pintura-cubista-pierrot-playing-guitar-cubist-painting
14 Descharnes, Robert/Néret, Gilles, *Salvador Dalí*, p.26
15 Dalí, Salvador, *The Secret Life of Salvador Dalí*, p.206
16 Shanes, Eric, *The Life and Masterworks of Salvador Dalí*, Location 137
17 Dalí, Salvador, *The Secret Life of Salvador Dalí*, p.204

Pouncing on Paris (pages 50–9)

1 Dalí, Salvador, *The Secret Life of Salvador Dalí*, pp.209-10
2 *Ibid.*, p.204
3 *Ibid.*, p.205
4 Gibson, Ian, *The Shameful Life of Salvador Dalí*, p.149
5 Shanes, Eric, *The Life and Masterworks of Salvador Dalí*, Location 46
6 Gibson, Ian, *The Shameful Life of Salvador Dalí*, p.155
7 Dalí, Salvador, 'Sant Sebastià', *L'Amic de les Arts*, Sitges, year II, no. 16, 31 July 1927, pp.52–4
8 Shanes, Eric, *The Life and Masterworks of Salvador Dalí*, Location 156
9 Dalí, Salvador, *The Secret Life of Salvador Dalí*, p.207
10 *Ibid.*, p.206
11 Descharnes, Robert/Néret, Gilles, *Salvador Dalí*, p.27
12 Gibson, Ian, *The Shameful Life of Salvador Dalí*, p.202
13 *Ibid.*, p.205
14 Dalí, Salvador, *The Secret Life of Salvador Dalí*, p.210
15 Gibson, Ian, *The Shameful Life of Salvador Dalí*, pp.203–4
16 Dalí, Salvador, *The Secret Life of Salvador Dalí*, p.220
17 Gibson, Ian, *The Shameful Life of Salvador Dalí*, p.210-11
18 Shanes, Eric, *The Life and Masterworks of Salvador Dalí*, Location 190
19 Dalí, Salvador, *The Secret Life of Salvador Dalí*, p.217
20 *Ibid.*, p.218
21 *Ibid.*
22 Grant, Annette, 'The Marriage à Trois That Cradled Surrealism', *New York Times*, 3 April 2005
23 Dalí, Salvador, *The Secret Life of Salvador Dalí*, p.233

Stepping into Surrealism (pages 60–77)

1 'The Dalinian Triangle', Gala-Salvador Dalí Foundation, https://www.salvador-dali.org/en/museums/the-dalinian-triangle/
2 Dalí, Salvador, *The Secret Life of Salvador Dalí*, p.226
3 Descharnes, Robert/Néret, Gilles, *Salvador Dalí*, p.37
4 Dalí, Salvador, *The Secret Life of Salvador Dalí*, p.234
5 Lear, Amanda, *My Life with Dalí* (Virgin Books Ltd., London, 1985), p.25
6 Cooper, Rachel, 'Review – Psychopathia Sexualis', *Metapsychology Mental Health*, 2003, http://metapsychology.mentalhelp.net/poc/view_doc.php?type=book&id=1562
7 Shanes, Eric, *The Life and Masterworks of Salvador Dalí*, Location 247
8 Descharnes, Robert/Néret, Gilles, *Salvador Dalí*, p.50
9 Dalí, Salvador, *The Unspeakable Confessions of Salvador Dalí* (1973) in *Complete Works: Autobiographical Texts*, vol. 2 (Ediciones Destino, Barcelona/Gala-Salvador Dalí Foundation, Figueres, 2003), p.463
10 Dalí, Salvador, *The Secret Life of Salvador Dalí*, p.250

11 Emerald Tufts, *Paranoid-Critical Method,* http://emerald.
tufts.edu/programs/mma/fah188/clifford/Subsections/
Paranoid%20Critical/paranoidcriticalmethod.html

12 *Ibid.*

13 Dalí, Salvador, *The Secret Life of Salvador Dalí,* p.251

14 *Ibid.,* p.252

15 *Ibid.,* p.253

16 *Ibid.,* pp.253–4

17 Descharnes, Robert/Néret, Gilles, *Salvador Dalí,* p.55

18 Dalí, Salvador, *The Secret Life of Salvador Dalí,* p.258

19 *Ibid.,* pp.257–8

20 *Ibid.,* p.258

21 Ultra Violet (Dufresne, Isabelle), *Famous for 15 Minutes:
My Years with Andy Warhol* (Harcourt Brace Jovanovich,
San Diego, New York, 1988), p. 77

22 Roig, Sebastià, *The Empordà Triangle* (Gala-Salvador Dalí
Foundation, Triangle Books, Figueres, 2016), p.7

23 Gibson, Ian, *The Shameful Life of Salvador Dalí,* p.278

24 *Ibid.,* p.279

25 MoMA Learning (Museum of Modern Art, New York),
The Persistence of Memory, https://www.moma.org/learn/
moma_learning/1168-2

26 Gibson, Ian, *The Shameful Life of Salvador Dalí,* p.280

27 Néret, Gilles, *Dalí,* p.34

28 Ades, Dawn, *Dalí* (World Art Series, Thames and
Hudson, London, 1992), p.70

29 Gibson, Ian, *The Shameful Life of Salvador Dalí,* p.285-6

Fascinations, Fantasies & Finances (pages 78–87)

1 Parkinson, Gavin, in *op. cit,* https://www.salvador-
dali.org/en/research/archives-en-ligne/download-
documents/16/salvador-dali-and-science-beyond-a-
mere-curiosity#_ftnref11

2 Gibson, Ian, *The Shameful Life of Salvador Dalí,* p.286

3 *Ibid.,* p.293

4 Jacobs, Lisa, *Julien Levy's Surrealist Art Galaxy,* http://
www.lisajacobsfineart.com/j_levy.pdf

5 'Surrealisme', *Artnews,* 16 January 1932, p.10

6 Gibson, Ian, *The Shameful Life of Salvador Dalí,* p.284

7 Freeman, Laura, 'Salvador Dalí and Marcel Duchamp: the
surreally odd couple at the Royal Academy', *Sunday Times,*
8 October 2017

8 The Guggenheim, *Salvador Dalí, Birth of Liquid Desires (La
naissance des désirs liquides),* https://www.guggenheim.org/
artwork/935

9 Gibson, Ian, *The Shameful Life of Salvador Dalí,* p.299

10 Royal Academy of Arts, *Dalí/Duchamp,* https://www.
royalacademy.org.uk/exhibition/dali-duchamp

11 Parkinson, Gavin, in *op. cit.,* https://www.salvador-
dali.org/en/research/archives-en-ligne/download-
documents/16/salvador-dali-and-science-beyond-a-
mere-curiosity#_ftnref11

12 Lyle, Peter, 'The Crosbys: literature's most scandalous
couple', *The Telegraph,* 19 June 2009

13 Dalí, Salvador, *The Secret Life of Salvador Dalí,* p.327

14 Gibson, Ian, *The Shameful Life of Salvador Dalí,* p.304

15 Dalí, Salvador, *The Secret Life of Salvador Dalí,* p.324

16 Néret, Gilles, *Dalí,* p.36

17 Dalí, Salvador, *The Secret Life of Salvador Dalí,* p.290

18 'Babaouo', Gala-Salvador Dalí Foundation, https://www.

salvador-dali.org/en/dali/dali-film-library/films-and-
video-art/1/babaouo

19 Gibson, Ian, *The Shameful Life of Salvador Dalí,* p.316

20 Mumford, Robert, *Mumford on Modern Art in the 1930s*
(University of California Press, 2007), p.107

21 Gibson, Ian, *The Shameful Life of Salvador Dalí,* p.333

22 Dalí, Salvador, *The Secret Life of Salvador Dalí,* p.327

23 *Ibid.*

24 *Ibid.*

25 *Ibid.,* p.331

26 *Ibid.,* p.328

I am Surrealism (pages 88–101)

1 Dalí, Salvador, *The Unspeakable Confessions of Salvador
Dalí* (1973) in *Complete Works: Autobiographical Texts,* vol.
2 (Ediciones Destino, Barcelona/Gala-Salvador Dalí
Foundation, Figueres, 2003)

2 Gibson, Ian, *The Shameful Life of Salvador Dalí,* p.344

3 Martinez-Conde, Susana; Conley, Dave; Hine,
Hank; Kropf, Joan; Tush, Peter; Ayala, Andrea; and
Macknik, Stephen L., 'Marvels of illusion: illusion and
perception in the art of Salvador Dalí', *Frontiers in Human
Neuroscience,* September 2015

4 'Suburbs of the "paranoiac-critical town" (Suburbis de la
ciutat paranoico crítica)', Gala-Salvador Dalí Foundation,
http://www.salvador-dali.org/cataleg_raonat/fitxa_obra.
php?text=outskirts&obra=434

5 Gibson, Ian, *The Shameful Life of Salvador Dalí,* p.349

6 Dalí, Salvador, *The Secret Life of Salvador Dalí,* p.345

7 *Ibid.,* p.346

8 *Ibid.,* p.348

9 *Ibid.,* p.350

10 *Ibid.*

11 Gibson, Ian, *The Shameful Life of Salvador Dalí,* p.348

12 Melly, George, *Swans Reflecting Elephants* (Weidenfeld and
Nicholson, London, 1982), p.6

13 Gibson, Ian, *The Shameful Life of Salvador Dalí,* p.351

14 Dalí, Salvador, *The Secret Life of Salvador Dalí,* p.361

15 Gibson, Ian, *The Shameful Life of Salvador Dalí,* p.352

16 *Ibid.*

17 Moorhead, Joanna, 'Dalí in a diving helmet: how the
Spaniard almost suffocated bringing surrealism to Britain',
Guardian, 1 June 2016

18 *Ibid.*

19 Dalí, Salvador, *The Secret Life of Salvador Dalí,* p.271

20 *Ibid.,* p.332

21 *Ibid.,* p.345

22 Dalí, Salvador, *The Unspeakable Confessions of Salvador
Dalí* (1973) in *Complete Works: Autobiographical Texts,* vol.
2 (Ediciones Destino, Barcelona/Gala-Salvador Dalí
Foundation, Figueres, 2003)

23 Kennedy, Randy, 'Mr. Surrealist Goes to Tinseltown',
New York Times, 29 June 2008

24 Riggs, Terry, *Salvador Dalí, Metamorphosis of Narcissus,
1937,* The Tate Gallery, March 1998

25 Ades, Dawn, *Dalí,* p.74

26 Etherington-Smith, Meredith, *Dalí,* p.269

27 Gibson, Ian, *The Shameful Life of Salvador Dalí,* p.397

28 Watson, Nanette, 'Coco Chanel's Villa La Pausa, Houses
with History', 4 May 2012, https://houseswithhistory.

wordpress.com/2012/05/04/coco-chanels-villa-la-pausa/

29 Dalí, Salvador, *The Secret Life of Salvador Dalí,* p.363

30 *Bacchanale, 1939,* Dalí Paintings, https://www.
dalipaintings.com/bacchanale.jsp

31 Sutton, Tina, *Goodbye Dalí: A Surreal Experience at the
Ballet,* The Making of Markova, August 2013, https://
themakingofmarkova.com/2013/08/16/goodbye-dali-a-
surreal-experience-at-the-ballet/

Camping out in America (pages 102–9)

1 *Salvador Dalí: Liquid Desire,* National Gallery of Victoria,
2009, p.265

2 Salvador Dalí, 'Times-Dispatch', 24 November 1940,
quoted in *Dalí: The Centenary Retrospective,* 2004

3 Gibson, Ian, *The Shameful Life of Salvador Dalí,* p.405

4 King, Elliott H.; Aguer Teixidor, Montse; Hine, Hank;
Jeffett, William, *Salvador Dalí: The Late Work* (Yale
University Press in association with the High Museum of
Art, 2010), p.15

5 Dalí, Salvador, *Dalí: A Study of His Jewels* catalogue, 1959

6 Descharnes, Robert/Néret, Gilles, *Salvador Dalí,* p.136

7 Gibson, Ian, *The Shameful Life of Salvador Dalí,* p.439

8 Salvador Dalí, *Hidden Faces* (Peter Owen, London, 2016)

9 Schorer, Mark, 'It's Boring, but Is It Art?' *New York Times,*
11 June 1944

10 Crow, Jonathan, 'Salvador Dalí Goes to Hollywood
& Creates Wild Dream Sequences for Hitchcock &
Vincente Minnelli', Open Culture, http://www.
openculture.com/2015/08/salvador-dali-goes-to-
hollywood-creates-wild-dream-sequences-for-
hitchcock-vincente-minnelli.html

11 Kennedy, Randy, 'Mr. Surrealist Goes to Tinseltown',
New York Times, 29 June 2008

12 Jewell, Edward Alden, 'Dalí, An Enigma? Only His
Exegesis', *New York Times,* 21 November 1945

13 *Ibid.*

14 Dalí, Salvador, *The Unspeakable Confessions of Salvador
Dalí* (1973) in *Complete Works: Autobiographical Texts,* vol.
2 (Ediciones Destino, Barcelona/Gala-Salvador Dalí
Foundation, Figueres, 2003), p.603

Religious & Political Metamorphosis (page 110–21)

1 Dalí, Salvador, *Diary of a Genius* (Solar Art Directives,
1964), p.26

2 Gibson, Ian, *The Shameful Life of Salvador Dalí,* p.446

3 Preston, Paul, 'Spain feels Franco's legacy 40 years after
his death', BBC, http://www.bbc.com/news/world-
europe-34844939

4 Domke, Joan, 'Education, Fascism, and the Catholic
Church in Franco's Spain', Loyola University Chicago
disseration, p.10, http://ecommons.luc.edu/cgi/
viewcontent.cgi?article=1103&context=luc_diss

5 *Salvador Dalí Liquid Desire,* A National Gallery of
Victoria Education Resource, http://www.ngv.vic.gov.
au/dali/salvador/resources/DaliandReligion.pdf

6 Gibson, Ian, *The Shameful Life of Salvador Dalí,* p.446

7 Dannatt, Adrian, 'Dalí in Manhattan', *St. Regis Online
Magazine,* http://magazine.stregis.com/the-surreal-life-
of-dali-in-new-york/

8 Warhol, Andy; Colacello, Bob, *Andy Warhol's Exposures,*

(Grosset & Dunlap, New York, 1979), p.127

9 Thurlow, Clifford, *Sex, Surrealism, Dalí and Me*, p.36

10 Ultra Violet, *Famous for 15 Minutes: My Years with Andy Warhol*, p.69

11 *Ibid.*, p.71

12 Maurell, Rosa Maria, 'Mythological References in the work of Salvador Dalí: the myth of Leda', Centre of Dalínian Studies, Gala-Salvador Dalí Foundation, https://www.salvador-dali.org/en/research/archives-en-ligne/download-documents/3/mythological-references-in-the-work-of-salvador-dali-the-myth-of-leda

13 *Ibid.*

14 Gibson, Ian, *The Shameful Life of Salvador Dalí*, p.454

15 *Ibid.*, p.456

16 *Ibid.*, pp.458–9

17 *Salvador Dalí Liquid Desire*, A National Gallery of Victoria Education Resource, http://www.ngv.vic.gov.au/dali/salvador/resources/DaliandReligion.pdf

18 Dalí, Salvador, *Mystical Manifesto*, 1951 in *The Collected Writings of Salvador Dalí* (Cambridge University Press, 1998), p.364

19 Jones, Jonathan, 'Kitsch and lurid but also a glimpse of a strange soul', *Guardian*, 27 January 2009

20 *Ibid.*

21 Gibson, Ian, *The Shameful Life of Salvador Dalí*, p.467

22 *Ibid.*, p.473

23 *Ibid.*, p.474

24 Kramer, Max, 'Images of Christ. Salvador Dalí: The Sacrament of the Last Supper', 21 February 2010, https://www.joh.cam.ac.uk/sites/default/files/documents/21%20February%202010.pdf

25 Palomar Baró, Eduardo, 'Dalí Franquista', Francisco Franco National Foundation, http://www.fnff.es/Dali_franquista_2224_c.htm

26 Thurlow, Clifford, *Sex, Surrealism, Dalí and Me*, p.39

27 Dalí, Salvador, *Les Cocus du Vieil Art Moderne* (Grasset, Paris, 2004)

28 Gibson, Ian, *The Shameful Life of Salvador Dalí*, p.483

29 *Ibid.*

30 *Ibid.*, p.485

31 *Ibid.*, p.313

32 'Disney and Dalí: Architects of the Imagination Exhibition', https://waltdisney.org/exhibitions/disney-and-dali-architects-imagination

33 'Salvador Dalí', Moderna Museet, https://www.modernamuseet.se/stockholm/en/exhibitions/dali-dali/salvador-dali/salvador-dali/

34 Gibson, Ian, *The Shameful Life of Salvador Dalí*, p.493

35 'Salvador Dalí Ovocipede', Associated Press Images, 22 December 1959

Science, Spirit & the Sovereignty of Gala (pages 122–37)

1 'Gala Dalí Castle in Púbol. History', Gala-Salvador Dalí Foundation, https://www.salvador-dali.org/en/museums/gala-dali-castle-in-pubol/historia/

2 'Chaos and Creation', Gala-Salvador Dalí Foundation, https://www.salvador-dali.org/en/dali/dali-film-library/films-and-video-art/7/chaos-and-creation

3 Robinson, Walter, 'Weekend Update', *Artnet*, http://www.artnet.com/magazineus/reviews/robinson/robinson7-3-08.asp

4 'Dalí's Factory I', *Formidable Magazine*, http://www.formidablemag.com/salvador-dali-factory/

5 'Crick and Watson (1916–2004)', *BBC History*, http://www.bbc.co.uk/history/historic_figures/crick_and_watson.shtml

6 Ruiz, Carmen, 'Salvador Dalí and science. Beyond a mere curiosity', Gala-Salvador Dalí Foundation, https://www.salvador-dali.org/en/research/archives-en-ligne/download-documents/16/salvador-dali-and-science-beyond-a-mere-curiosity

7 Ultra Violet, *Famous for 15 Minutes: My Years with Andy Warhol*, pp.72–3

8 *Ibid.*, p.73

9 Gibson, Ian, *The Shameful Life of Salvador Dalí*, p.510

10 Otte, Torsten, *Salvador Dalí & Andy Warhol: Encounters in New York and Beyond*, (Scheidegger & Spiess, Zurich, 2016), p.109

11 Gibson, Ian, *The Shameful Life of Salvador Dalí*, p.527–8

12 Lear, Amanda, *My Life with Dalí*, p.12

13 *Ibid.*, p.13

14 *Ibid.*, p.34

15 Gibson, Ian, *The Shameful Life of Salvador Dalí*, p.525

16 'Dada, Surrealism, and Their Heritage', Press Release, Museum of Modern Art, New York, 25 March 1968, https://www.moma.org/documents/moma_press-release_326559.pdf

17 Dalí, Salvador, *The Unspeakable Confessions of Salvador Dalí* (1973) in *Complete Works: Autobiographical Texts*, vol. 2 (Ediciones Destino, Barcelona/Gala-Salvador Dalí Foundation, Figueres, 2003)

18 Lissack, Sewell, 'Dalí in Holographic Space', *SPIE Professional*, January 2014, https://spie.org/membership/spie-professional-magazine/spie-professional-archives-and-special-content/2014_jan_archive_spie_pro/dali-in-holographic-space?SSO=1

19 Ruiz, Carmen, '"What's new? Velázquez." Salvador Dalí and Velázquez', Gala-Salvador Dalí Foundation, https://www.salvador-dali.org/en/research/archives-en-ligne/download-documents/2/what-s-new-velazquez-salvador-dali-and-velazquez

20 Gibson, Ian, *The Shameful Life of Salvador Dalí*, pp.555–6

21 Koons, Jeff, 'Who Paints Bread Better than Dalí?', *Tate Etc.*, Issue 3, Spring 2005

22 Lot 104 - Salvador Dali – Compression, Auction FR, https://www.auction.fr/_fr/lot/salvador-dali-compression-3654448#.WiVQhVWnHRZ

23 'Homage to Ariane Lancell', 20th Century Masterworks, http://20thcenturymasterworks.cybermill.com/lancell.html

24 'Central Panel of the Wind Palace Ceiling', Gala-Salvador Dalí Foundation, https://www.salvador-dali.org/en/museums/dali-theatre-museum-in-figueres/the-collection/123/central-panel-of-the-wind-palace-ceiling

Immortality & Death (pages 138–49)

1 Aguer, Montse, 'The Dalí Theatre-Museum: the result of an artist's obsessive zeal for research', Gala-Salvador Dalí Foundation, https://www.salvador-dali.org/en/research/archives-en-ligne/download-documents/7/the-dali-theatre-museum-the-result-of-an-artist-s-obsessive-zeal-for-research

2 Meisler, Stanley, 'Salvador Dalí as You've Never Seen Him', *LA Times*, 15 May 2005

3 'Dalí, The Genius From Cadaqués', *Cap Creus Online*, http://www.cbrava.com/en/magazine/dali-the-genius-from-cadaques/

4 The Mike Wallace Interview with Salvador Dalí, 1958, https://www.youtube.com/watch?v=eoKh0GU38BA

5 'Dalí, The Genius From Cadaqués', *Cap Creus Online*, http://www.cbrava.com/en/magazine/dali-the-genius-from-cadaques/

6 'Dalí Theatre-Museum. History', Gala-Salvador Dalí Foundation, https://www.salvador-dali.org/en/museums/dali-theatre-museum-in-figueres/historia/

7 Gibson, Ian, *The Shameful Life of Salvador Dalí*, p.561

8 *Ibid.*, p.563

9 Martinez-Conde, Susana, 'Dalí Masterpieces Inspired by Scientific American', *Scientific American*, 17 June 2014

10 'Gala Contemplating the Mediterranean Sea which at Twenty Meters Becomes the Portrait of Abraham Lincoln-Homage to Rothko (Second Version)', The Dalí Museum, http://archive.thedali.org/mwebcgi/mweb.exe?request=record;id=152;type=101

11 Gibson, Ian, *The Shameful Life of Salvador Dalí*, p.569

12 Markham, James M., 'For Salvador Dalí, Life Itself Has Become a Surreal Canvas', *New York Times*, 12 October 1980

13 Gibson, Ian, *The Shameful Life of Salvador Dalí*, p.574

14 Markham, James M., 'For Salvador Dalí, Life Itself Has Become a Surreal Canvas', *New York Times*, 12 October 1980

15 Gibson, Ian, *The Shameful Life of Salvador Dalí*, p.583

16 *Ibid.*

17 *Ibid.*, p.585

18 *Ibid.*, p.586

19 Etherington-Smith, Meredith, *Dalí*, p.472

20 Descharnes, Robert/Néret, Gilles, *Salvador Dalí*, p.200

21 Roig, Sebastià, *The Empordà Triangle*, p.194

The Dalinian Legacy (pages 150–61)

1 The Gala-Salvador Dalí Foundation, 'Documentary on Dalí and his studio in Portlligat', https://www.salvador-dali.org/en/services/press/news/343/documentary-on-dali-and-his-studio-in-portlligat

2 Jones, Jonathan, 'Kitsch and lurid but also a glimpse of a strange soul', *Guardian*, 27 January 2009

3 Gibson, Ian, *The Shameful Life of Salvador Dalí*, p.485

4 Otte, Torsten, *Salvador Dalí & Andy Warhol: Encounters in New York and Beyond*, p.15

5 'Dalí, Art Painting', *Time Out Paris*, https://www.timeout.com/paris/en/art/dali

6 Koons, Jeff, 'Who Paints Bread Better than Dalí?', *Tate Etc.*, Issue 3, Spring 2005

7 Jewell, Edward Alden, 'Dalí, An Enigma? Only His Exegesis', *New York Times*, 21 November 1945

8 'Salvador Dalí House – Portlligat History', Gala-Salvador Dalí Foundation, https://www.salvador-dali.org/en/museums/house-salvador-dali-in-portlligat/historia/

9 Thurlow, Clifford, *Sex, Surrealism, Dalí and Me*, p.39

10 Roig, Sebastià, *The Empordà Triangle*, p.7

INDEX

SELECT BIBLIOGRAPHY

Ades, Dawn, *Dalí, World of Art* (Thames and Hudson, London, 1992)

Dalí, Salvador, *The Secret Life of Salvador Dalí* (Dover, New York, 1993)

Dalí, Salvador, *50 Secrets of Magic Craftsmanship* (Dover, New York, 2015)

Descharnes, Robert/Néret, Gilles, *Salvador Dalí* (Taschen, Cologne, 1993)

Etherington-Smith, Meredith, *Dalí* (Sinclair Stevenson, London, 1992)

Gibson, Ian, *The Shameful Life of Salvador Dalí* (Faber and Faber, London, 1997)

King, Elliott H.; Aguer Teixidor, Montse; Hine, Hank; Jeffett, William, *Salvador Dalí: The Late Work* (Yale University Press, 2010)

Lear, Amanda, *My Life with Dalí* (Virgin Books Ltd, London, 1985)

McNeese, Tim, *Salvador Dalí* (Ediciones Poligrafa, Madrid, 2003)

Néret, Gilles, *Dalí* (Taschen, Cologne, 2004)

Pollack, Rachael, *Salvador Dalí's Tarot* (Michael Joseph, London, 1985)

Roig, Sebastià, *The Empordà Triangle* (Gala-Salvador Dalí Foundation, Triangle Books, Figueres, 2016)

Shanes, Eric, *The Life and Masterworks of Salvador Dalí* (Temporis Collection, Digital Edition, 2010)

The Gala-Salvador Dalí Foundation, www.salvador-dali.org

Thurlow, Clifford, *Sex, Surrealism, Dalí and Me: The Memoirs of Carlos Lozano* (YellowBay Books Ltd, 2011)

Ultra Violet (Isabelle Dufresne), *Famous for 15 Minutes: My Years with Andy Warhol* (Harcourt Brace Jovanovich, San Diego, New York, 1988)

ACKNOWLEDGEMENTS

Writing a book for the first time, especially about the enigmatic Dalí, has been a wonderful, yet huge challenge. The task of immersing myself into Dalí's persona and life was, at times, a very difficult journey, made easier by those close to me. In particular, I would like to express my deepest gratitude to my partner, Joao Paulo, whose love and support were central to my creative process. He also took care of the mundane tasks, allowing me the freedom to research, process and write.

My heartfelt thanks to my father, Seán Bourke, who was a rock throughout the research and writing process. He offered wise counsel and love, stepping into the unofficial role of editor, imparting sound, constructive criticism – a job that undoubtedly came naturally to him, as both his father and brother were published authors. My stepmother Stella not only gave me feedback on the manuscript, but unreserved encouragement, especially during periods when I was experiencing self-doubt.

I am extremely grateful to my close friend, Fionnuala McAuliffe, another wonderful person, who took the time to offer impartial feedback on the manuscript and encouragment. Annabel and Luis Alfano, Shane Quilty and Richard Burgess deserve my immense gratitude for helping me source research and for special support during the creative process.

There are so many others, good friends and family, that I would like to mention, but it is impossible to name everyone. Please know that I am deeply thankful to you all. There is one last person whose eyes used to light up when I spoke to him about the progress with the book; Vitor Candeias. Vitor sadly passed away suddenly on 18 February 2018, but my memories of his encouragement linger on.

This book would not have been possible without the lovely Nicki Davis, who discovered my connection to this area. Nicki has been wonderful to work with; encouraging and patient with me throughout my first book writing process. My editor, Michael Brunström, has been superb. His words and feedback meant a great deal to me, and his suggestions truly helped to shape the book into a better version of itself.

I was delighted to be commissioned by White Lion Publishing when I saw the beautifully presented first book of this series, *Frida Kahlo at Home*. I am very thankful to all of those behind the scenes that have contributed to making this book. Finally, I would like to thank everyone who helped with research and spoke to me about Dalí.

PICTURE CREDITS

The publishers would like to thank all those listed below for permission to reproduce artworks and for supplying photographs. Every care has been taken to trace copyright holders. Any copyright holders we have been unable to reach are invited to contact the publishers so that a full acknowledgement may be given in subsequent editions.

All artwork by Salvador Dalí © Salvador Dali, Fundació Gala-Salvador Dalí, DACS 2018 Image Rights of Salvador Dalí reserved. Fundació Gala-Salvador Dalí, Figueres, 2018

akg-images: 34 (Bildarchiv Monheim), 44 (Album / sfgp), 128 (picture-alliance)

Alamy Stock Photo: 11 (Photo 12), 43 (Alberto Paredes), 65 (The Print Collector), 83 (Pictorial Press Ltd), 99 (Peter Barritt), 104 top (Pictorial Press Ltd / photo Eric Schaal © Fundació Gala-Salvador Dalí, Figueres, 2018), 104 bottom (Chronicle), 119 (Photo 12), 121 right (Keystone Pic-tures USA), 129 (Jordi Sans Galito), 131 top (Hemis), 131 bottom (Lucas Vallecillos), 132–133 (Jeronimo Alba), 136 (Realy Easy Star / Giuseppe Masci), 146 (Hemis), 148–149 (PvE), 152 left (Pictorial Press Ltd), 160–161 (Prisma by Dukas Presseagentur GmbH)

Bridgeman Images: 4 (Salvador Dali 1957), 8 (Private Collection / Photo © Christie's Images), 17 (PVDE), 24 (PVDE), 29 (Private Collection), 32 (Private Collection / Photo © Christie's Imag-es), 39 bottom (Fundacio Gala-Salvador Dali, Figueres, Spain / Photo © AISA), 40 (Underwood Archives/ UIG), 46 (Museo Nacional Centro de Arte Reina Sofia, Madrid, Spain), 48 (Private Col-lection / De Agostini Picture Library / G. Dagli Orti), 53 (PVDE), 55 (Museo Nacional Centro de Arte Reina Sofia, Madrid, Spain / Photo © AISA), 57 (Salvador Dali Museum, St. Petersburg, Florida, USA), 59 (Granger), 61 (Museum of Modern Art, New York, USA), 62 (SZ Photo / Sammlung Megele), 63 (Museo Nacional Centro de Arte Reina Sofia, Madrid, Spain), 64 (Staatsgalerie Moderner Kunst, Munich, Germany), 69 (Private Collection), 71 (Salvador Dali 1957), 72 (Museum of Modern Art, New York, USA), 75 (PVDE), 78 (Perls Gallery, New York, USA), 81 (Peggy Guggenheim Foundation, Venice, Italy), 82 (Private Collection), 84 top (Granger), 88 (Private Collection), 90 (Museum Boymans van Beuningen, Rotterdam, The Netherlands), 96 (Philadelphia Museum of Art, Pennsylvania, PA, USA / The Louise and Walter Arensberg Collection, 1950), 100 (Private Collection / Prismatic Pictures), 101 (Private Collec-tion / Photo © Christie's Images), 109 (Private Collection), 110 (Fukuoka Art Museum, Japan), 112 top (Marquette University Fine Art Committee, Milwaukee, WI, USA), 112 bottom (Museo Dali, Figueres, Spain), 113 (Photograph by Roger Higgins, 1965 / Granger), 115 (Art Gallery and Museum, Kelvingrove, Glasgow, Scotland / © CSG CIC Glasgow Museums Collection), 116 (Sal-vador Dali Museum, St. Petersburg, Florida, USA), 117 (National Gallery of Art, Washington DC, USA), 121 left (Rene Saint Paul), 123 (Salvador Dali Museum, St. Petersburg, Florida, USA), 127 (Paul Ricard Foundation, Bandol, France), 135 top (Private Collection), 135 bottom (Private Col-lection / Photo © Christie's Images), 138 (Museo Dali, Figueres, Spain / Index), 159 top (SZ Photo / Jose Giribas), 159 bottom (SZ Photo / Teutopress), 162 (Christie's Images)

Cristina Clara: 91

Dreamstime: 10 top (Valery Bareta), 10 bottom (Digoarpi), 26 (© Alexsalcedo)

Getty Images: 6–7 (Raphael Gaillarde), 19 (Heritage Images), 25 left (ullstein bild Dtl.), 25 right (ullstein bild Dtl.), 42 left (Cristina Arias), 42 right (Cristina Arias), 56 (Fred Stein Archive), 70 top (Alain Benainous / Gamma-Rapho), 70 bottom (Alain Benainous / Gamma-Rapho), 76–77 (adoc-photos), 87 (Bettmann), 102 (Bettmann), 106 (The LIFE Picture Collection), 124 (Bettmann), 134 (Bettmann), 140 (Orphea Studio 3), 150 (Charles Hewitt), 152 right (Charles Hewitt), 153 left (Lies Wiegman), 153 right (Lies Wiegman), 154 (Chadwick Hall), 156 (Kammerman), 157 (Gianni Ferrari), 158 (adoc-photos), 50 (Fox Photos), 126 (Gianni Ferrari), 144 (Keystone), 145 (Bertrand Rindoff Petroff)

National Galleries of Scotland: 94 (International Surrealist Exhibition 1936 Photo Album, from Rolland Penrose Collection)

Rex / Shutterstock: 107 (Selznick / United Artists / Kobal)

Fundació Gala-Salvador Dalí, Figueres: 14 (Gasull Fotografia S.L), 15 left (Gasull Fotografia S.L), 15 right, 54, 84 bottom, 104 top (Eric Schaal), 118, 125, 141, 143

Scala, Florence: 22 (Christie's Images, London), 47 (Album), 68 (The Metropolitan Museum of Art / Art Resource), 80 (Christie's Images, London), 120 (Album)

Shutterstock: 2 (shufu photoexperience), 12 (dmitro2009), 20–21 (Magdalena Juillard), 27 (Simona Dibi-tonto), 28 (Toniflap), 31 (Iakov Filimonov), 39 top (Gitanna), 52 (Karol Kozlowski), 66–67 (Dam-sea), 92 (Cezary Wojtkowski), 105 (Lorraine Kourafas), 166–167 (nito)

Tate, London, Tate Images: 95, 97

First published in 2018 by White Lion Publishing,

an imprint of The Quarto Group

The Old Brewery, 6 Blundell Street, London, N7 9BH, United Kingdom

www.QuartoKnows.com

A catalogue record for this book is available from the British Library.

ISBN 978 0 7112 3943 2

10 9 8 7 6 5 4 3 2 1

Design by Sarah Pyke www.sarahpyke.com

Printed in China

Brimming with creative inspiration, how-to projects and useful
information to enrich your everyday life, Quarto Knows is a
favourite destination for those pursuing their interests and passions.
Visit our site and dig deeper with our books into your area of interest:
Quarto Creates, Quarto Cooks, Quarto Homes, Quarto Lives,
Quarto Drives, Quarto Explores, Quarto Gifts, or Quarto Kids.